GILLIAN AYRES

GILLIAN AYRES

MEL GOODING

LUND HUMPHRIES

This book is dedicated to Henry,
Jimmy and Sam

Acknowledgements

Special thanks are due to René Gimpel. I thank my editors
at Lund Humphries, Lucy Myers and Lucy Clark, for their
help and encouragement. It has been a pleasure to work
again with Ray Carpenter. Harry and Sam Mundy have
been indispensable and unerringly accurate sources of
information. Above all I am indebted to Gillian Ayres, for
her unfailing confidence, patience and generosity, and
for many marvellous hours of conversation.

First published in 2001 by
Lund Humphries
Gower House
Croft Road
Aldershot
Hampshire GU11 3HR

and

Lund Humphries
131 Main Street
Burlington
VT 05401
USA

Lund Humphries is part of Ashgate Publishing

British Library Cataloguing-in-Publication Data
A catalogue record for this book is available from the British Library

ISBN 0 85331 809 3

Designed by Ray Carpenter
Typeset by Tom Knott
Printed in Singapore under the supervision of MRM Graphics

Library of Congress Cataloging-in-Publication Data
Gooding, Mel.
Gillian Ayres/Mel Gooding
p.cm.
ISBN 0–85331–809–3
1. Ayres, Gillian, 1930. 2. Painters–England–Biography.
3. Painting, Abstract–England. I. Ayres, Gillian, 1930– . II. Title.
ND497.A89 G66 2001
759.2–dc21

Contents

Introduction 6

1 Setting Out: From Barnes to Camberwell, 1930–1946 12

2 Opposed to the Tonal: At Camberwell, 1946–1950 18

3 The Notion of Abstraction: In the Fifties at the AIA 26

4 Seeing What Paint Could Do:
 Free Abstraction and the *Hampstead Mural*, 1956–1957 34

5 Young and Jubilant: Corsham and the Sublime 44

6 Nature in the Act of Painting: *Situation*, 1960 50

7 Sailing off the Edge: Into the Sixties 62

8 Crivelli/Shells/Uccello Hats: A Digression in the Sixties 78

9 The Questionable Limits of Painting: The 1970s 100

10 A Complete Combination of Heart and Mind: To Wales, 1977–1983 118

11 The Paintings That You Want to See: The Late Style 136

Notes and References 183

Biography/Exhibitions 185

Select Bibliography 186

Public Collections 187

Awards/Film 188

List of Illustrated Works 189

Index 191

Introduction

'But all right, so one's a painter, one's nothing but a painter.'

(*Gillian Ayres*)

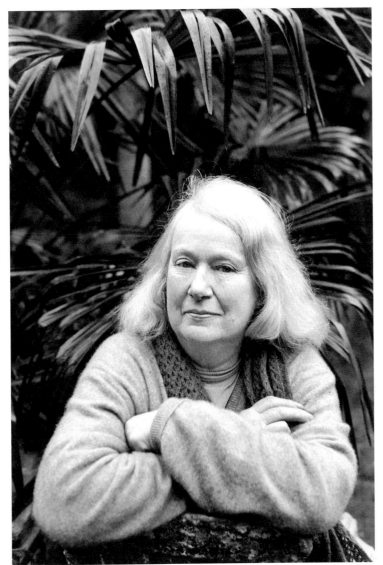

Gillian Ayres, 1997
(photo: Jane Bown)

Gillian Ayres is one of the most widely loved of contemporary British artists. The painterly vitality and lyrical brilliance of her painting, over the last twenty years especially, has won her both critical respect and public admiration. Fiercely intelligent and independent of spirit, she has continued to make work with the extraordinary energy and compulsive creativity that have characterised her career from its beginnings. Over many years of prolific production Ayres has established her presence as an artist of the first rank, original and surprising, evasive of fixed category, always following her own star, careless of fashion and of commercial viability, always held in high regard by other artists. With the emergence of what might be described as her late manner, an exuberant, poetic abstraction that admits aspects of the figurative and an abundance of reference to the light and colour of the natural world and its objects, Ayres's work has achieved an unmistakable originality within a rich tradition, extending its communicative potential and affirming its aesthetic validity.

Her belief in painting is that of an avowed modernist, her position unreconstructed in the light of post-modernist intellectual and critical trends that raised doubts as to the continuing viability of the medium. Ayres persists in thinking of painting as a primary mode of modern creative expression, an interrogation of reality still capable of surprising and exciting discoveries and revelations. Her commitment to painting was unshaken during those periods, most notably in the 1970s and the 1990s, when painting was seen by many influential and successful artists and critics as no longer appropriate to the expression of a truly contemporary consciousness, regarding it as a dying language, its speakers a tribe unwilling or unable to adapt to new modes of communication. Ayres's sense of what constitutes 'modernism' is broad-based, political and not uncritical, and has a particular historical perspective; it is defined for her, above all, by its constructive critical temper:

Modernism meant a lot of different things, and some of those things one may not like or agree with. But what it meant above all was hope in a brave new world. And what did go on under Modernism was a *questioning* In fact the whole of Western society since the Renaissance has been a society that moves and questions. I don't quite see that clear cut between the pre-modern and the modern that some earlier artists did. In fact I can see modern art coming for a very long time. And under Modernism, that questioning is almost a condition of being creative.

As a young artist in the 1950s Ayres responded boldly and in her own highly individual way to the vital post-war movements of European and English abstraction and then to the excitement surrounding the revelation of American abstract expressionism that followed from the first exposure in Britain of the New York painters, in the final gallery of the MOMA-conceived exhibition *Modern Art in the United States* at the Tate Gallery in early 1956. This was followed by a series of exhibitions at the American Embassy and at the Whitechapel Art Gallery of major figures in the movement, and by the much larger selection of *The New American Painting* at the Tate in 1959. In 1960 Ayres belonged to the loose grouping of British abstract artists who, under the critical leadership of Lawrence Alloway and Roger Coleman at the Institute of Contemporary Arts, had confidently organised *Situation*, their own highly influential exhibition of large non-figurative paintings at the RBA Galleries in Suffolk Street, London, in which the direct influence of American painting, especially with regard to scale, was openly acknowledged. In an exhibition dominated by a tendency (recent in origin) towards the hard-edge quasi-geometric separation of flat planes of pure colour, Ayres's painting was, in contrast, informal and gestural, atmospheric and tonal.

The critical arrival of American painting in London in the mid- to late 1950s had not been necessary, however, to validate Ayres's confidence in large-scale abstraction, or in automatic techniques, which brought a painting into existence as a kind of spectacular event (on whatever scale) in its own right, an objective component of the environment, offering aesthetic sensation and having no conceptual or moral designs upon the spectator. She was not unaware of the critical arguments that opposed 'modernist' flatness and edge-consciousness to 'traditional' pictorial elements of composition and the illusion of recessive space, or of those that denied any logical connection between the *quality* of a work and such aspects of its definition as its 'style' or its 'subject', or whether it was representational or abstract, and so on. Indeed, her early established commitment to abstraction and to the idea of 'pure painting' meant that for Ayres every new painting raised afresh the inescapable creative and critical question of the time: what can painting do that no other medium can achieve? It was a question that

had exercised modernists at least since the inception of so-called 'pure painting' in Paris in 1913, and was given a new intensity of critical focus by Clement Greenberg in his influential 1960 essay 'Modernist Painting'. For the modernist the answer was to be found in the spectator's response to the visible traces of the artist's actions on the canvas, irrespective of subject matter or other purposes. The subjective encounters of both the artist and the spectator with the completed work had implications that for many abstract artists went no further than the experience of the painting as a self-contained object having no external reference; such an experience, beginning with optical sensation, might be simple or complex. For Ayres, however, it was a matter of conviction that in its making and its reception, in both process and image, abstract art, even at its 'purest', continued to perform the historical function of painting: the revelation, *by analogy*, of aspects of nature.

Sometime in the mid-1960s, according to the American critic Thomas McEvilley, writing in the early 1990s, painting went into 'disgrace and exile'. What happened in the late sixties to make painting 'difficult', if not impossible, for many artists, clearly had to do with a crisis of confidence in the broader certainties of progressive modernism, and more particularly in those practices of painting that accorded most neatly with Greenberg's narrow definition of 'modernist painting', with its Kantian imperative towards pure (and puritan) clarities of self-definition and the absolute abstract probity of non-referential completeness-in-itself. By the late 1960s the 'evolution' (the use of the term, with its tele-ological implications, is Greenberg's) of that kind of 'optical' painting had come to a dead end. Artists were rediscovering Duchamp (the first big retrospective of his work was put on at the Tate in 1966) and Schwitters (important shows were held in New York and London during the late 1950s, the 1960s and the early 1970s). On both sides of the Atlantic the heroic idealism of pure abstraction in all its manifestations – painterly, post-painterly, hard-edge, colour field – and the high-mindedness of its critical promoters, was critically challenged by the engaged (and engaging) ironies of Pop Art, by the deadpan coolness of Minimalism, by the ludic provocations of Conceptualism, by Performance Art and Fluxus antics, and by the art-politics of Beuysian actions that carried art directly into the arena of life. It seemed that painting *as such* was no longer capable of confronting the true, and terrible, realities of the post-modern world. Abstraction was denigrated as 'merely decorative', and figuration was considered to be retrogressively locked into worn-out conventions serving uncertain purposes. Easel painting was in any case com-promised by its status as commodity.

Ayres's work in the 1970s was in certain respects a response to this complex crisis. It was a response characterised above all by a heroic and strenuously active refusal of the view that painting had nothing to say to the contemporary condition. Her approach to abstraction had from the mid-fifties admitted the possibilities of natural analogy and metaphor, and she had consistently resisted the reductively formalist premises of 'post-painterly' abstraction while holding without compromise to the idea of painting as a distinctive thing in itself, capable of providing experience unavailable by other means. Now she em-barked on an exploration of instinctive painterly abstraction, working for some years on an environ-mental (and perversely uncommercial) scale, persisting when at times her work seemed locked into polar ice, confronting an antarctic void, radically absolute in its rejection of subject matter or of any decorative coherence of internal formal relations.

According to McEvilley, the 'exile' returned at the end of the 1970s, bringing with it an ironic

figurative panache, an eclectic heterogeneity compounded of carnival grotesque, pastiche neo-classicisms and expressionist bravura. (In this country the return was celebrated in 1982 at the Royal Academy by the spectacular exhibition of *The New Spirit in Painting*.) 'As if to demonstrate its awareness of past sins', McEvilley wrote, 'it returned with a self-critical manner. As if to redress its former arrogance it returned with self-mockery. As if to offset its former elitism and puritanism, it returned in a costume of rags collected from everywhere. It returned as Conceptual painting and found a variety of new uses for the medium.' Whatever its forms and purposes, for a heady period in the 1980s painting was back in critical and curatorial favour. As far as Ayres was concerned, however, her painting continued to be an engagement with material substance whose possibilities of poetic expression might be unaffected by post-modern ironies or reflexive self-consciousness.

The true history of art at any time is more complicated and layered than art historians or art journalists make it out to be. Ayres and other painters, both abstract and figurative, had of course continued to work through the 1970s, when the magazines, and the students who read them, were interested in something else. For these artists painting had never gone away, nor had its communicative potential ever been denied. The 'new spirit' brought with it a pervasive sharpening of international critical and commercial focus on figurative painters of the older generation, such as Frank Auerbach, Leon Kossoff, Renato Guttoso and, of course, the late Picasso, whose astonishing exhibition of 201 paintings of unprecedented expressive vehemence at the Palais des Papes, Avignon, in 1973 had been greeted with a mixture of indifference, bewilderment or critical dismay at what seemed a sad decline of his creative powers. By a sort of historical irony, moreover, the critical interest in 'the new figuration', with its eclectic borrowings from both classicism and expressionist 'primitivism', engendered a revival of interest in those painters who had resolutely maintained *non*-figurative styles. Artists as diverse as Ayres, John Hoyland, Bridget Riley and Prunella Clough, who, against the trend, continued to remain committed to abstraction, were beneficiaries of the return of painting to critical and commercial credibility.

By the early 1980s Ayres had, in fact, won through to a distinctive new manner of her own. She had persevered, through several years of intense effort, to the discovery of a marvellously flexible expressive language in which high chromatic colour and complex relations of clearly discernible forms had emerged from near-monochrome, highly textured, formless abstraction. Ayres has developed this late style with extraordinary flair and flexibility, and with an unforced integrity of purpose. 'We all want truth', she once said,

that is, reality. Art gets there in the form of poetic or artistic truths, which are products of the creative imagination. That's what's behind it all, and it means you want to shock yourself a bit, make something new. You could simply say that the imagination is *anti-cliché, against known experience*. You are always trying to find something you haven't seen before, an experience that is true to oneself.

This book traces the lifelong quest of a remarkable artist for authenticity and imaginative truth, conducted in the light of an overriding and unwavering artistic conviction of the necessity of painting, and of the centrality of abstraction to its modern history and to the larger history of art itself. 'Abstract art', Ayres has said, 'has been an absolute force in visual art in this century.' It is a force to which she has added her own considerable creative energies and a unique imaginative vision.

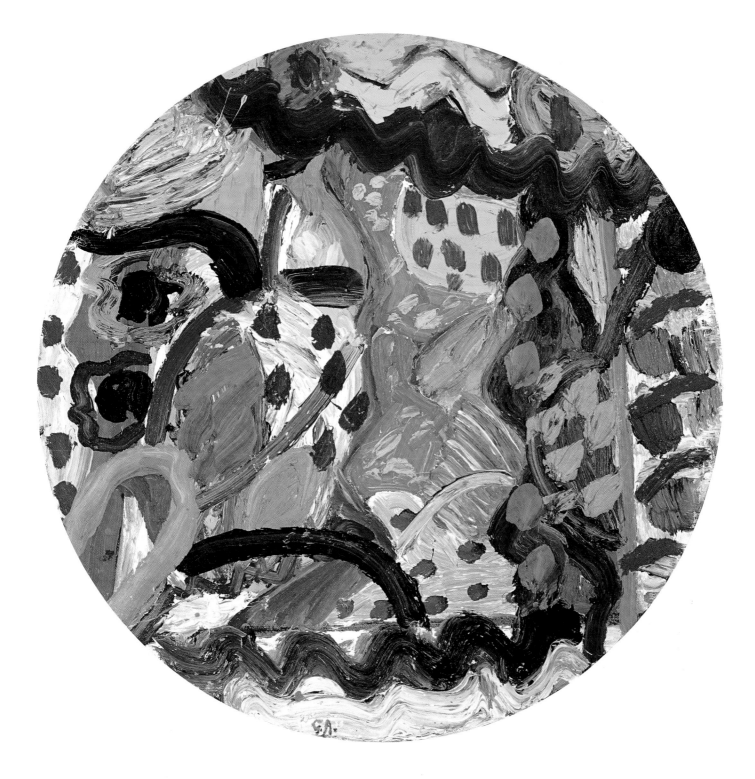

Isle
1988
oil on canvas
91.5 cm (diameter)

1

Setting Out: From Barnes to Camberwell, 1930–1946

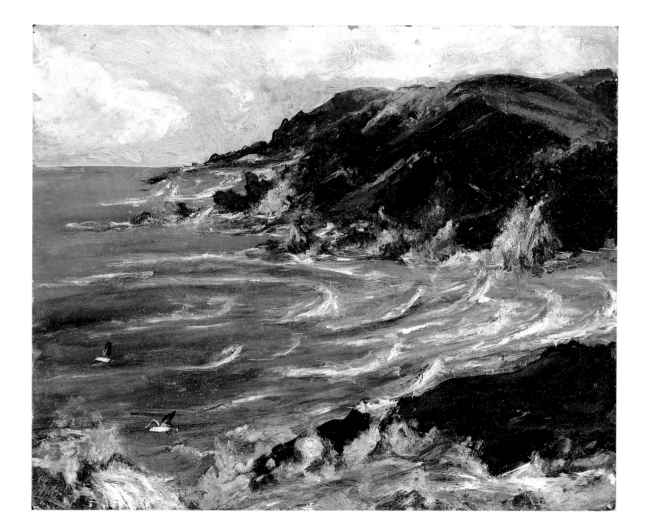

Harlyn Bay
1945
oil on cardboard
50 x 61 cm

One day in 1943 Gillian Ayres stopped on the steps going up to the art room at St Paul's Girls' School, London, where the art library was shelved. She opened one book, then another, then another: illustrated monographs on van Gogh, Gauguin, Cézanne, Monet. It is the moment she remembers as when, amazed and excited, she began to be an artist. At thirteen she was already aware of poetry and music, already serious about art, a regular visitor to the National Gallery, where through the war years under the directorship of Kenneth Clark a single great painting was shown each month, and where she spent hours looking at El Greco's *Agony in the Garden*, 'because there was nothing else to look at', and was first entranced by Renoir's *Les Parapluies*. At that moment, however, something happened that surprised the precocious and unconventional schoolgirl, something profound and private: it was the startling revelation of 'what painting could do'. Nearly sixty years later the artist remains amazed: 'Gauguin, van Gogh, Cézanne! I still think, my God! What did they do with painting?'

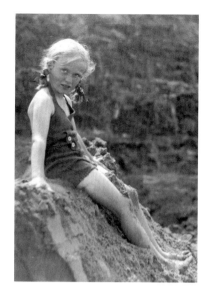

Gillian Ayres on the beach at Margate, August 1937

The intimation of artistic vocation often comes early in life; many artists speak of having known it from early childhood. For Ayres, as for many whose talents determine quite other lives than that of an artist, there had certainly been, from early on, the experience of pleasure in art. She remembers feeling proud as a six year old of her abilities to draw and colour, and from the age of eleven she regularly received oil paints as Christmas presents, but before that Pauline moment on the Art Room stairs these things had seemed to offer no promise of the future course of her life. Ayres had no doubt from then that she would be a painter. For some time this was a private conviction. Her closest school friends had other interests, other ambitions; among them was the young Shirley Williams, intending even then to become the first woman Prime Minister. Gillian sought people with whom she might talk about her 'wonderful discovery', but with little success. The art mistress was the sister of Victor Pasmore, whose volume in the *Penguin Modern Painters* series came out in 1945, but she showed little interest in his work, and seemed to share a general suspicion of 'modern art', which for its detractors continued to include even the gentle post-Impressionism of which her brother, at this time, was so adept a practitioner.

Gillian Ayres with Shirley Williams (left) and Helen Meyer (behind), summer 1946

The extreme independence of spirit that has characterised Ayres's pursuit of her chosen career, and her dealings with life in general, was nurtured in a middle-class childhood spent in the quiet London suburb of Barnes, which until the early 1930s was a semi-rural Surrey retreat across the river from the busy and very urban Hammersmith. It was in those days an un-sophisticated village, bounded to the west by wooded commons and, within the sweeping horseshoe bend of the Thames, to the north and east by extensive reservoirs, market gardens and farmland. Ayres was born there in 1930, the youngest of three girls, and has lived there for much of her life, and although since 1981 she has lived in Wales and in the West Country, has continued to keep a small house in nearby Sheen. Barnes changed drastically in the years of Ayres's childhood, its farms built over with suburban estates, its stables closed and the carriage horses that she just remembers stroking in the street gone. In 1939 Ranelagh, the famous club and playground of the rich, with its polo grounds and tennis courts by the river close to the reservoirs at Barn Elms, was finally closed and became wartime allotments, one of which was taken, out of patriotic duty, by Gillian's father.

Gillian was sent, at six, as a day girl to Ibstock, a school in Roehampton run on progressive Froebel principles, where she was allowed to do more or less what she wanted, and spent much time looking after the school goats and making pots. She shone at maths, and although she did not learn to read, at Ibstock this was not regarded as a problem. A frail child, she was often ill, and, in spite of the free and easy regime of the school, was at her happiest at home, where her parents were loving and tolerant and she was free to paint and play alone, being younger than her sisters by several years. It seems more than likely that it was in these years of a securely happy but often solitary childhood that Ayres acquired the capacity to work to her own pace, and to enjoy the long reveries that became essential to her working practice.

If it is possible to see how her early schooling and life at home encouraged in Ayres a kind of waywardness, an idiosyncratic individuality that has persisted valuably in her character, then it is also the case that she inherited from both paternal and maternal grandmothers something that had made them particularly strong-minded and independent women. She

came from a family that on both sides had forceful female antecedents. Her paternal grand-mother had been the driving force behind the family business, which in the first years of the century in two big factories in Lexington Street, Soho, made the newly fashionable peaked caps for motorists. She kept the books and steered the family's fortune from modest beginnings in nearby Berwick Street to a succession of substantial houses in the prosperous riverside suburbs of West London. Gillian's maternal grandmother had married into a respectable yeoman farmer family in Somerset but left her husband to become the mistress of an aristocratic playboy friend of Edward VII, with whom she lived quite openly in Albany Terrace, Regent's Park. At that time to follow your heart in such a manner and court such scandal took remarkable strength of character. Ayres recalls her with a qualified admiration: 'she was no intellectual, [and] probably rather silly … but [she was] stubborn and strong. She was outrageously generous, and she ended up broke.' Gillian's mother, whose training as a buyer for Woolands, the Knightsbridge department store, was paid for by her mother's lover, sought an early independence of the arrangement, and went to work for the firm in Lexington Street. There she met Stephen Ayres, whom she married in 1919.

Stephen Ayres was a remarkable man. The younger son of the family, he had been made deeply deaf by a childhood fever, and was intensely shy. He was possessed of a strong sense of duty and although he had won an Oxford scholarship was pressed instead to enter the family firm, and did so, though he had no great feeling for business. He is remembered with great affection by Ayres as unfailingly kind and sweet-natured. Stephen Ayres observed a strict but highly individualistic code of behaviour, a personal morality untouched by any religious con-viction. He would drink always in the public rather than the saloon bar of a public house, and travel third rather than first class on the railway. It was not that he was at all mean; rather it was that in spite of his wealth he was modestly against indulgence and ostentation in any form. Like his wife, whose lead he tended to follow, he was not particularly intellectual but he was intelligent; though outwardly conventional, they were both in fact highly original and open in their approach to matters that touched them closely, quietly advanced in the upbringing of their children and absolutely without snobbery. They provided a generously unconventional model of parenthood, to which Gillian was herself in many ways to adhere.

In 1939 the long anticipated war became a reality, and Ibstock was evacuated to Woodstock near Oxford. In September Gillian's bags were packed and she was driven down by her father for the new term. She was resigned to going away to school, had accepted that it was determined. Things, however, happened differently, and it was her mother who made the decision, as always. 'We drove up to this big house … and my mother said "Drive on". And we drove round the drive and drove away and I never went.' Gillian returned to Barnes, where there were now no children to play with, the war was on and there were no schools open for her to attend. She rode about the quiet streets of the village on a bicycle with solid tyres and no brakes and was left largely to her own devices. After a few months a class was started, 'like a village school', for a handful of local pupils of all ages, and later a small Catholic convent school was opened opposite Barnes pond. Gillian attended for a couple of terms, and then in 1941, blissfully uneducated, she was sent to Colet Court, the junior school for St Paul's, in Hammer-smith, where the teachers at that time outnumbered the pupils. Once there, she proved to possess a quick aptitude for learning and on the day of her eleventh birthday, under a great deal of teacherly pressure, she finally began to read. The following year she passed the entrance exam to the senior girls' school on Brook Green at Hammersmith.

Once started reading she could not be stopped, rising at six o'clock in the morning to read anything and everything that came to hand. Richmal Crompton's stories of the wayward *Just William* were a particular (and perhaps predictable) early favourite, but before long she was reading Dylan Thomas and other contemporaries, alongside the classic English poets Chaucer, Spenser and Shakespeare and the Romantics and the Victorians that were the staples of a literary education at St Paul's that Ayres remembers with gratitude. The habit of prolific reading, wide and deep, has persisted throughout her life and deeply informed her art. She also enjoyed the music for which the school was famous: the composer Herbert Howells was music master, having succeeded Holst in 1936. Not every aspect of the school's regime was as

congenial to her spirit, however. The art teaching was generally dull and uninspiring. The school was rigidly rule-ridden, highly academic and conventional, and strict in enforcing homework demands that Gillian found irksome and time-consuming when she would rather have been painting.

At St Paul's a social conscience was actively encouraged. Many of the teachers had been politically engaged as suffragettes, and older pupils were sent to do voluntary work in the East End slums. This was something of a St Paul's tradition: it was a connection that could be traced back to the founder, John Colet, whose estate lands in seventeenth-century Stepney continued in later urban days to provide income for the school. After working at a medical centre, Gillian and her best friend Shirley Williams taught weekend art classes in the docklands for the children of Stepney. The area had been badly blitzed and the conditions of life that the young public school girls encountered there were as nothing they had known. Deeply shocked and full of youthful indignation, they protested at school at what they saw as patronising charity. This response was characteristic of the pair, who had become comrades in rebellion, sharing a sense of difference from their parents' generation, despite their utterly different backgrounds: Shirley Williams came from a high-flying, intensely cultured, intellectual and politically radical family, and had returned to the school in 1943 from evacuation to Canada, along with many other girls who had likewise been sent away from London during the early years of the Blitz.

The war continued and with it the bombing, and a great deal of time was spent in air-raid shelters. Air raids could occur, of course, at any time of day, and it was not unusual for Gillian to be caught travelling home from Hammersmith across the river to Barnes as bombs fell. On one summer evening she watched London burning from her father's allotment at Barn Elms: a panorama across the river of a sky that was entirely lit red. Death was a close and present reality. An intense four months was spent with the older brother of two of her closest school friends, who was on leave with money after four years in the desert war; he took them out to the theatre, and they saw their first strange foreign films at the newly opened Academy Cinema on Oxford Street. A few months later, in July 1944, he was killed as the allies took Caen. Even as the war neared its end there came the V2 attacks, terrifyingly unpredictable and devastating: just before VE day one fell at Shepherd's Bush, a few hundred yards from the school, killing over eighty people.

It was an extraordinary time to come into early adulthood, and a deep seriousness of attitude and behaviour, still recognisable, marked that generation: it is an approach to living imbued with an awareness of the value and the vulnerability of the things important to civilised life. It was from that time that Gillian came to feel, quite consciously, that art – literature, music, painting, architecture – were quintessential manifestations of the human spirit, transcending the contingencies of the mortal. She realised also that this feeling was not unusual; the war created in people a heightened intensity of attachment to the things they loved and valued. She recognised in her contemporaries something special to the time: 'It was quite a common feeling with a lot of people in the war Goodness knows what the mood was. Strange! And a strange optimism too Quite philosophic and deep . . . I'm not being romantic; I don't think [they were] uncommon . . . these strange values. We used to read everything: we were horribly serious!'

It was in the expectation of being with people to whom art mattered as much as it did to herself that Gillian determined, in 1946, to leave St Paul's and go to art school. The head-mistress, alarmed, summoned her mother: 'You know what sort of men you get in art schools.' It was accepted that if Gillian stayed on, out of harm's way, she would be given the freedom to do much as she liked, with unrestricted access to the art room and the library. At once astounded and tempted by this offer, but secretly infuriated by the assumptions behind it, Gillian insisted on leaving. Committed now to being an artist, she was adamant about what she thought would best suit her purposes. Easy-going as ever, her mother accompanied her to the Slade School of Art, with a portfolio that filled the interview room with work. She was interviewed by Ralph Nuttall-Smith, and offered a place, but being too young for the Slade was advised by him to spend a year at Camberwell School of Arts and Crafts, where he also had a say on admissions.

The paintings that impressed Nuttall-Smith enough to grant her a place had been made not at school but at home or on holidays on the Cornish coast. *Harlyn Bay* (1945) was typical of such work. Although Ayres was well acquainted by this time with the graphic linear English art that was regularly represented in Kenneth Clark's changing exhibition of war artists at the National Gallery – she admired Eric Ravilious and Albert Richards particularly – her own inclination was to an expressive painting whose precedence was no less English. *Harlyn Bay* was painted not from the motif but composed from memory indoors, and it is clear that the memory included not only the scene itself but Turner's painterly atmospherics and Constable's textural turbulence. The pictorial rhythm and counter-rhythm of the landward-riding white horses against the opposing dark mass of the coast is original to the artist herself, precociously confident in its oppositions of light to dark, space to mass. The seagulls add a evocative note to the vigorous visual sounding of the waves. 'To this day', Ayres remarked on looking at this painting after many years, 'I love the sounds of the seabirds on that coast.'

It was not, in fact, that uncommon at the time for students to begin an art school training as early as sixteen years old. Indeed, many of the colleges had junior schools where pupils could begin a serious preparatory part-time course at fourteen. What was exceptional in 1946 was the influx of large numbers of demobilised ex-servicemen, many of them, like Terry Frost and Harry Mundy, from working-class origins, encouraged to go to college by post-war optimism and generous grants from the new Labour government. For a few years it created a vibrant student population whose mix in age, experience and social background was quite un-precedented and never to be repeated. Student numbers trebled at Camberwell, the school building was overcrowded and every available space – alcoves, corridors and stairwells – was used for working and teaching. It was a brave and very different world from that of an exclusive girls' public school, where eating an ice-cream in the street was regarded as a major infraction of the rules. The people in this world were not inclined to be rule-ridden or regimented. Many had been through the war, had seen and survived terrible things; they were of the generation that had put Labour in power. It was time for new beginnings.

2

Opposed to the Tonal: At Camberwell, 1946–1950

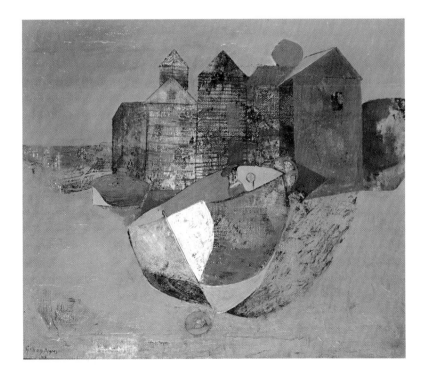

Beached Boat
1949
oil on canvas
42 x 46 cm

The principal at Camberwell was William Johnstone, an artist of great gift and a visionary educator who believed that art schools should employ the best contemporary artists and designers. At Camberwell after the war his staff included William Coldstream, Victor Pasmore, Claude Rogers, Lawrence Gowing, William Townsend, John Minton and Frances Richards, among other artists of distinction. It is not surprising that the school attracted many of the best students of that extraordinary generation. Coldstream was a very effective organiser and a forceful teacher, and the regrouping there of most of the important artists of the pre-war Euston Road School meant that post-war Camberwell was quickly established as the academic home of the style of painting that continued to carry the name. The Euston Road approach to painting, governed by what Gowing later described as 'an aesthetic of verification', placed overwhelming emphasis on observation and visual perception, favoured 'realist' disciplines of modulated stroke-making and muted tonality, and set much store by measurements carefully marked on the canvas, entailing the use of ruler and plumb line, to ensure horizontal and vertical exactitudes of placement and relation. It was still the recognisable Camberwell house style, albeit in mannerist decline, in the late 1950s when Robert Medley became Head of Painting:

[I came] to the conclusion that the teaching of painting in the school needed the added dimension of a tougher perceptual and intellectual discipline. The painting of sensitive pictures in an acceptable Sickert–Euston Road style which had become the norm at the school was all very well, but it left too much out of account, too many possibilities unexplored. Sensibility, so highly valued by the English that they think that is what a picture is about, is not enough.

Ayres, predictably perhaps, was among those students who rejected the aesthetic of Euston Road and its approach to picture making – 'the measuring thing' – despite the dominance of its mode and methods in the painting department: 'the Coldstream thing was completely dictatorial . . . it was dot and dash and measure.' What it left out of account – imagination, invention and feeling – and the possibilities it left unexplored – colour, texture and form – were precisely what excited her in the painting she most admired. It was not surprising that Ayres reacted negatively to the underlying pedagogic premises that drawing was the basis of 'realist' painting, and that anyone could be taught to draw 'scientifically' using the appropriate tools and techniques. Anything softer than an HB pencil was disapproved of, and drawings were constructed from plotted moves between 'fixed points', marked by dots and crosses, establishing 'objective' relations on the plane that corresponded to those existing between aspects of the motif. Looking back she is clear about her objections at the time, both to the style and to its overtly moralistic propagation:

really it was learning to measure up, and learning to see a tone and put a tone down that you see. I'm totally opposed to the tonal. If Bonnard drew a line down a door, and it's a dark line, it could be painted yellow or pink It's totally opposed to the Euston Road – [where] if it's a dark line it will go into a dark colour, and if it is pale it will be whitened up. But I like *intensity*, where yellow comes up with black The measuring thing, all right, it's one way of drawing: it's very restrictive, but OK, it's a method [but] I disagreed with setting [this up as a] method that was to be spread, which in fact *was* spread I think the result is very, very English, even the tonal thing, and the sensibility of it. And I think there is such a thing, possibly, as an *English* sensibility that responded to them.

Ayres's disagreement with the tenets of 'Euston Road' went, in fact, beyond the aesthetic to the epistemological: 'and then they always had this object/subject thing, which I don't really believe in'. It was the characteristically English empiricist separation of objective reality from subjective experience, and the implicit (and sometimes explicit) valuation of the objective as the truly real, to which she most deeply objected. The detailed journal kept at the time by William Townsend is illuminating on the artistic preoccupations of Coldstream and his close colleagues at Camberwell in this period: their discussions reveal a philosophy informed by a dualistic materialism and positivistic confidence in objective 'reality'.

Walk with Victor and Bill beside the canal at Peckham between afternoon and evening teaching sessions. We

talked about the difference of attitude, especially of attitude to the objective world, between realist painters of our kind and the contemporary romantics or the idealists of the école de Paris. Bill, pointing to a crane, folded against one of the warehouses across the canal, stated like this the fundamental divergence between the painter interested first in a world outside himself and the painter interested in a world of his reactions with only the picture as an outside object. 'They start where we leave off. They believe they can draw that crane without any difficulty, the only problem is where to place it and in what picture. We are not sure we can draw it as we see it and the whole picture is our attempt to do so and we consider we have done well if we get somewhere near it.'

Later, earnestly discussing the 'reality' of a pepper pot and a salt pot on a café table, they agree that what they see and what they know of it through learning and memory are only 'understood by direct contact with the objects themselves and of [sic] the space in which they are sited'. 'This', avers Townsend, 'is the material of our paintings.' The 'romantic painter', he declares, would quickly become more interested in 'analogy and association' (with what he felt the pots might 'look like') than in 'the objects themselves', and seek to capture aspects of the objects that help him 'to express this feeling'; 'the expressionist ... would concentrate on certain qualities that would give maximum expressiveness in some sense or other to the forms depicted. Bill says he tries to paint things "not more nor less expressive than they are".' (October 1947)

Much admired by them, Pasmore was always more idiosyncratic and wilfully inconsistent than his colleagues. Townsend describes him delivering an end of term criticism in pure Euston Road terms in the Camberwell life room in December 1947:

He stood by the model's throne and delivered a carefully-prepared statement – half reading it from notes – of the relation of the painted surface to reality; the theme being that it is not a question of copying lights and shades of imitation but of understanding and controlling the seen thing and then in lines and dots ... making shapes on the canvas in which the object is re-identified.

A few months later, in March 1948, Pasmore is perversely praising students who have 'the intelligence to copy some other painter' rather than attempt to draw or paint from nature: 'I don't believe in this looking at nature. Looking at nature never made anyone want to paint pictures. You only want to do it and learn how to do it by looking at other pictures.' Townsend is clearly disconcerted:

These are pretty closely his words and this is an attitude he boasts of now ... yet even his earliest pictures show an extraordinary interest in particular things seen and a visual memory of appearances Bill always argues that Victor's best painting is done when he is trying to represent something he has in front of him, and tries hard to save him from intoxication with aesthetic theories and the wiles of the self-styled or approved 'moderns'.

A month later Townsend visited Pasmore's studio to discover 'four small abstracts' that heralded his famous conversion to the modernism of an entirely non-figurative art. It was at this time that Ayres attended by choice Pasmore's extra-curricular Saturday morning still-life classes at Camberwell. She found him tersely dogmatic but perceptive, and was surprised that unlike 'the others' he spoke about *feeling*: 'You're painting that', he said to her, 'because you feel something particular about it.' On this occasion, as it happened, this was not true, but the sentiment behind the remark struck a note of unaccustomed sympathy.

Townsend's precise and unintentionally comic description of Coldstream's *modus operandi* provides a vivid indication of the spirit that the disaffected young Ayres, her imagination fired by her discovery of Gauguin and van Gogh and stirred by the living presence of Picasso and Matisse, found so unappealing in the recrudescence at Camberwell of pre-war 'realist' painting. Townsend had agreed to sit for Coldstream in the Lord Chancellor's robes to enable him to make progress on a commissioned portrait of the great man:

Bill settled me in the robe, stiff black moiré surfaces encrusted with embroidery in wiry gold thread and there I sat for two hours while Bill screwed and stretched his eyes in agonies of penetration and balanced rulers on an extended finger in search for statements of pure location, and in the course of it put down some fifty

touches of yellow ochre and black to establish a fragment of the surface of one of the sweeping panels of the front of the robe. (May 1948)

As at school, Ayres at Camberwell was 'awkward' and argumentative, unafraid to speak her mind in matters relating to her vocation. When Coldstream, who could be formidably cool and formal in manner to students, remarked in her presence 'Matisse can pass me by', she replied tartly 'He may pass you by but he won't pass me by.' Ayres acknowledges that she was not an amenable student: 'I taught later, and I don't know that I ever came across such difficult people as myself.'

Training at Camberwell entailed an inordinate amount of time in the life class, beyond which Ayres managed to find very few sympathetic teachers, preferring to work on her own. She liked Johnstone, who, although he could be something of a bully and was strict in enforcing rules, was indulgent of her, allowing her to find quiet places to do her own work free of supervision. Minton taught illustration and composition, and although much admired and greatly loved by the students, he was very much a lone figure in the school, which he left for the Royal College of Art in 1947. His replacement was Michael Rothenstein, who is remembered by Ayres, as by many other ex-students, for his kindness and generosity of spirit. Rothenstein, for all his modesty and gentleness of manner, was a true radical, and possibly the most distinguished artist at the school during that period, though none of his colleagues would have recognised it at the time. Ayres was welcome to spend as much time as she liked in his studio, although as tutor in illustration he never taught her formally.

Rothenstein, a perfect example of Townsend's 'contemporary romantic', was a brilliant and enthusiastic talker about art. A dialogue he wrote at the time (entitled 'The Romantic Impulse') provides a taste of the piquant contrast his conversation offered to the prevailing philosophy at Camberwell. In a gallery hung with paintings by Colquhoun, MacBryde, Sutherland, Minton and others of the kind disapproved of by Coldstream and his school, a friendly artist (Rothenstein himself) attempts to enlighten an uncomprehending visitor as to how a modern painter works:

a good painting, like a book or a poem, starts with a very definite and vivid experience. In my case, this experience gives me a feeling of sudden closeness and identity with the thing I want to paint. You seem suddenly to find yourself *in* the object, or, to put it another way, you discover that the thing looked at fits in with your own kind of imagination, with the shapes and colours you like visualising and thinking about. This experience gives you a feeling of homecoming: of getting in touch with something which is intimately connected with your own make-up as a personality Subject only matters when it means added excitement.

It was not surprising that Ayres found Rothenstein sympathetic. One day he declared with remarkable prescience and typical vehemence that she would one day be a great colourist. Ayres was both touched and greatly encouraged by this. Small remarks and modest actions by teachers often count for more in the memories of their students than they might ever imagine.

To a great extent, as with many of the best artists, Ayres's real education took place outside the academy. She had seen the revelatory post-war Picasso and Matisse exhibition at the Victoria and Albert Museum in December 1945, which featured wartime paintings by both artists as well a small retrospective of earlier works by Matisse, and, in the following year, exhibitions of Cézanne watercolours and paintings by Braque and Roualt at the Tate. She went many times (as did Patrick Heron at the same time) to the Redfern Gallery in Cork Street to study Matisse's great 1911 painting *The Red Studio*, which hung on the downstairs wall there for many months towards the end of the war. This was all before she had arrived at Camberwell. In the winter of 1947–8 there was van Gogh at the Tate and, a month later, the first exhibition organised by the ICA, *40 Years of Modern Art*, drawn from British private collections, which included first-rate works by Klee, Derain, Picasso, Miró and Matisse. In December 1948 the ICA followed this with the spectacular *40,000 Years of Modern Art*, a 'Comparison of Primitive and Modern', which brought together prehistoric, African, Australian aboriginal and Oceanic art with Picasso, Ernst, Moore, Miró and other major modern artists. 'There was so much happening: it was very alive . . . suddenly there was a burst of

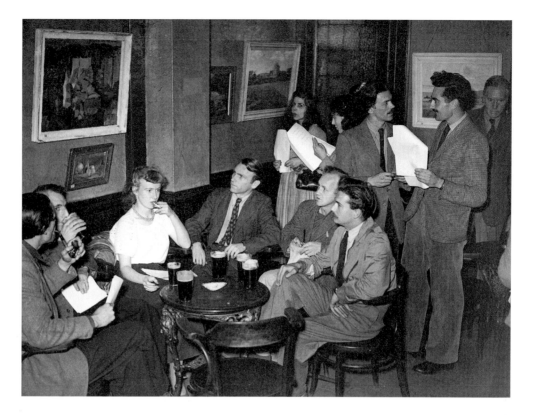

Gillian Ayres, Henry Mundy (right of Gillian Ayres) and others at the Walmer Castle, near Camberwell, June 1948

wonderful things And they were terribly accessible. Wonderful things! And so, yes, one did see so much stuff, such great stuff really.'

At 3.30 sharp, at the end of afternoon classes, Ayres would escape by bus to the West End to spend time in the contemporary art galleries in Cork Street. By the end of her first year at Camberwell she was already launched into a lifetime of intent and concentrated *looking* at paintings, a sustained and disciplined enthusiasm of the eye that became essential to the practice of her own art: 'You go on looking, you always keep re-finding things ... or rather one thinks one finds different things to what one found twenty or thirty years ago and yet the impact is very much the same' She went frequently to the British Museum, and at the National Gallery she was excited by Rubens (then very much out of fashion), enchanted by Piero della Francesca's *Baptism of Christ* and *Nativity*, and enthralled by Crivelli's *Annunciation*. (Terry Frost, whom Ayres had met on his first day at the school, was a Camberwell contemporary who also undertook extra-mural studies with Rubens and Piero at the National Gallery.) In London and in Paris she sought every opportunity to see works by Bonnard, Matisse and Picasso in the dealers' galleries.

There can be no doubt that this intensive experience of great painting was in the most profound ways formative, but of the few pictures that survive from her time at Camberwell, the small and modest paintings that Ayres made during her last full year there owe as much to recent English 'romantic painting', to Rothenstein and Minton in particular, as to anything classical or modern European. *Railway Station* (1949) shares with *Boats on a Beach* (1949) a vital compositional dynamic that sets the geometric planes of the buildings and the disc of the setting sun against sweeping landscape curves from lower right. Their organisation is essentially graphic, the landscape and object motifs 'abstracted' into an imaginative design of coloured shapes: whether based on actual places or not, they have a pictorial structure that is intrinsic. *Beached Boat* (1949), with its more tightly controlled tonal range, its centralised composition and rigorous scraping back of paint to canvas, has more formal coherence of structure and texture, and a painterly objectivity that the others lack. Taken together, however, they register an intelligent awareness of the more sophisticated contemporary British responses to French art: they have a touch of William Scott's painterly 'gaucheness', and their reductive play of architectural rectangle against curve closely follows the manner of Ben Nicholson's post-war paintings. Also Nicholsonian is their moody tonal range, duns, khakis

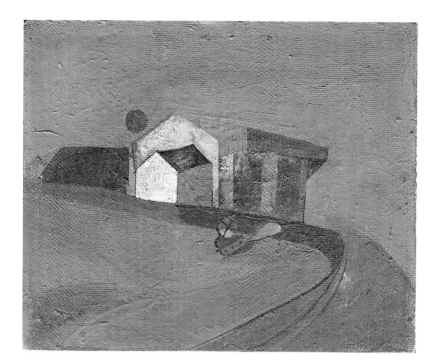

Railway Station
1949
oil on board
28 x 35.5 cm

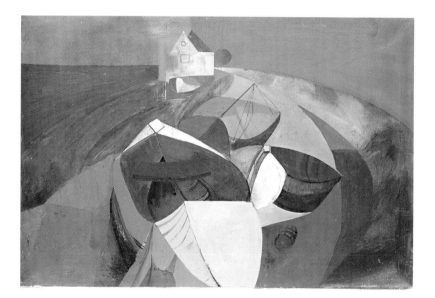

Boats on a Beach
1949
oil on canvas
51 x 76.2 cm

and ochres, dirty whites and greys, relieved by dark reds and pinks. There is little hint of the 'great colourist' of the future, but their subdued, even delicate, colourism is in fact quite characteristic of a great deal of Ayres's later painting.

Ayres was not unhappy at Camberwell, but much of what she found enjoyable there had to do with what she refers to as 'the by-the-way things': out-of-class conversation, the social life of the pubs and jazz clubs (Humphrey Lyttleton and Monty Sunshine were both contemporaries), foreign films at the film society, poetry and novels. In her second year she went to Paris for the first of several visits. She was enthralled by the knowledge that Picasso and Braque were still living and working there, but quickly came to the view that the dominant French abstractions of the immediate post-war – the somewhat cerebrally structured, shallow space post-Cubism of such artists as Manessier, Bissière and Mortensen, and so-called *art concret* geometrics – lacked the force and edge of the great figurative painting of the previous generation of the School of Paris.

Post-war Paris was important in other ways, however: there was tangible political and artistic excitement in the air, a cultural sophistication lacking in London. Above all, there was the pervasive atmosphere of Existentialism, which brought to every discussion about art and everything else the crucial questions, Is this act authentic? Is this act free? Ayres was temperamentally predisposed to find sympathetic a view of life that placed a crucial emphasis on the moral imperative of choice, on the requirement to take responsibility for one's acts, and to act out of inner necessity. It codified what was natural to her; without undue intellectualising it became an undercurrent of thought and feeling that has ever since in-formed her attitudes not only to life but to painting. From Paris she brought back art books and catalogues, and in secret defiance of English puritanism and official censorship she returned with banned Olympia Press erotica in her suitcase.

Gillian Ayres, 1949

In 1950 Ayres walked out of Camberwell a month before the final examination. It was a fine May morning, and she caught a train to Penzance – as far as a train would take her. For that summer she worked as a chambermaid at the newly opened Land's End Hotel. The decision to leave Camberwell before taking the diploma exams was, of course, typical of Ayres's tendency to act upon principled impulse and of her insouciant disregard of any kind of authority. Although she was to spend many years as a professional teacher, she has never overcome a distaste for formal education that was first nurtured at the Froebel school in Roehampton. The National Design Diploma examination entailed a written paper and three paintings on specified themes to be made over a limited period of time. In the light of eternity, perhaps, to take the exam was a small matter. 'But what should one have taken it for?' she asked many years later. 'For whom?'

3

The Notion of Abstraction: In the Fifties at the AIA

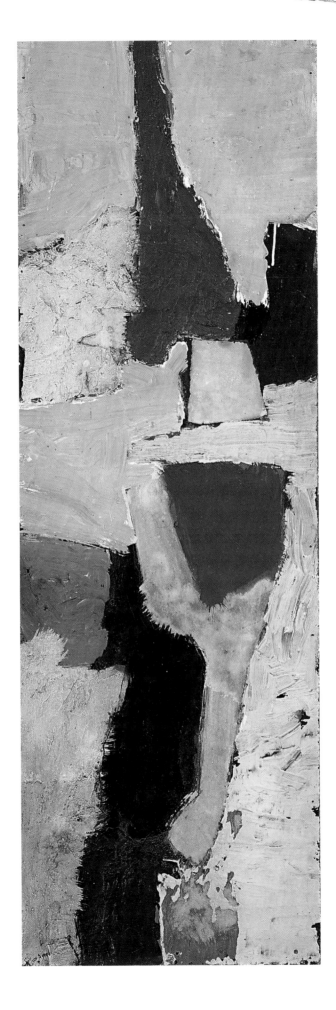

Vertical Blues
1956
oil and household paint on board
117 x 40.6 cm

27

In her first week at Camberwell Ayres had met Henry Mundy. She was a shy but strong-willed sixteen-year-old, living with her parents in Barnes, obsessed with art and already utterly committed to being a painter, wanting to talk about little else. Harry Mundy was twenty-seven and had come back from a long war, including active service in Burma, before which he had worked professionally in Liverpool. They became close friends at the outset. They shared a passion for painting, and both took against the dominance of Euston Road at the School, preferring the freer, romantic approach represented by Minton and Rothenstein, and the French-influenced painting of Scott and the Roberts Colquhoun and MacBryde. Mundy and Ayres looked at a great deal of art together, but always remained independent when it came to their own work. After completing the NDD exam, in the early summer of 1950 Mundy joined Ayres in Cornwall, taking a job as a barman at nearby Sennen Cove. When they returned to London in the autumn, Ayres turned down a typically generous offer by her father to pay for her to live and paint for a year in Paris. For better or worse, she had decided now that London was the place to be a painter.

It was not easy to begin with. Ayres worked first at a bookshop in Clifford Street, which was conveniently close to the galleries in Bond Street and Cork Street, but later took a succession of uninspiring temporary jobs, selling Danish cheese at the Ideal Home Exhibition, and souvenirs at the Battersea Festival Gardens during the 1951 Festival of Britain. Her belief in modernism, in the possibilities of an intelligently ordered world, though not formulated with any particular theoretical coherence, was very much in the spirit of the Festival and the South Bank Exhibition that was its major manifestation. She loved the Skylon, admired the Royal Festival Hall and subscribed to the political and social optimism of the Festival effort to kick-start a revival of pre-war modernism in British architecture and design.

Notwithstanding her misgivings about the formal and official aspects of art school education, in the months after leaving Camberwell Ayres felt isolated, 'out in a world . . . [in which] nobody is the slightest interested in your existence and what you are doing' Working six days a week, trying to paint in the evening, exhausted at the weekends, she missed the discussion and criticism that had been part of everyday life at college. When Michael Rothenstein asked her to stay for a weekend at Great Bardfield in Essex and to bring her work to show him she was surprised and grateful, but it was an unusual event. In these circumstances the artistic and intellectual comradeship she enjoyed with Harry Mundy – a friendship that has lasted a lifetime, surviving marriage and divorce – was of the greatest importance to both of them. Mundy was working unhappily in a drawing office in Lambeth, designing trade-fair exhibition stands for Olympia, desperate to find a way to continue with his own work as a painter.

A few months after their marriage in February 1951 Ayres and Mundy were offered a job at the Artists International Association Gallery in Lisle Street, Soho. They had visited the gallery regularly, and were friendly with the painter Gerald Marks, a committed AIA activist who was on the exhibitions committee. Ayres had exhibited a small Cornish landscape in the 1950 summer exhibition. When it was agreed by Diana Uhlman, the Association's organising secretary, that they could share the five-pounds-a-week post of gallery assistant the couple were jubilant: this would free them to paint for three full days a week each. As Ayres remembers: 'It seemed like heaven.' What is more, working at the AIA Gallery brought them immediately into close and constant contact with a broad spectrum of artists, a lively milieu of a special kind, and would give them a insider's insight into the professional world of art. Their tasks were to help hang the exhibitions, to staff the gallery during opening hours, to keep the accounts and to administer the AIA picture hire scheme. This was an imaginative and highly successful scheme whereby artist members could deposit pictures with the gallery for extended loan to annual subscribers, with terms for their subsequent purchase.

The AIA had been founded in 1933 to mobilise artists sympathetic to the Soviet Union and opposed to the rise of fascism in Europe, class oppression at home and colonial imperialism abroad. Among other things, its aims were to work for 'the improvement in the status of the artist and [. . .] for his recognition as necessary for the well-being of the community', to organise artists to use their skills in 'the spreading of propaganda by means of exhibitions, the Press, lectures and meetings', to encourage them to take part in demonstrations, design

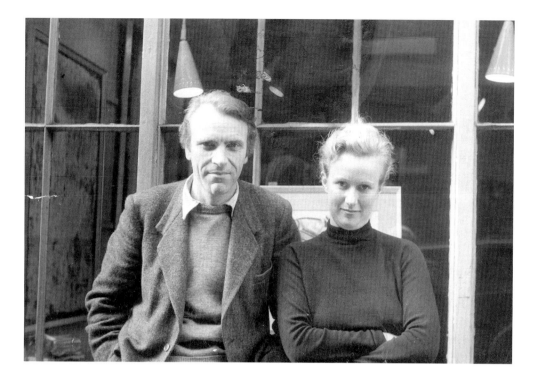

Gillian Ayres and Henry Mundy outside the AIA Gallery, Lisle Street, early 1957

and paint posters and banners, publish cartoons and pamphlets and, in the terms of the catch-all so-called 'political clause', to 'take part in political activity' in support of any action or manifestation 'in sympathy with the aims of the Association'. The Association had a history of considerable success and significance in these terms during the 1930s. It continued through the war, as part of the war effort, to organise conferences, lectures and exhibitions, opening a one-room centre in Charlotte Street in 1943 with an exhibition of *Hogarth and English Caricature* and organising a continuing series of social events, talks, art courses and exhibitions.

When the centre closed in 1945 the search began for a new and permanent base for the Association. In 1947 it acquired the ground floor and basement of the building at 15 Lisle Street, and the first floor was added in 1950. Artist members cleaned and decorated the premises, and by 1948 there was a regular programme of exhibitions and the gallery was already an important venue for contemporary art. This coincided with a period of considerable change in the political complexion of the Association itself. In the charged atmosphere of the post-war period, with Soviet consolidation in Eastern Europe (the 1948 Communist coup in Czechoslovakia was a turning point) and the beginning of the Cold War, it was moving away from its overtly political stance towards a policy concerned more with the creation of opportunities for the exhibition of the work and promotion of the interests of member artists. In 1949 the Exhibition Committee issued a statement that stressed, significantly, that 'the gallery has been and will continue to be completely independent of political policies or controversies within the AIA. The gallery has NO POLITICAL BASIS WHATEVER.'

Much of the debate in the AIA, as elsewhere in art circles at the time, focused on the critical conflict between realism, in its various guises, and abstraction, also diverse in its manifestations. Several of the more influential younger members were committed to non-figurative modes, and although their writings generally betrayed no great interest in radical politics, and certainly did not promote abstraction as itself political in its implications, in the critical climate at the time there was a tendency among the ill-informed to associate abstraction with an imagined anti-humanist left-wing threat to the 'civilised values' of the free world. Ironically, it was the view of many abstract artists at the time that art should be freed from the programmatic simplicities of social realism and from sentimental illustration in order to give expression by means of a 'universal language' to 'inner truths', or to make possible the revelation of the underlying forms or dynamics of the natural order. In other words, most abstractionists were of the view that art was a phenomenon to be regarded as separate from direct political or social concerns.

In a series of exhibitions and events in the 1950s the AIA was very much involved in the broader didactic effort to increase professional and public understanding of abstraction and to place it critically in relation to the various kinds of realist and figurative art, which were themselves seen by more and more members as divorced from political purpose. In October 1951 Stephen Bone, who from early 1948 had led the campaign within the Association to scrap the Constitution's 'political clause' (number 2f), proposed an exhibition that would address 'the prevailing controversy between those whose work is Abstract and those with a Humanist approach'. Only the AIA, Bone argued, could organise such an exhibition: 'Neither the Royal Academy nor the ICA could do it. As artists do not fall into neat groups, at one end of the hall there should be a crystal, at the other a mirror, and the work of artists should be graded between them according to the degree of abstraction or realism.' John Berger, who was active as both artist and critic in the realist camp at this time, proposed 'that there should be more than two categories. For instance we might have Realistic, Abstract and Subjective.' Under the title of *The Mirror and the Square*, the exhibition was mounted at the New Burlington Galleries in December 1952. Over sixty artists, constructivists and 'pure' abstractionists, socialist realists, Euston Roaders, romantics and expressionists, were represented by 287 exhibits. *Measurement and Proportion*, with a similar didactic purpose and comparable range of representation, was organised by Adrian Heath and Andrew Forge (whose own artistic formation was Euston Road) in 1955, the year after Heath, who had supported the final deletion of clause 2f in December 1953, had become chairman of the Association.

It was the AIA Gallery, in fact, that mounted the first post-war public exhibition in this country devoted purely to abstract art as a movement. Organised by Heath in May 1951, it included work by Terry Frost, Barbara Hepworth, Anthony Hill, Roger Hilton, Kenneth and Mary Martin, Ben Nicholson, Victor Pasmore, Ceri Richards, William Turnbull and Heath himself, among others. It was accompanied by a pamphlet, *Broadsheet No.1*, with a short manifesto essay, 'Abstract Art', by Kenneth Martin, which made explicit the distinction between the work of the more rigorous non-referential ('constructive') artists such as Pasmore, Hill, Mary Martin and himself, and the 'abstraction from nature' of such painters as Frost and Scott. 'Abstract painting', Martin wrote,

is truly the externalising, in a new way, of the innermost nature of the painter What is generally termed 'abstract' is not to be confused with the abstraction from nature which is concerned with the visual aspect of nature and its reduction and distortion to a pictorial form; for, although abstract art has developed through this, it has become a construction or concretion coming from within. The abstract painting is a result of a creative process exactly the opposite to abstraction Just as an idea can be given a form so can form be given a meaning.

Heath organised several exhibitions of work by his 'constructivist' friends in his own studio in Fitzroy Street over the next year (his critical generosity extending to work by such referential abstractionists as Frost) and was a tireless and influential promoter of the general cause of abstraction during this period. The importance of his little book on the subject, *Abstract Art, its Origins and Meanings*, which came out in 1953, lay in its treatment of the early pioneers, such as Malevich, Kupka and Mondrian, whose work was little known, seen or understood in post-war London, and its suggestion that the work of his abstract contemporaries was somehow continuous with the pre-war project of modernist idealism. *Abstract Art* was a good exhibition for the AIA in the year of the Festival of Britain.

It was this lively and contentious world of the AIA at the period of its most intense re-evaluation of its aims and purposes that Ayres and Mundy entered in 1951. It was no mere coincidence that this institutional self-examination was being conducted at precisely the time that many artists were themselves seeking to define their identity in terms of allegiance to abstraction or figuration, allowing for many diversities of interpretation for either of those terms. At the AIA Gallery, independent, non-commercial and no longer committed to a political stance with particular implications for the kind of work it might show, Ayres quickly met and became friendly with some of the best and most advanced British artists of the period, as they engaged with, and discussed with urgency, the central aesthetic problems of the age. It was an

extraordinary turn of fortune, above all because the situation brought with it the opportunity to paint for a good part of the week. Among the artist friends with whom she was in frequent contact were Heath, Hilton and Scott during the early 1950s, and later, Frank Avray Wilson and Denis Bowen: all showed at times at the AIA Gallery, Hilton and Heath on a regular basis from 1950 onward.

It is not easy to imagine just how hostile was the general reception of abstract painting at this time. Writing in 1951 of Ben Nicholson's painting as 'an art of absolute form . . . abstraction carried to its logical extreme . . . as pure and absolute as the art of music', Herbert Read observed: 'This art has met with almost universal resistance in England, not only from the public, but even from those critics and fellow-painters who cannot be accused of conservatism.' Although Nicholson's work in the late 1940s and early 1950s clearly incorporated landscape and still-life motifs (which makes Read's description of them surprising to the retrospective eye) he was regarded by younger abstractionists as a model of integrity, whose significance for them related also to his international connections in the pre-war modernist movement. Both Pasmore and Heath, London-based leaders of the 'constructivist' tendency, visited Nicholson in St Ives, respectively in 1950 and 1951. Of abstraction in general Read went on to remark that '[nothing] is more astonishing, in contemporary art, than the persistence of this abstract style in the face of the obliquity of critics and the indifference of the general public'. Even allowing for Read's habitual tendency to see the modernism of Nicholson, Hepworth and others in a heroic light, these statements, in a survey of contemporary British art for the general reader, reveal something of the embattled situation in which abstract art in any of its manifestations found itself in the early 1950s.

It was within both this broader environment of hostility and the more exclusively contentious context of the AIA that Ayres began to forge her own creative vision. She was then, as she continued to be, intensely aware of contemporary artistic and critical currents, and well informed about what was happening in art here and abroad. In spite of her friendships with Heath and Hilton, and her involvement, after the autumn of 1951, with the AIA exhibitions programme in which they and other avant-garde painters regularly featured, it would take her some time to commit to abstraction. In the early 1950s she was painting, as she remembers, figurative works that conformed to Kenneth Martin's definition of 'abstractions from nature . . . concerned with the visual aspect of nature and its reduction and distortion to a pictorial form'. Ayres and Mundy had moved in 1951 to an attic flat in a house in Castelnau, Barnes, where they shared the largest room as a studio, their painting alternating with work at the Gallery in three-day sessions. Although Ayres painted a great deal, there is little that has survived from this period.

Probably the greatest influence upon her development during these years was Roger Hilton, a regular visitor to the Gallery, and a frequent acerbic presence at the convivial evening sessions at the nearby pub. Hilton was formidably intelligent, fearlessly and sometimes cruelly articulate, and utterly committed to abstraction: 'The abstract painter submits himself entirely to the unknown', he wrote in his statement for Lawrence Alloway's 1954 compilation *Nine Abstract Artists*, a book known to Ayres from the moment of its publication. In 1952 and 1953 Hilton spent time with the Dutch artist Constant in Amsterdam and Paris, encountering the ideas of de Stijl, and in his 1954 statement he expounded a view of the painting as an autonomous object, 'a space creating mechanism . . . a kind of catalyst for the activisation of the surrounding space'. Ayres greatly admired Hilton's work of this period, but she did not find these ideas convincing. 'You don't know *anything* about painting', he said with typical asperity to Ayres not long after meeting her, but he took a genuine interest in her work, and for several years they talked a great deal about painting, about 'space, edge . . . colour and the notion of abstraction'. 'I have a taste for plain pictures', he wrote, and as Ayres later recalled he was 'for environmental colour and against mood or any romanticism in painting'. Hilton's emphatic fulminations against the 'slushy, easy sentiment' of associative colour, and his dismissal of any kind of figurative cliché, undoubtedly steered Ayres towards what she thought of as the 'totally abstract, *not* abstracted' paintings of 1955–6 which she showed at her first one-person show at Gallery One in June 1956.

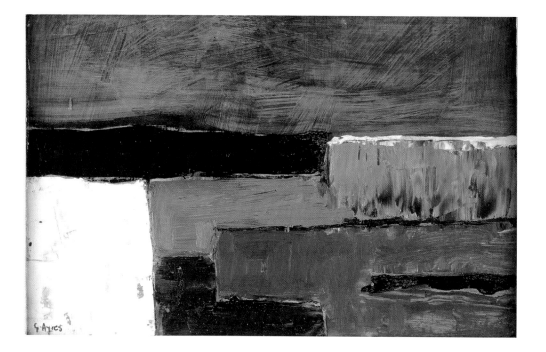

Green and White
c.1955
oil on board
26.5 x 39.5 cm

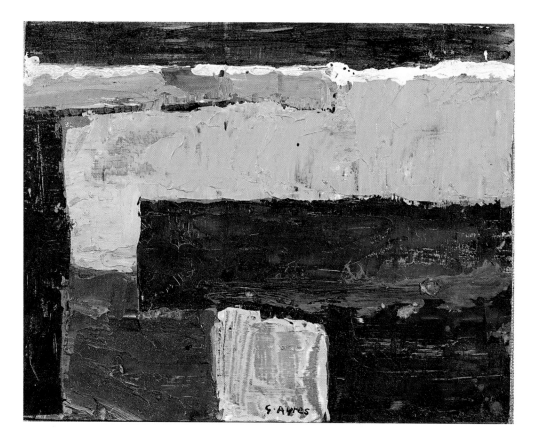

Grey, Green and White
c.1955
oil on board
19.7 x 24.8 cm

The Notion of Abstraction

Green and White (c.1955) and *Grey, Green and White* (c.1955) have a cool formality, a deliberate lack of high colour and a measured deliberation of application that reflect a determination to exclude the 'easy' emotive effect. Their modesty of scale and disciplined quasi-geometric composition suggests the effort to exclude any kind of reference to the external world; at the same time, the intuitively provisional blocking-in of the roughly rectangular interlocking shapes denies any geometric precision. The vitality of these images derives very much from the variations of stroke and gesture, visual evidence of a change of tool from brush to palette knife, corresponding to visible variations in the viscosity of the medium, from the thinly diluted to the thick and slabby. These variations intend that the focus of the viewer's eye should be kept on the object itself, on the painting as such rather than what it might 'picture': 'I wanted abstraction, I wanted pure painting', said Ayres later. There is certainly something of Hilton's insistence on the autonomous object in this, indeed the works lack the psychological drama of his own painting of the early 1950s, implicit in the odd figurative hint that Hilton, ironically, was never able completely to eliminate from his imagery, even at his most adamantly abstract. Even so, for all their claims to a pure objectivity, the emphatic horizontality and moody tonal weather of these little paintings of Ayres's may remind us of nothing so much as Cornish harbour scenes or seascapes.

Vertical Blues (1956) is more typical of the style of the paintings that Ayres exhibited at Gallery One. It is painted with a brash robustness in oil and household paint on the rough side of hardboard, which gives the surface tooth where the paint is thinly applied, and provides grip for thicker layers. As with the earlier paintings *Vertical Blues* exploits the contrasts of matt and shiny finish, thick and thin application, smooth and impasto handling, asserting these textural variations as elements as important to the eye as the musical play of colours. Colour and tone in the painting have a subtlety of relationship that recalls Scott, of whose painting Ayres was very much aware, though there are none of the direct or indirect figurative allusions that characterise Scott's work of the early and mid-1950s, nor is there a hint of any hidden image – of a tabletop or a window or landscape – beneath the surface. The image is purely abstract. It is quite possible, moreover, to see how it has been made: *Vertical Blues* is composed, though not painted, from the edge. The time sequence of the actions that have created the image is visible, undisguised. The smooth dark blues were laid down first; then the impasto whites; then the creamy whites and their overlay of pale blues. These pale forms press into the painting from the vertical edges, like ice-floes locking in passages of dark blue water. What we are presented with is a highly original variation of the ragged-edge profile-and-interlock abstraction that was very much in vogue in the mid-1950s; as well as in Scott, it can be seen in the work of Nicolas de Staël (who was enormously influential in this country after his first highly successful show in London in 1952), Serge Poliakoff, Heath and Hilton among many others. It was a versatile style. With her version of it, with its particular emphasis upon making visible the *process* of facture, its denial of a 'timeless' completeness of image, Ayres can be seen finding her own way into the contemporary European conversation of abstraction. It was not to be long before she made an even more decisive move into a style even more her own.

4

**Seeing What Paint Could Do:
Free Abstraction and the** *Hampstead Mural,* **1956–1957**

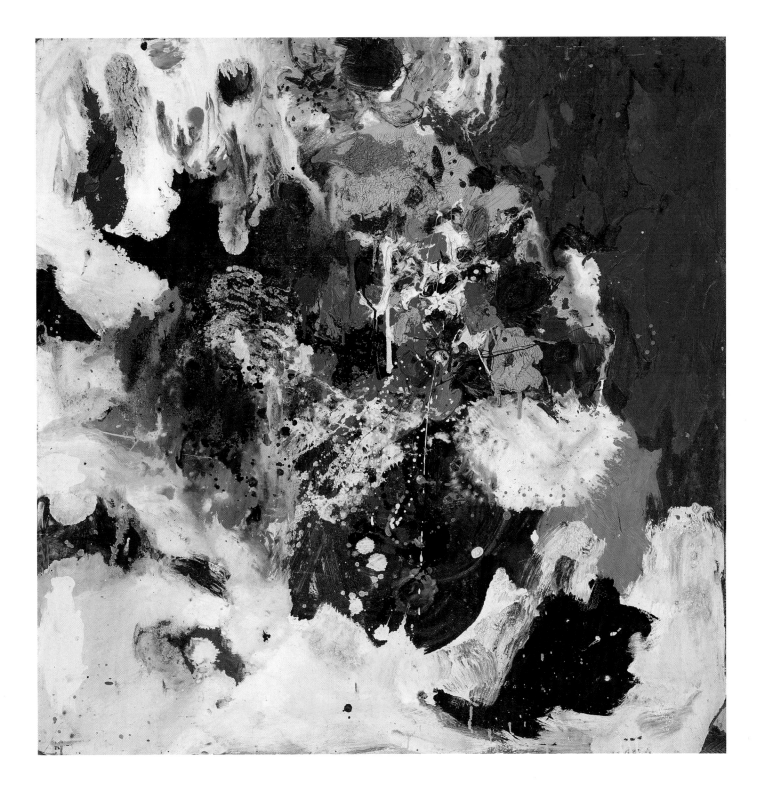

Tachiste Painting No.1
1957
oil and ripolin on board
122 x 122 cm

Victor Musgrave at Gallery One was a brave and discerning gallerist. The first to show Yves Klein in London, he was an enthusiastic supporter of young artists; Robyn Denny, Gwyther Irwin and Bridget Riley were among those artists whose first one-person exhibitions were put on at Gallery One in the mid-1950s. His virtue was all too often ill-rewarded: only one painting was sold from Ayres's show, and this was by no means an unusual response to his pioneering enterprise. Her work had, however, caught the attention of other dealers, and when Godfrey Pilkington at the Piccadilly Gallery showed a painting in his summer show it was seen by Rex Nan-Kivell, the director of the prestigious Redfern Gallery, who from then on included her work in mixed exhibitions. The most notable of these was *Metavisual, Tachiste, Abstract*, a major survey of British non-figurative painting in April 1957, which featured most of the leading British abstract painters of the day, including Nicholson, Hilton, Heath, Heron, Frost and Pasmore. Ayres, with Irwin, Denny and Ralph Rumney, was among the youngest artists in the show: the powerful presence in the central space of her large new paintings was a recognition of her emergence as an artist of forceful originality. The black-and-white reproduction in the catalogue (there is one for each artist represented) is of a painting in the manner of *Vertical Blues*, but by early 1957 Ayres had already discarded this style, and the paintings in the exhibition were in a quite different mode. A great deal had happened since the Gallery One exhibition, and an important contributory factor to a change of approach can be traced back to early 1956. This was the revelation of Abstract Expressionism in January 1956, in the final room of the exhibition *Modern Art in the United States* at the Tate Gallery.

At last we can see for ourselves what it is to stand in a very large room hung with very large canvases by Jackson Pollock, Willem de Kooning, Mark Rothko, Clyfford Still, Franz Kline and others. I think it is true to say that the fame of these painters just managed to precede the arrival of their canvases in London: in other words the exhibition has come at 'the psychological moment' – the moment when curiosity was keenest.

Thus begins a vivid first-hand report on the new painting by an English artist deeply involved with the critical and creative issue of abstraction in the mid-1950s. Patrick Heron, whose critical standing had been confirmed by the publication in 1955 of *The Changing Forms of Art* (a selection from his writings of the previous ten years), was at this time the London correspondent for Hilton Kramer's magazine *Arts (New York)*, and his review was not widely seen in Britain. (Its subsequent notoriety stems from Heron's own references to it in a series of famous articles published in the late 1960s and early 1970s, in which he vigorously asserted the critical claims of British abstraction in the 1950s and 1960s against what he saw as the politically inspired over-promotion of American painting.) Heron's thoughtful and qualified enthusiasm was in marked contrast to the condescending and generally hostile reception of British critics, whose views he summarised in the article with dismissive authority. With certain perceptive qualifications, it was warmly enthusiastic, written with the insight of a highly intelligent painter, himself just at the point of 'going abstract'.

Heron's response, though measured and judicious, was closely in tune with many of the younger British artists who saw these paintings: 'I was instantly elated by the size, energy, originality, economy and inventive daring of many of the paintings. Their creative emptiness represented a radical discovery, I felt, as did their flatness, or rather, their spatial shallowness. I was fascinated by their consistent denial of illusionistic depth' There followed a detailed discussion of works by individual painters, including Pollock, Rothko, de Kooning and Still, in which Heron remarks a general 'lack of resonance in their colour', which is for him 'the great surprise of the show'. Heron noticed, also, and finally reproved, in terms that come as no surprise from an avid admirer of Matisse, the recurrent evocation or emulation of natural phenomena. 'Yet the emulation of nature's own forms and forces is not enough. The American abstract expressionists are possibly still concerned too much with such an emulation. Should they not now begin to *impose* man-made signs and images upon this very admirably realised ground of natural patterns?' Whatever his misgivings, Heron had no doubt of the significance of the moment. Addressing his American readers, he wrote in conclusion:

Whatever I have said, I would like to end by insisting that to me and to those English painters with whom

I associate, your new school comes as the most vigorous movement we have seen since the war. If we feel that far more is suggested than is achieved, that is in itself a remarkable achievement. We shall now watch New York as eagerly as Paris for new developments (not forgetting our own, let me add) – and may it come as a consolidation rather than a further exploration.

The note on which Heron ends is a telling indication of the continuing significance of Paris for British artists at the time. Important as it was, there is a tendency to exaggerate the impact on British artists of that final room at the 1956 Tate exhibition because it was the first showing in Britain of several of the leading American artists of the New York School. Certainly the much more comprehensive exhibition, also from MOMA, at the Tate Gallery in early 1959 was greater in its immediate influence on British artists, though it too was greeted by a generally negative critical response. But by that time there had been a full-scale retrospective of Pollock at the Whitechapel Gallery, exhibitions of American painting at the American Embassy and important paintings by Rothko, Pollock and Still had been shown at the ICA. Ayres herself had continued to visit Paris during the early 1950s whenever funds allowed, and was most certainly aware of the vigorous development there of the 'new' painting. This 'other' art, *un art autre* as it had been nominated by the Paris critic Michel Tapié, and loosely described as *art informel* or *tachisme*, had arisen in reaction to the pervasive rationalism of the post-cubist and geometric abstractions that had emerged immediately post-war. In common with many of the younger artists in Paris, Ayres felt these latter modes, which for most European critics were the acme of 'contemporary art', had deteriorated into a predictable academism. The arrival in London in 1956 of actual examples of American painting – 'at last we can see for ourselves' – brought with it confirmation that not only in France, but also in New York, a new kind of abstract painting, rejecting painterly 'cuisine' and confounding the pictorial orthodoxies of figure-ground/object-space, was not only possible but *necessary*. The ignorant and often childish reaction of establishment critics to the new international 'infomalism', and the sometimes hysterical hostility of the champions of realism, served to strengthen this conviction.

If there is one thing clearly evident from her paintings in the mid-1950s it is that Ayres was determined to leave visible not only the traces of her actions on her materials, but to allow the materials themselves to declare their nature. There is a conscious avoidance of any-thing that smacks of fine painting, or of an aesthetic unity. There is no effort to create an image that is composed and self-contained. Diversity of application draws attention to the paint as substance as well as declaring the action of the painter on it. The surface texture of the support, usually hardboard, is always somewhere evident; it is frequently left uncovered at some point, or a later layer of paint is scraped back to reveal a thin earlier layer through which the board can be discerned. There is no aspect of the image that has precedence over any other. The presence is always of an object that refuses to ingratiate itself, that abnegates charm. There is a brusque and arbitrary quickness about her painting at this time, a summary disregard for any nicety of address to the viewer. In all this it anticipates her breakthrough, in late 1956, to a new mode of free abstraction that was highly original and profoundly radical in its break with the past.

An early example of Ayres's painting in the new free manner is *Untitled* (1956) which is executed in oil and household paint on hardboard. The household paint she used in the paintings of this period was Ripolin, a French high-quality enamel gloss paint that she had first encountered in works by Picasso, who had used it as early as 1912. Picasso had of course first used Ripolin (as with his incorporation of collage elements) for precisely the same purposes as those artists, figurative as well as non-figurative, who turned to it in the 1950s: to assert a new kind of direct reality in painting, to deny the *belle peinture* subtleties of texture, tone and complementary colour. For Ayres, as for other abstract artists at this time, the use of house-hold paints, as well as other 'non-artistic' materials (bitumen, glue, plaster, earth, etc.), was a deliberate act in defiance of good taste, with the further intention of emphasising the materiality of the painting as object. It was, as it happens, the figurative artist Dubuffet's provocative incorporation of sand, tar, salt and other such materials into his post-war 'thick paintings' that had been most influential in this respect on European abstract painting in

the 1950s. Ayres confined her own use of 'non-artistic' materials, significantly, to household enamels: she continued to define her aesthetic purposes in terms of the possibilities of painting, and within the complex histories of post-Renaissance and modern European painting. Neither was she inclined to reject the beautiful, but rather to seek to redefine it, or go beyond it towards the sublime.

Pollock had of course used domestic and industrial enamel and aluminium paints (quite visibly in *Number 1 1948*, by which he was represented in the 1956 Tate exhibition), but for Ayres there is no doubt that her choice of Ripolin can be traced to her awareness of Picasso's use of it throughout his career. It is clear that *Untitled* (1956) was painted on the horizontal, with the paint splashed, poured, dripped and puddled, and sometimes brushed. Matt effects were achieved by thinning down and spreading gloss paint with turpentine, and artist's oil paint, sometimes squeezed direct from the tube and sometimes brushed, was used to create high-lights of rich colour, deep browns and blues, in contrast to the neutral household greys and creams typical of domestic decor at the time. In places the enamel paint has congealed and wrinkled as it has dried, and where the top of a paint tin has been carelessly laid on to the board it has left its unabashed trace, the pale grey of the surplus paint defining or spilling from its perfect circle, a flap of skin folded back. There is a compressed richness in this little painting, but the denial of any attempt at picture-making control is absolute. It is an object made with certain materials. Seeking no critical favours, it declares without affectation – 'take it or leave it'.

It may be that the larger scale of *Tachiste Painting No.1* (1957), also executed in household paints and oils, enables it to offer more to the imagination than the stark challenge of *Untitled* (1956). Certainly its cataclysm of colour, the aftermath of the violent events that brought it into being, is inescapably evocative of analogous events in nature. The upper central passage images a chaotic entropy, while round it and enclosing it – like a flow of lava, a flood of water, drifts of snow – are atmospheric densities whose elemental colours – red, white, blue, ochre, oxide violet – suggest the liquid beginnings of formative differentiation: it is a painting about cosmic origination. Of course, this is fanciful. Look again at the patch of bare hardboard at centre-right, the thinly painted blues and reds, the patches and splodges of wrinkled Ripolin, the smudge and blot and scatter of thinned oils, the crudely brushed-in ochres and dirty whites in the lower third of the board: this rawness and roughness, this alienating diversity of accidental or arbitrary effects, this unresolved complication is an extreme manifestation of Ayres's characteristic evasion of any kind of authority over the image. The painting refuses to present an image that might invite pictorial interpretation, or that might propose any analogy beyond that manifest in the energetic distribution of pigmented material across a character-less fabricated surface. Other things in the world are subject to the energies here made visible, but there is no requirement of the artist to specify or to represent them. The painting is just such a thing-in-itself: its meaning is to be discovered in that actuality.

It was clear from her work in *Metavisual, Tachiste, Abstract* in the spring of 1957 that Ayres, by now a self-declared 'tachist', was as extreme a free abstractionist as it was possible to be. In the circumstances it was extraordinarily imaginative of the young architect Michael Greenwood, who was that summer renovating South Hampstead High School for Girls, to commission an artist as radically uncompromising as Ayres to create 'decorations' for the school dining room. Greenwood, who had first met Ayres at the AIA Gallery, and seen her work at the Redfern in April, knew what to expect; as much, that is to say, as anyone, including Ayres herself. It was an amazing challenge for a young and untried artist at a time when public commissions of any kind were few and far between. Ayres rose magnificently to the occasion, creating one of the great ensemble works of British abstraction, on a scale unprecedented for such painting in this country, and demonstrating that a complex work for a public place could be made not only without a given subject or theme, but, what is more remarkable, without any kind of formal programme. Greenwood was perfectly well aware of Ayres's complete commitment to pure painting, to pure abstraction created by unpredictable actions. He did not ask to see a maquette, which in any case Ayres would not (could not) have provided, but took on trust that she would create a work on her own terms that would serve his purpose. He

Gillian Ayres in front of
Tachiste Painting No.1, 1957
(photo: Denis Bowen)

designated the work to be done as 'decoration' in order to avoid the requirement of seeking approval from the school governors for 'art work'. The fee for the work was £100.

After several sleepless nights – 'I was frightened' – Ayres turned up at the school to find four panels of high-quality block-board beautifully primed with gesso, and, as she had ordered, a supply of household paint brushes, gallons of turpentine and the unprecedented luxury of as many cans of Ripolin as she was ever likely to need. She had had no previous opportunity to make work on such a scale. It was in this aspect more than any other that the revelation of 'the size, energy, originality, economy and inventive daring' of the new American painting might have proved inspirational. In fact Ayres can remember no reassurance on that account: 'I found the size terrifying', she recalls, 'in those days, a 3 by 4 [foot] painting was a big painting.' The block-board panels for the Hampstead mural were each seven and a half feet high, and respectively three, four, nine and eleven feet wide. *Tachiste Painting No.1*, by comparison, is four feet square. The largest of the Hampstead panels alone was greater in area than any of the abstract paintings in the 1956 Tate exhibition. Completed and together, the paintings would constitute the largest single work of 'informal' abstract painting made in this country.

In the event, confronted by the challenge, Ayres was undaunted. Working with the panels on the floor, within an hour she had covered the entire surface of each horizontal panel with thrown paint and turps, much to the amazed consternation of the workmen on the school site, who promptly summoned the architect. Arriving at her makeshift studio he said 'Gillian, they think they've got a madwoman in here'. The basic configurations of colour and texture were laid down in that first assault upon the block-board planes, and the general tonal and chromatic atmospherics – the determinants of mood – established. Ayres continued to work on the paintings for a fortnight, spilling and pouring, trailing lines and thin skeins over the surfaces, spattering and splashing, dabbing and brushing vigorously from the edges, and, in the case of the narrowest panel, lifting the board to the vertical and allowing the paint to run and dribble downwards. But the crucial work was done in that first brave hour.

Ayres had already started to work on the floor in her Castelnau studio, pouring paint, thinned and liquified with turps, directly on to the hardboard support, creating areas of free imagery that registered the natural processes of splash, flow and puddle. She had certainly seen Hans Namuth's famous photographs of Pollock at work on the drip paintings, and she had been impressed by the image of his dance-like physical involvement in the action of painting. (She knew also, incidentally, that Alan Davie, who was regarded at the time as a home-grown abstract expressionist, though he was in fact nothing of the sort, also worked with his canvases on the floor.) Except in that respect – of bodily movement as a determinant of image – Ayres was not at that time particularly knowledgeable about Pollock, and his paintings in the 1956 Tate exhibition had made no great impression on her. It was historically incorrect and some-what (if predictably) fanciful of Lawrence Alloway to suggest, as he did in his catalogue note to Ayres's 1960 exhibition at the Molton Gallery, that Pollock was 'the biggest technical influence on her work . . . not his linear webs of dripped paint but the pools and skins that formed where he allowed the paint to collect'. This would imply an assiduous and purposeful attention to detail in certain paintings by Pollock from the late 1940s that had simply not been available for scrutiny in this country, and would not be seen here until the end of 1958. As Alloway allows, and as is self-evident in her paintings of the mid- to late 1950s, Ayres was not at all interested in the all-over graphic linear rhythm that is the most powerful of Pollock's pictorial inventions, and which is the characteristic most visible in Namuth's photographs. The *idea* of Pollock as heroic painter, existentially committed to the work, absolutely authentic in his actions as an artist, was far more powerful an influence upon Ayres, and others of her generation, than any particular technical innovation.

There was a fashion in French critical writing on *l'art informel* at the time to view tachist painting as a reaching out for the transcendental, an expression, beyond language, of the inexpressible unknown and incomprehensible. 'The true creators know that [today] the only way for them to express the inevitability of their message is through the extraordinary – paroxysm, magic, total ecstasy . . .' wrote the ineffable Michel Tapié in 1952. 'There can be no question today of an art for pleasure Art is made elsewhere, outside it, on another plane

Untitled
1956
oil and ripolin on board
48.7 x 31.8 cm

of that Reality which we perceive in a different fashion: art is other' Ayres was rather more down to earth, and she was intelligently empirical about the creative uses to which tachist techniques could be put, and the diversities of feeling and mood that they could engender. Apprehensive though she may have been about the scale of the task, she nevertheless approached the Hampstead commission not in an 'orgiastic agony of paroxysm' but with simple joy at the thought of its siting among schoolchildren. Even so, she would have found sympathetic Tapié's insistence that '[it] is no longer the movements that interest us, but the authentic . . .'. She was not interested in using the mural as the occasion for a manifesto painting: she was not inclined to align herself with any tendency beyond that towards the discovery of new possibilities for painting itself. And although her methods may have seemed haphazard and subject to chance, she had no great interest in techniques of surrealist revelation, or in 'pure psychic automatism' as the royal road to the unconscious. Ayres's interest was in something simpler, more material and formal: it was, in her own words, in 'seeing what paint could do'. Behind that apparently down-to-earth idea of painting as a kind of research lay questions more difficult and profound: What is a painting? What can a painting do?

The *Hampstead Mural* should be treated as a single work in four movements. Although its grandeur of scale and richness and diversity of texture might invite its description as symphonic, the analogy would be false: it has no structural programme, nor any subject matter or theme; there is no formal statement, development, recapitulation and finale. There is no connecting link, in terms of determined relations of forms or colours, between different elements within any of the panels taken as a unit, or between any panel and another. Each is a separate visual event, coextensive with the panel that is its support; each image-event is a variation on the possibilities of what might have occurred within the confines of the rectangular edges of the panel. There is no progression or determined order to these events. The experience of them will begin where the eye first encounters the painted surface of whichever panel the viewer sees first. How it is experienced will depend upon proximity or distance, on the arbitrary concentration of the eye on one area or another, on the involuntary movement of the eye from one point on the surface to another, on the movement in or out of focus as from detail to the whole image, or on the movement of the eye from one panel to another. There is no visual device in the paintings intended to direct these movements of the eye. There is no 'compositional' design, the purpose of which is to order response. The key to the power of the mural is to be found purely in the shaping imagination of the spectator.

Scale is, of course, crucial to the work's effect. As paintings change scale so do the ways in which they work: scale is functional. To explore the implications of that fact was one of the most exciting aspects of the Hampstead commission, and Ayres was not unaware that the siting of the panels would be a school dining room, a place of quotidian utility if not without ceremony. The *Hampstead Mural* was not framed but 'slotted into a wall with doors and a serving counter interrupting the explosive showers of sensual paint'. It was thus conceived to be approached close to on a daily basis by the pupils as they queued for their lunch, and seen from a distance as they sat at their tables. Greenwood's choice of Ayres for the commission, so far from being an indulgence of personal enthusiasm, was critically inspired. His primary intention was clearly to provide pupils with a spectacle that would maintain its interest over time. Aware of Ayres's interest in the materiality of paint he could expect her to create a surface that would be crowded with textural incident and local colour; at the same time he could anticipate an over-all image that had no fixed focal centre and that invited an ever-changing reverie.

The *Hampstead Mural* meets these requirements perfectly. It is at once a work of extreme complexity and assured visual refinement. Each panel has a subtly different mood, each offers the spectator diverse visual and mental pleasures. It is not merely free association that brings these pleasures home to the eye and the mind, though that inescapable habit of response will play its part in the process. Each panel prompts the eye to discover thrilling resemblances to natural phenomena, to seas, skies and clouds, to flames, to floes and snowdrifts. The work brings to mind the more complex pleasures of *allusion* and *analogy*, complex responses to the palpable flow and flourish, sweep and diffusion of the paint across the picture surface. The

Hampstead Mural takes its place in the line of European painting that treats of the violence and beauty of the natural world: of its cosmic energies and ceaseless motion, its rhymes and repetitions, its confluences and separations, its light and darkness; elemental earth, air, water, fire and ice. It recalls the atmospheric energies of Tintoretto, the nature drama of Turner and Constable, the apocalyptic visions of John Martin, the painterly cataclysms of early Kandinsky. In painting it Ayres discovered a subject and announced an ambition. From now on her painting would engage with the phenomenal world, its space, its energies, its infinity of forms and colours, and the unending variegations of its turbulent weathers.

ABOVE AND OVERLEAF
Hampstead Mural
1957
ripolin on blockboard
230 x 91.5 / x 111.8 / x 274.4 / x 335 cm
(four panels respectively)

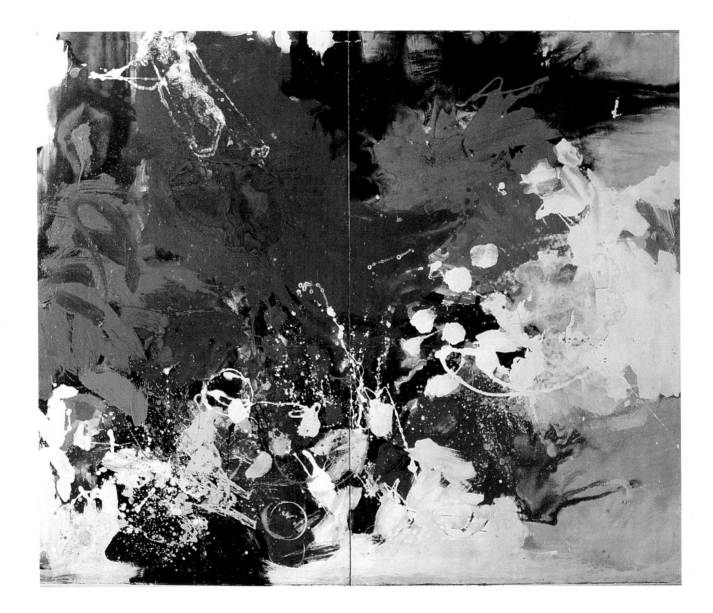

Seeing What Paint Could Do

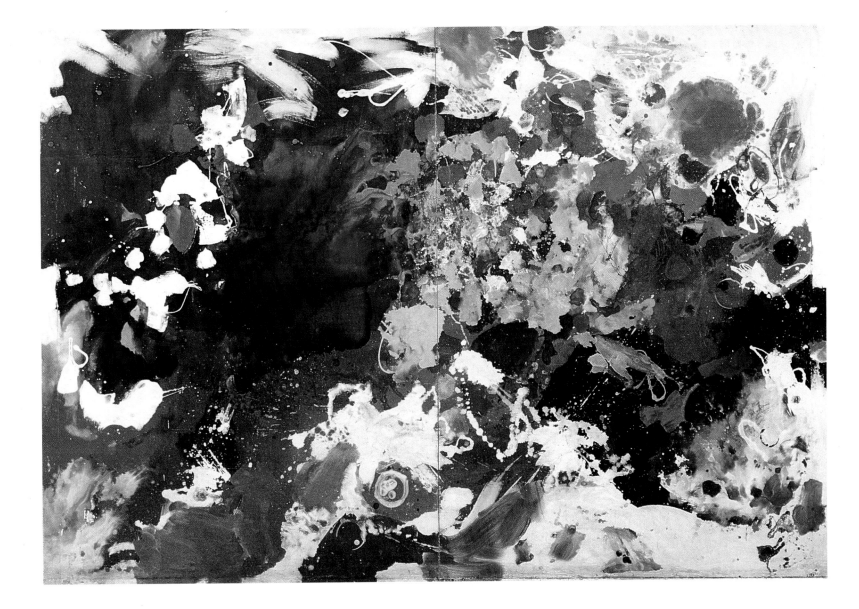

5

Young and Jubilant: Corsham and the Sublime

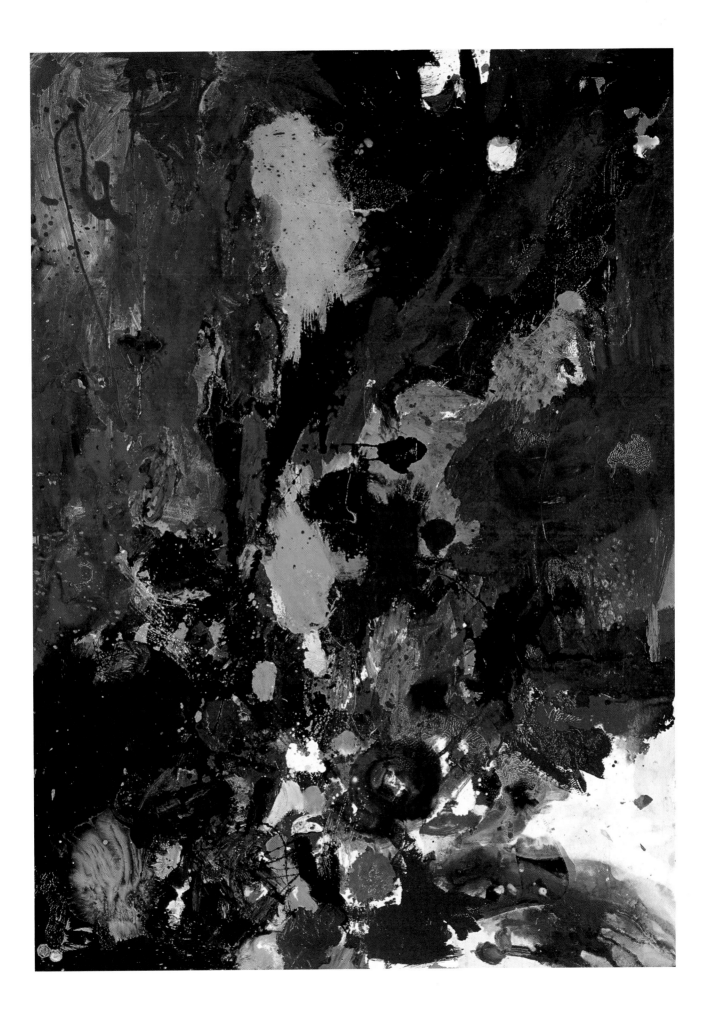

Towards the end of the 1950s things rapidly began to change. In 1958 Mundy was offered a part-time teaching post at Bath Academy of Art, Corsham. The following year Ayres was asked to do six weeks teaching there, and in the event remained on the staff for seven years. Corsham was unique among art schools. An independent foundation, occupying part of Corsham Court, the country house of the painter Lord Methuen, it was a residential school, set in beautiful grounds. It had been started on progressive lines shortly after the war by the artist Clifford Ellis, who had brought many of the best artists of the period to teach there, William Scott, Terry Frost, Anthony Fry, Bernard Meadows, Bryan Wynter and Peter Lanyon, among others of distinction. There were resident musicians and poets, and a thriving teacher training course led by Rosemary Ellis. Corsham in the early 1950s had formed something of a connection with St Ives, but in the later years of the decade Ellis employed a number of the more brilliant younger London-based artists, including Ayres and Mundy, Robyn Denny, Howard Hodgkin and Gwyther Irwin. In this way, in spite of its rural setting, Corsham maintained its deserved reputation as one of the best art schools in the country.

Clifford Ellis had been one of the older artists represented in the Redfern *Metavisual* show, and was included later that year in the AIA exhibition, *Pictures without Paint*, which was devised and selected by Ayres with Adrian Heath, who had himself taught at Corsham since 1956. He was, then, aware of the growing reputations of Mundy and Ayres, both of whom were now showing regularly in group exhibitions, and were of course close friends of Heath. Mundy's appointment was to make crucial difference to their circumstances: at two days a week Mundy was earning four times as much as their shared income at the AIA (which in total had amounted to less than the basic pay of a bus conductor: Ayres had noted a London Transport advertisement for the job). The offer came during a period of considerable turmoil. In the autumn of 1957 they had been obliged to leave the Castelnau flat, and moved first to Chiswick Mall, where for nearly a year they occupied what had been a saddle-room and used the adjoining stable as a studio. There followed a further short period in a basement flat in Castelnau, but with the prospect of regular earnings, in spring 1959 they were able to take a mortgage on a house in Beverley Road, Barnes. There was also now a small income from sales of pictures, and to help with the house payments they let rooms.

In October 1958 Ayres had been scheduled for a one-person exhibition at the Redfern: a significant recognition of her promise. The private-view card was produced and mailed out, but after difficulties with the gallery she somewhat impetuously cancelled the show. All this happened in the first few months after the birth of her first son, Jimmy, in June 1958. Ayres had lost the opportunity of an important solo show and was now without a gallery to represent her. None of this affected her commitment to painting, and after Hampstead she was determined to paint free abstraction at a scale that met her ambition. Among works painted at this time was *Distillation*, now in the Tate Gallery collection, which was first shown at the first Paris Biennale in October 1959, though it dates in fact from late 1957. It was after her inclusion in the Biennale that Ayres was invited to Corsham. 'I got a letter saying, "will you come for six weeks, half a term?" and thought I was going to get the push at the end of it.' But Ellis approached her on the last day of term: 'he just came up and said, "The lighting will be much better in the studio next term".'

Teaching at Corsham provided a new milieu of artists, no less interesting than that at the AIA though with different preoccupations. This was for Ayres a re-entry into the world of artists' education. Corsham, though it had to meet national requirements for the validation of its diploma, was run on a much less formal system of teaching than that which obtained in the big urban colleges. Students were assigned to small studio groups, each in its own hut in the grounds, usually run by two teachers, whom Ellis selected to work together on the basis of their differences of approach to art and teaching. Creating the right mix was, as he once described it to Ayres, like making a good soup from different ingredients. From the outset, then, as head of a studio, Ayres had genuine responsibility for her teaching programme, which was supposed to be based loosely on a syllabus written for the school some years previously by William Scott. The artist-teachers were also responsible for an informal 'history of art' programme. Ayres was determined not to teach as she had been taught, prescriptively and

The house in Beverley Road, Barnes

Redfern Gallery private view invitation to an exhibition that never took place, 1958

according to set methodological formulae. For a great deal of her time at Corsham she shared a teaching studio with Malcolm Hughes, whose practice, firmly within the ambit of constructivism, tended to an intellectual formalism, and whose pedagogy, though certainly not academic in the old sense, was highly structured and meticulous in its attention to programmatic detail. The combination made for an interesting soup.

Ayres greatly enjoyed being at Corsham, travelling down, often with others, on the train, staying once a week overnight in the big house, teaching, talking, eating and drinking with some of the best and most progressive artists of her generation, for two days intensively involved in the teaching, and free for the rest of the week to paint. Far more than as a student at Camberwell, and more so than in either of her later teaching appointments, she found excitement and professional comradeship at Corsham: 'we were all young, and perhaps jubilant about what we were doing, and I got far more out of associating with those people, as an artist … [there was] affection, respect ….' Corsham allowed Ayres to find herself as a teacher, to discover, in good company, that she had another gift, and that teaching was not merely a necessary evil but something to be valued and enjoyed. Through an initiative of Howard Hodgkin, who had himself studied at the school, it was Corsham in the early 1960s that pioneered the tutorial system, in which students were encouraged, with critical guidance from a tutor, to follow their own lines of creative investigation. Changes, in any case, were in the air. With the introduction later in the decade of the Coldstream reforms, which brought a much greater degree of autonomy and institutional responsibility to the art schools, the tutorial system was more or less universally adopted as their primary mode of teaching.

Painted in the stable studio early in the period that Ayres lived on Chiswick Mall, *Distillation* (1957) is an ambitious painting in the manner of the *Hampstead Mural*. It was painted in the same way, with the board on the floor being quickly covered with turps-thinned poured Ripolin, and further complex effects created by successive actions of spattering and dribbling, brushing and dabbing, using both the enamel paint and artists' oils. Modulations of matt and gloss, thickness and thinness, and an effect similar to marbling were controlled by variations of turps dilution, and further local complications of texture came about as random splodges of thick paint dried and wrinkled. As with all great and complex painting, reproduction cannot do justice to *Distillation*; most particularly it cannot reproduce the effect of scale. Approached close it rises above the spectator (if hung at two feet above floor level it reaches to nine feet) with the area of greatest painterly turbulence at eye level – a maelstrom of gaseous blue and magenta, earth reds and greys – and above it great liquid passages of the deepest and richest blues enveloping patches of yellow and brown ochres. The spectator is involved in a most dramatic encounter with pure painterly matter, which, defying analogy, is complexly – not simply – *what it is*. Step back and the overwhelming impression is of volcanic energy exploding outwards and upwards from the lower left of the painting, matter in confusion resolving provisionally into blue-dark atmospherics and the density of congealed pitch.

'That pigment on canvas has a way of initiating conventional reactions for most people needs no reminder. Behind these reactions is a body of history matured into dogma, authority, tradition. The totalitarian hegemony of this tradition I despise, its presumptions I reject ….' Ayres has marked this quotation from Clyfford Still in the catalogue notes for the exhibition *Some Pictures from the E. J. Power Collection*, which she saw at the ICA in March 1958. We may take it as expressing a sentiment with which she felt at the time a deep sympathy. Indeed, it is with the paintings of Still far more than those of Pollock that her work at that time might seem to have something in common, though there is nothing in Still's *method* – his effects are entirely the outcome of oil paint brushed on to canvas – that corresponds to Ayres's combination of media applications, or to her use of turps-thinning and semi-automatic pouring. There are, nevertheless, correspondences of scale and effect. There is a similar sheerness of surface, the *facing out* from the surface of pure pigment; there is a similar organic raggedness of edge and contour to the areas of paint, large and small, that cover the plane. In each case something that has the very feel of the natural to it defies the 'conventional reactions' of the spectator steeped in the dogmatic tradition that calls for the *likeness* of the painted image (whether abstract or figurative) to natural phenomena. We cannot avoid tracing

such likenesses in *Distillation* or in a painting by Still, but there is a crucial difference: it is the world that looks like the painting, not the painting that looks like the world. 'We are now committed', continued the quotation from Still, 'to an unqualified act, not illustrating outworn myths or contemporary alibis. One must accept total responsibility for what he executes.'

The self-mythologising rhetoric of Still's statements is an extreme version of the American-heroic equivalent to the existential or transcendental afflatus that accompanied 'informal' art in Europe. Ayres, with an English disinclination to exaggerated utterance, has always instinctively avoided such language in both its manifestations, but her ambitions for her painting at this time were without doubt in the direction of the sublime. This is to say that she regarded the work as self-evidently the product of actions that take the artist, and the spectator, to the edge of the unknown, and not as a representation, however abstract and imposing, of the known, observed world. It is not the task of the sublime in art to represent the grand or the beautiful, but to create in the spectator something of the experience of awe that is felt in the presence of an overwhelming aspect of nature, of that which is beyond the limits of human control, and cannot be reduced to conventional forms. Ayres had not at this time seen Barnett Newman's 1948 essay 'The Sublime is Now', and she cannot recall ever having read Alloway's later essay (published in 1963) on 'The American Sublime', which connected the work of Newman, Rothko and Still to the eighteenth-century ideas on the subject. Her own interest in the sublime was inspired directly by her great love and admiration for Turner, the greatest of all its exponents, and the artist whom she acknowledges as the most profound of all influences on her own work. Always a prolific reader, she naturally turned to Burke, the greatest English theorist of the concept, and to Kant, in whose *Critique of Judgement* it reaches its clearest and most complete articulation.

In Burke and Kant Ayres found exhilarating definitions of an idea that was to continue to be of central importance to her work. The sublime, according to Burke, may be defined as the experience aroused by those qualities in things that induce 'terror', the extreme emotion that fuses wonder, fear and awe, and gives rise to an astonished or melancholy consciousness of the greatness of nature. At the heart of the sublime experience there is always a tension created in the subject by contradictory emotions, such as fear and wonder, and by the inability of the eye, in spite of its desire, to compose and bring to rest what it beholds. Qualities conducive to the sublime are categorised by Burke as 'obscurity' (darkness holding threat), power beyond human control, vastness and suggestions of infinity. Burke anticipates the profound subjectivism of Kant, whose definitive emphasis is on the effects of those qualities in external things being sited in the individual's receiving consciousness: the sublime is a condition of subjective experience not a quality of the objects that induce it. Beauty, on the other hand, is found in the *form* of objects, defined in terms of their limits, and definable as such, and conducive to 'a feeling of the furtherance of life, and is thus compatible with charms and a playful imagination.'

For Ayres it was precisely this distinction that liberated her practice, and provided the rationale for her 'actions in the arena' of the painting. Kant's inventory of the kinds of natural phenomena that awaken feelings of the sublime is conventional but his description of those effects is complex and suggestive:

threatening rocks, thunder-clouds piled up to the vault of heaven, borne along with flashes and peals, volcanoes in all their violence of destruction, hurricanes … the boundless ocean rising with rebellious force … and the like, make our power of resistance of trifling moment in comparison with their might. But, provided our position is secure, *their aspect is all the more attractive for its fearfulness*; and we readily call these objects sublime, because they raise the forces of the soul above the height of vulgar commonplace, and discover within us a power of resistance of quite another kind, *which gives us courage to be able to measure ourselves against the seeming omnipotence of nature.* [my emphases]

It was not the function of painting simply to give pleasure by discovering the beauty of unity and order in nature. It was the fate of the artist to confront reality, look into the darkness, acknowledge the infinite, be aware of the fearful power of nature. The purpose of painting was to create analogous feelings in the spectator, 'by the art of the sublime, the spectator is in a

predicament that is beyond delight'. It is a state that, in Kant's phrase, 'merits the name of a negative pleasure'.

The qualities that Burke anatomised are precisely those to be found in James Ward's magnificent *Gordale Scar* (1812–14), one of the great programmatic essays in the sublime, and long admired by Ayres for its extraordinary ambition, its scale and visual drama:

> The eighteenth-century sublime was concerned with the effect of nature. An artist like Turner was concerned with the plastic things in nature – clouds, wind and rain, steam, sea, cliffs, as parallels with the plastic things in paint. *Gordale Scar* isn't a great painting but it is a wonderful painting nevertheless, and I always go and look at it when I'm bored or fed up at the Tate

It is those very qualities of the sublime affect that make *Distillation* a remarkable painting for its time. For all the differences, its forms and effects are, in fact, not dissimilar to those of Ward's painting, as described by its most assiduous historian, Edward J. Nygren:

> areas of darkness are juxtaposed against those of intense light . . . the eye shoots back rapidly through dark, overhanging cavernous walls to the brilliantly lighted torrent cascading over the rocks and up the seemingly endless cavern beyond; there is no gentle recession into pictorial space The orientation of the picture is pronouncedly vertical . . . dark ominous clouds portend a violent storm Visually, the viewer of the painting experiences a vertiginous burst of elation in the rush from the light foreground up the dark cavern walls

In *Distillation*, of course, the effects are achieved by abstract colour and texture on the plane (though it is impossible to use variegations of blue without invoking the sensation of space), but it shares with Ward's great work the sheer physical presence that dominates the spectator who moves into its anterior space. For Ayres, paintings such as the *Hampstead Mural* and *Distillation* would surely have recalled to mind those ideas she had discussed with Roger Hilton some years before about the environmental dynamic of the abstract painting: 'It has become an instrument, a kind of catalyst for the activisation of the surrounding space', he had written in 1954. In the same text he had stated '[the] abstract painter submits himself entirely to the unknown', describing precisely the situation of the painter whose ambition was to invoke the sublime. For Hilton of course that 'activisation' was not of *scale* enveloping the field of vision but of an *image-object* neither 'environmental' nor sublime. Ideas, however, are wayward in their workings, and undergo unpredictable and fruitful transformations in the minds of artists and the work they make.

The determinations of an artist's practice and philosophy are indeed complex and various, as is the relation between them, and the extent to which arbitrary events and occasional relationships (personal acquaintance and its resultant conversations, for example), visual experience of the world and of art, thinking and theory, personal taste (for which there is no accounting) and other factors all play their part in the formation of the artist's vision is ultimately beyond description or definitive analysis. In particular, the ways in which artists are influenced by critical, scientific or philosophical ideas are complex, often tangential and always difficult of definition. Some artists are more alive to the critical discourse than others, some artists are more interested in aesthetic and moral theory than others, some less.

Ayres has always been imperturbably intuitive rather than intellectual or theoretical in her approach to painting. Though she is by no means a systematic aesthetician, she has always been intensely aware of historical, philosophical and critical cross-currents in art. Her aesthetics are derived primarily from her direct visual experience of painting conceived as an imaginative response to the world. Titian, Rubens, Turner, van Gogh and Gauguin are among the painters most important to her, for their formal vigour and extravagance, their treatment of light and colour and, above all, for their vision of the dynamic reality that lies behind appearance, their vital realisations of the energy that gives things their life. A habit of reading and thinking has accompanied her creative investigations from the moment she decided to be an artist. For Ayres, whose procedures consist essentially of spontaneous actions upon materials within formal constraints of scale and shape, plane and edge, the practice of painting is always informed by philosophical discipline and critical historical awareness. In her artistic practice impulse is tempered by reflection, reflection enlarged by imagination.

James Ward
Gordale Scar
1812–14
oil on canvas
332.7 x 421.6 cm
(© Tate, London 2001)

Cumuli
1959
oil and ripolin on board
305 x 320 cm (two panels)

6

Nature in the Act of Painting: *Situation*, 1960

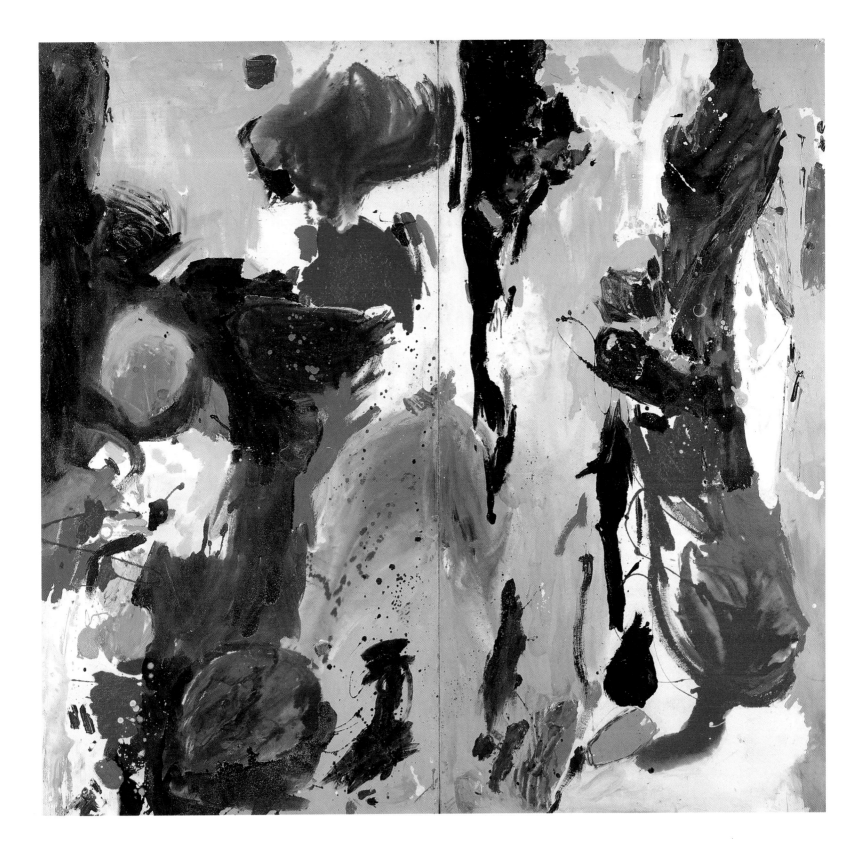

Climbing to the top of Cader Idris it is exhilarating to pass through smoky clouds, mist-blinded, to emerge then into bright sunlight and the rediscovery of colour and look up to see the high cumulus rising into clear blue skies, piling billow upon billow, and down to see the lower mists now disguising ridge and gully, erasing the view of Llyn-y-Cau. For Ayres and Mundy this was, through the 1950s, a familiar experience; together they climbed Cader Idris at least seventeen times, in all seasons and weathers. 'When we could afford to leave London for a weekend, if we didn't go to Paris we went to North Wales.' They walked and climbed to the peaks in the Llanberis Pass, and to the high mountain lakes of the Idwal valley below Tryfan. For Ayres, moving through that high landscape, there was a recurrent sensation, Wordsworthian in kind and intensity, that the rising and falling of the mist's swirls and eddies, now revealing, now concealing mountainside and rock-face, crag and scree, seemed to enact the very process of plastic composition. It was as if to be caught up in these dynamic translucencies was to be within a creative furore in which the solid – 'rocks and stones and trees' – and the atmospheric – air and cloud – were of one element, one medium, out of which things differentiated or into which they dissolved.

View from Glyder Fach, mid-1950s
(photo: Gillian Ayres)

It was a phenomenon she recognised above all in the powerfully generalising art of Turner, especially in the informal watercolours and in the elemental chaos of light and atmosphere in those late oils, in which the principal components of the 'finished' landscape painting – linear description, and a prospect of topographical distance with an horizon or visible limit to view – are banished. It was in those very mountains of North Wales that Turner had gathered the impressions of storm cloud and storm light that were to be utilised in his earliest essays in the sublime. For Ayres, as for Turner, that intense experience of being *in nature* in such a setting, with its particularities of atmosphere and weather, was more than an intimation of the sublime; it was a revelation of the very way in which paint might be made to enact natural processes without the conventions of representation, or the artifice of perspective, chiaroscuro and tonal shadow. It confirmed that it was possible for art to be more than a matter of *representing*, even in 'abstract' forms, the objects or effects of nature; painting could discover a reality that comprehends both, and was to be experienced as immanent in either. And for Ayres, as for Turner, it was the study and practice of art that preceded and created that vital perception of nature as actively creative. For the artist, Turner wrote,

J. M. W. Turner, *View towards Snowdon*, 1798–9, watercolour on paper, 26 x 33 cm (© Tate, London)

[every] glance is a glance for study: contemplating and defining qualities and causes, effects and incidents, and develops by practice the possibility of attaining what appears mysterious upon principle. Every look at nature is a refinement upon art. Each tree and blade of grass or flower is not to him the individual tree, grass or flower, but what it is in relation to the whole, its tone, its contrast and its use, and how far practicable: admiring Nature by the power and practicability of his Art, and judging his Art by the perceptions drawn from Nature.

Cottage at Corris, close to Cader Idris, where Gillian Ayres and Henry Mundy stayed during the 1950s

Cumuli (1959) was typical of the paintings that Ayres showed in *Situation*, the almost legendary artist-led exhibition at the RBA Galleries in London in September 1960, and at the Molton Gallery the following month, in what was her first one-person show since her solo debut at Gallery One in 1956. The loose ragged-edged painterly forms of this work resemble the billowing clouds that give it its title only in respect of the impression they give of rising atmospheric energy. The colours are arbitrary – yellow ochres, blood red and dried-blood brown, blues and blacks – and they are brushed, poured and spattered straight from housepaint can or oilpaint tube, rising up the towering ten-foot surface of the hardboard support like licks of fire, wisps and plumes of dense smoke, as if released from the glowing coals of pink, purple and orange at lower and centre left. 'The structure of Ayres' paintings is present in the sustained rhythms and the colour change of her luxuriant paintings', wrote Alloway in his catalogue note to the Molton show, thereby pinpointing both the formal dynamic and the peculiar textural richness of her painting at this time. Though it shares the essential upwards and rightwards rhythm of *Distillation*, whereas the paint in the earlier painting creates the impression of magmatic density, in *Cumuli* it achieves a gaseous luminosity. Ayres was later to study Turner's colour theory, and would appreciate his crucial distinction between 'pure combinations of aerial colours' and their opposite in dense mixed 'material colours ... the destruction of all, or in other

Gillian Ayres on Cader Idris, late 1950s
(photo: Henry Mundy)

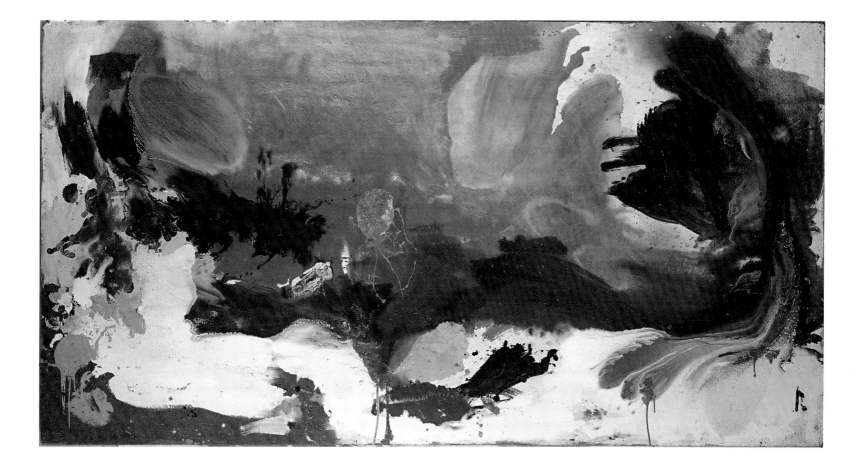

Cwm Bran
1959
oil and ripolin on board
160 x 305 cm

words – darkness'. Her paintings had long exploited those oppositions.

In the paintings made between 1959 and 1960 Ayres demonstrated a virtuosic command of atmospheric effects – 'pure combinations of aerial colours' – and dramatic mood. It is impossible now to look at *Cwm* (1959), *Cwm Bran* (1959), *Untitled* (1960), and *Muster* (1960) (shown with *Cumuli* at *Situation*) without detecting in their translucent and melting cloud-like forms, their vivid contrasts of tonal darkness – greys and dark greens, misty duns and shimmering blacks – and their patches of brilliant sky colours – blue, rose and mauve – something of the rapid dissolve from one to the other of cloud shadow and sunlit radiance that is typical of the ceaselessly changing mountain weather of North Wales. This is not a matter of description so much as of metaphor, of the paint and its disposition over the extensive planes of these large paintings being the poetic image, the making visible of an informing plastic energy. The image is to be experienced first as a vista, the painting itself a sensuous topography that demands the movement of the eye or the head to take in the whole view, which never allows the eye to come to a focal point of rest, and then as an ambulatory visual-tactile experience, as the viewer closes in and walks its length, enveloped and immersed in the immediate sensations of the paint as substance, caught up in a meteorological sweep and whirl of pigment and brushstroke.

Organised by Roger Coleman and Lawrence Alloway, colleagues at the ICA, and a number of artists, including Bernard Cohen, William Turnbull and Gordon House, *Situation* was an exhi-bition of 'large paintings' – 'abstract … and not less than 30 square feet'. The term 'abstract' was defined tendentiously as 'without explicit reference to events outside the painting – landscape, boats, figures' (Hence 'the absence [from the exhibition] of the St Ives painters, for instance'). Henry Mundy joined the 'executive committee', Robyn Denny became 'honorary secretary', and Gwyther Irwin, another Corsham colleague, was also involved. Ayres, not surprisingly, was very much of the party, taking part in many of the discussions that took place – at Corsham and at Saturday evening suppers at the Alloways – during the several months of the exhibition's preparation. In the event, she was the only woman among the twenty artists who exhibited at the RBA, and in the two subsequent *Situation* exhibitions, at the Marlborough New London Gallery in August and September 1961, and a summarising Arts Council touring exhibition in 1962–3. The title of the project was intended to reflect its purpose: to demonstrate that many abstract artists were painting – *as a rule* – on a scale larger than had hitherto been customary, and that this was an important aspect of 'the situation in London now'. 'In fact,' wrote Coleman in his introduction to the exhibition, '25 to 30 square feet is now considered quite an average scale for a painting.' The commercial prejudice against such work meant that at the time most of the artists were without a gallery to represent them. As Ayres remembers, 'we had all done this great big work and it all existed, and it wasn't getting shown I mean it was just the thing of putting it up and showing it.'

There was, however, more to the venture than simply showing large works that were not being seen by the art public. *Situation* – the exhibition and its catalogue – constituted a practical manifesto, with a developed critical rationale that was not a justification of a group style – there was none – but a response to a genuine creative phenomenon. The active promotion of their own work by professional artists with diverse styles and purposes was something unusual, though not entirely unknown, in this country. The 'large paintings' in *Situation* were the outcome of diverse approaches, and different intentions and ambitions, across a generational divide. Mundy and Turnbull, the oldest, were forty and thirty-eight respectively; the youngest, John Hoyland and Ralph Rumney, were in their mid-twenties; Ayres and Denny were thirty. What a 'majority of the exhibitors' had in common, according to Alloway, in an article on the exhibition in *Art News and Review*, was that they had, 'in various ways, been influenced by American painting' and that these influences had been 'assimilated into purposeful personal styles'. The vital significance of American painting had been con-firmed for many of them by their exposure to Abstract Expressionism at the Tate Gallery exhibition in early 1959, although a creative interest in American Action Painting went back for many of them at least to 1956.

To understand this American connection, Alloway emphasised, it was important to realise

Catalogue cover for *Situation* (Arts Council exhibition), 1962–3

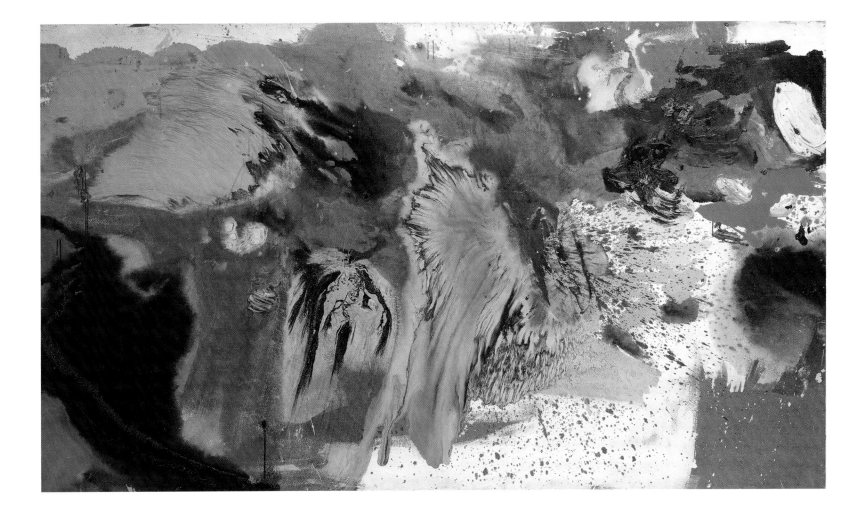

Cwm
1959
oil and ripolin on board
160 x 305 cm

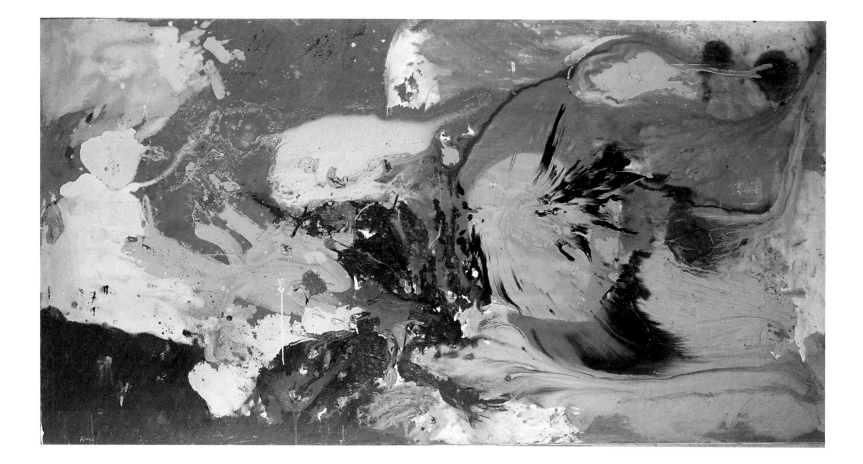

Unstill Centre
1959
oil and ripolin on board
160 x 305 cm

Nature in the Act of Painting

Untitled
1960
oil and ripolin on board
160 x 305 cm

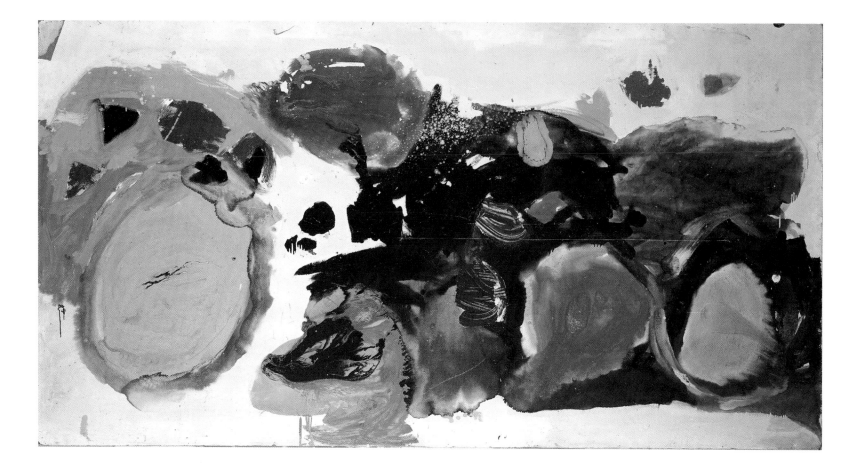

Muster
1960
oil and ripolin on board
160 x 305 cm

Nature in the Act of Painting

'that American art is not an exotic national style. It is the mainstream of modern art, which used to run through Paris.' Coleman's introduction came directly and unequivocally to the point: 'During the 1950s American painting introduced, among other things, the concept of the large painting into British Art the whole concept is the invention of American painting ... the values that have been accepted are an outcome of the influence of the Americans.' For Alloway, *Situation* was clearly more than an exhibition of those London artists he admired, it was another event in a sustained programmatic promotion, in writing and exhibitions, of the claims of American painting to conceptual and stylistic priority, and critical pre-eminence in post-war modern art. Although Ayres had made her own way to the large painting by another route, more circumstantial and personal than that of emulating the Americans, she was not unhappy to be associated with these claims; she had, in any case, been impressed and excited by the revelation of post-war American painting. And she recognised in her own practice 'the values implicit in the large painting' advocated in a catalogue polemic that was confidently persuasive if not entirely critically coherent with many of the works on show.

In the first place, Coleman argued, the large painting brought with it 'a new conception of space in painting, and with it a new conception of the spectator's relationship to a painting'. The denial of recessive and perspectival space resulted in a 'logical' expansion of the painting's space 'horizontally and vertically to extents where the spectator is contained and confined by it, and where in some cases a turn of the head of several degrees right or left is needed before it can be fully incorporated into his experience'. This defined the painting as 'environmental', although Coleman was at pains to point out that these paintings were not murals but retained 'the mobility of easel painting'. (This recalled the rationale for *Place*, an exhibition organised by Coleman a year earlier at the ICA, in which Rumney, Richard Smith and Denny had created a maze-like environment of 'individual' large paintings rising directly from the floor and abutting each other at right angles.) With the new 'large painting', the spectator became, as it were, part of the action, involved in the space of the work.

Secondly, the *Situation* paintings, although most of them were not in the now-familiar gestural manner of 'painterly abstraction', were 'action paintings' in the broad sense that they were 'the record of a sequence of actions'. Coleman argued that they were 'events' in the terms of Harold Rosenberg's famous definition – 'What was to go on the canvas was not a picture but an event' – because in each case the artist had committed himself to making the work directly on the canvas without benefit of preparatory sketches or 'previous planning': this was true, he claimed, even of the systematically serial, schematic hard-edge paintings that dominated *Situation*. This immediate directness of engagement with the canvas (however deliberated) was presented by Coleman, in line with the familiar Abstract Expressionist rhetoric, as a quality of existential commitment: he cited the ethical value of 'venturesomeness' claimed for 'modern painting' by Robert Motherwell in his note to the catalogue of the 1959 Tate exhibition. Thirdly, the scale and absolute abstractness of 'large painting' carried it to a new level of the object-reality that had been one of 'the constant preoccupations of modern art'. Such a work was not a picture of something else, it existed in its own right, offering an experience that was of itself, unique and not specifically referential.

It might be said that Ayres's work at this time, in terms of both its procedures and its objective forms, perfectly exemplified the principles enunciated with such confidence in Coleman's manifesto essay. She was, of course, familiar with the arguments and with the rhetoric of their presentation. In the note on Clyfford Still written by Alloway for the catalogue to the 1958 ICA exhibition of the E. J. Power Collection Ayres had marked: 'The large format of action painting emphasises, as Greenberg says, space as the lateral expansion of the canvas in addition to illusions of recession.' The large painting acquires 'a kind of fullness when intimately seen the enlargement of the picture ... involves the spectator by expanding in his space' In promoting *Situation* Alloway and Coleman both emphasised this 'environmental' aspect of the large-scale painting, its envelopment of the spectator. 'The large scale', wrote Alloway, 'does not require a large floor space in front of it, a vista to terminate With flat pictorial space, mid-century large paintings work well close to, in terms of intimacy and involvement.' This was something deeply understood by Ayres since the making of the

Hampstead Mural in the summer of 1957, though she had never formulated a programme or articulated a critical case, prospective or retrospective, for her practice. Her only published statements before *Situation* are quotations from an informal interview in a composite 'imaginary colloquy' put together by Penelope Gilliatt in *Vogue*, June 1959. These remarks are revealing on the subject of space: 'We paint the essence of something – of space. *These canvases engulf space. That's why their size is so important.* I don't know how to be very clear about it in words: I suppose that's why I paint it' Ayres added, in terms that give a clear indication of what she thought of at the time as the provenance of her own approach: '*Art autre* makes painting a truly visual art.' The interview itself took place sometime in the autumn of 1958.

While it is true, of course, that most large paintings will offer visual/tactile excitements when seen close up (as indeed will any small painting or print when approached with a magnifying lens) it is difficult now to see in what ways this was especially or particularly true of the majority of the paintings in *Situation*; their impact depended on schematic hard-edge divisions of the picture plane and emblematic motifs that demanded a reading of the painting as a whole. In certain cases – those of Bernard Cohen, Harold Cohen, Robyn Denny, Gordon House, Peter Stroud, John Plumb, John Hoyland, among others – it seems evident that the apprehension of the whole canvas-image seen at once and at a slight distance was crucial to its effect. The scale of these paintings was without doubt crucial, giving their stark and simple emblematic designs, large single colour fields, stripes, geometric or near geometric divisions and shapes and architectural references (to windows, doorways, arches) an inevitable environmental impact. Photographs of the installation at the RBA bear this out, with the relation of one work to another, and of vistas through doorways and across gallery spaces, assuming obvious significance.

Given the degree of design that was evident in many of the finished works, and the careful premeditation required to achieve desired relations of motif, colour and scale, Coleman's view of much of the work shown in *Situation* as meeting an essential criterion of 'action painting' also seems to stretch a critical point almost to breaking; indeed, in respect both to 'direct execution on to the canvas itself' and to the explicit connection of this 'closer relationship with his work' to the artist's 'ethical commitment', Coleman's arguments could be said to apply to paintings of any size, and not only to the purely 'abstract'. Both aspects – of creative action and its moral implications – were in fact central to a great deal of high modern thought and practice from Cézanne on. It was in that powerful line of a modernist practice that preceded and comprehended American action painting that certain artists in *Situation* – Ayres, Mundy and Turnbull most notably – sought to locate themselves, though not of course, in terms of style, manner or subject matter, and not without due admiration for the innovations of the New York painters. In 1958 Turnbull had written: 'The antagonist of tradition is its true heir.'

Like Ayres, Mundy and Turnbull were, in quite distinct ways, equally concerned with modalities that derived from and related to nature. Their paintings rewarded both a speculative response to the image as a whole and a close-up engagement with unpredictable complexities of surface. Thinking of Monet's large late lily-pond paintings in terms that might apply just as well to late Turner ('without horizon, and with little sensation of high or low', in which 'the events on the surface are related to a new attitude to nature') Turnbull had written in 1957 of the new painting: 'This object then exists in the world as part of nature, as the person who makes it is – its qualities never absolute but changing in relation to the participation of the spectator. The spectator finds nature in art and the artist finds nature in the act of painting.' This applies as closely to Ayres's work of the late 1950s as to his own. In her painting in this period Ayres was seeking a quality of engagement with nature that was 'modern' in just the way that Turnbull described: 'For many artists of the '50s the absorption of nature and the act of painting are two activities reconciled during the act of painting.' Such a preoccupation had little to do with the ideas that informed the hard-edge architectural and emblematic formalism of many of the *Situation* paintings. Ayres was, in fact, the only artist in the exhibition whose work seemed to relate in a direct way (if 'without explicit reference') to the observable phenomena of the natural world. Her titles in themselves signalled a clear intention to call to

Gillian Ayres in the garden
at Beverley Road, Barnes, 1959

mind the forms of natural objects (*Moraine, Track, Sedge, Dune*) or the flow, pause and gather of natural dynamics (*Unstill Centre, Muster, Trace, Trap*); the titles of *Cwm* and *Cwm Bran* refer directly to the mountainous landscape of North Wales. Alloway was aware of this aspect. Writing in the catalogue for her exhibition at the Molton Gallery, which opened in October, he resorted himself to nature imagery: 'In Gillian Ayres' paintings the paint flows in a spectacle of liquidity that covers the surface like a tidal movement.' In his review of *Situation*, a month before, he had referred, in a remarkably inadequate formal summary, to her 'scattered but held-together marks'; now he recognised that Ayres was not interested in the optical language-games that characterised the typical *Situation* painting. He remarks a change in her technique to a greater use of the brush, which allows a more direct control than previously, 'when she poured more extensively', though her work is still 'unpremeditated', '[lately] . . . the role of brushwork has much increased . . . [she] uses the brush (usually a house-painter's) on a canvas swimming in turps, so that the direction of the brush is always threatened with dissolution, its linear thrust constantly diffused.' For Alloway, perception of Ayres's 'mobile and dramatic configurations' of 'objectless colour' tends to mingle 'painterly and referential qualities in a new way'. This raised new questions about the relation of abstraction to nature: 'the antithesis of "abstract" and "figurative" art, once so convincing, turns out to be very awkward in connection with certain works by Pollock and De Kooning.' (Pollock had already been identified by Alloway as 'the biggest technical influence on her work'.)

This citation of the American masters is held by a characteristic critical sleight of hand to validate Ayres's easy-going attitude to an associative reading of her paintings; for Alloway, that she is aware of this 'new state of affairs' is revealed in a quotation from 'an unpublished statement': 'although I do not use things seen or remembered as a point of departure, I do not mind if a finished picture evokes a feeling of flowers, minerals, feathers, or whatever it may be, to different viewers.' In fact this permission to imagine and create in front of the picture, in its abnegation of any effort to assert control over the work's reception, was much at odds with the optically aggressive determinations on the spectator of most hard-edge painting, the cool aestheticism of formalist post-painterly abstraction, or the knowing ironies and celebrations of British Pop Art. In a cloudy terrain between impression and expression, evocation and invention, nature and art, Ayres was, as an artist, as ever, on her own.

Gillian Ayres in her studio, 1961
(photo: Roger Mayne)

Nimbus
1962
oil and ripolin on canvas
274.4 x 152.5 cm

7

Sailing off the Edge: Into the Sixties

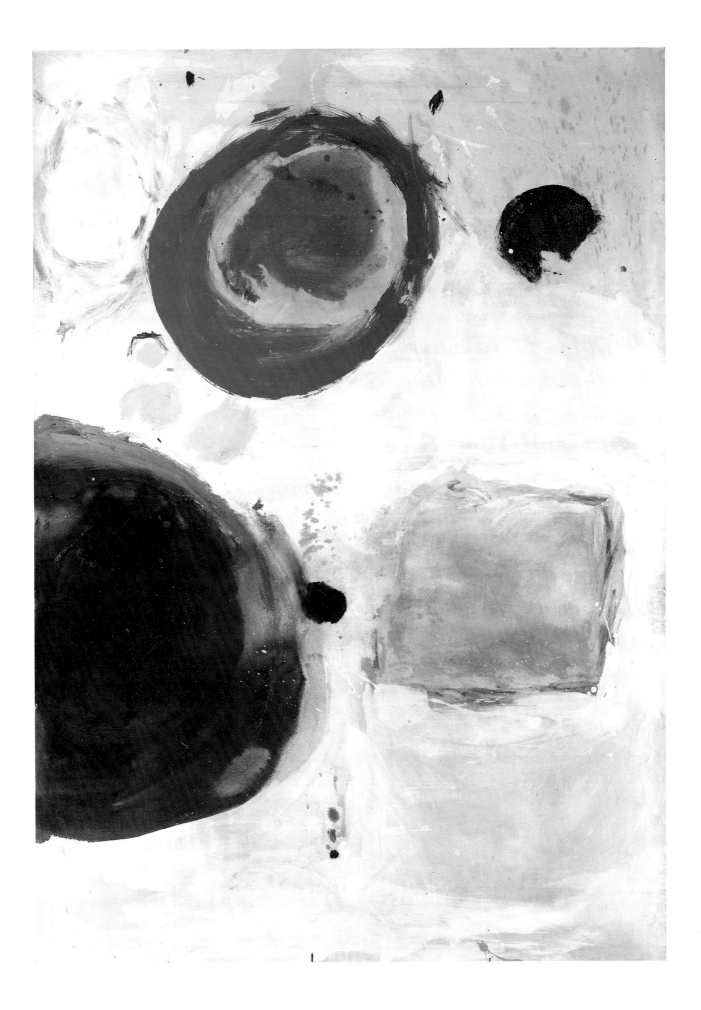

By the turn of the decade Ayres, at the beginning of her thirties, had established a consider-able presence in British art, but one that is not easy to characterise: hers was an awkward and unpredictable presence, individual, even idiosyncratic. Ayres had no programme and had made no statements of intent, but it was widely recognised among artists and critics alike that she was a highly original artist, adventurously pushing painting to the limits of certain possibilities. Her use of aleatory procedures allowed the accidental splash, dribble and stain to compete with the marks and motifs created by deliberate but instinctual gesture; she had no truck with the English critical appreciation of hard-won painterly technique, and of the painting as a lovingly crafted domestic object. Few of her contemporaries were as prepared to let the materials and the media of the art play so active a role of their own in the creation of the image. Her paintings had an unforced directness of utterance, they proclaimed a rough innocence of intent: they had a rawness and energy that was disconcerting, the more so in that the artist was a woman. As for scale, to all three of the *Situation* exhibitions she submitted paintings that were larger than any of the others (being outstripped only by the huge collages of her friend Gwyther Irwin). What is more, she was constantly developing and changing, without compromise or regard to any commercial constraint.

So it was that the paintings Ayres showed in *New London Situation*, at the Marlborough New London Gallery in August 1961 and at her second Molton Gallery exhibition in January 1962, marked a significant shift in manner from those exhibited in 1960. Alan Bowness, in a brief note in the Molton catalogue, described her new style in terms that hinted gently at critical reservations with regard to the earlier work:

Catalogue cover for *New London Situation*, 1961

Having for a time enjoyed unlimited freedom with painterly exuberance, Gillian Ayres now seems to be in process of redefining her painting, and redefining it in terms of a more measured, less unfettered art. She retains the conspicuous ease of handling and the effulgent, luxuriant, sensuous, perhaps peculiarly feminine colour that have always characterised her work, but a new sense of order is emerging.... The forms in her pictures ... have a definition and a concreteness that they until very recently lacked. No longer do they exist in a limitless atmospheric space; the pools of colour now lie more solidly on the surface of the canvas.

These new paintings of Ayres's were on canvas, a change of support that may reflect the change in her economic circumstances: by the beginning of 1961 she and Mundy were each teaching two days a week at Corsham, and Mundy was enjoying considerable critical and commercial success (he showed at the prestigious Hanover Gallery for the first time in 1960, and in 1961 he won the highly regarded first prize at the John Moores Open, as well as an important painting prize at the Carnegie Institute International at Pittsburgh). The couple had moved into their fair-sized house in Beverley Road, Barnes, in early 1959, and though for some time they had to let rooms, they both had studio space. (*Cumuli* was the first painting Gillian made there.) Within the space of a year they had moved from a modest shared weekly wage at the AIA into a condition of relative affluence and a new pattern of life.

There is certainly a greater openness of lateral space across the plane in the new paintings of 1961, and what Bowness calls the 'pools of colour' tend to be separated one from another and distributed across a white rough-sized surface. This new spatiality may be seen as a direct consequence of working on canvas, some areas of which might be primed, some unprimed, allowing not only for textural subtlety and variation, but also for the suggestion of aerial light as a primary element *before* the addition of colour or forms. The colour-forms, near-square-near-oval shapes, and their formal disposition across the surface of these works, are not unlike those in paintings by William Scott and Patrick Heron at the end of the 1950s and early 1960s (described by Heron as 'square-round shapes'), but there is an absolute difference in their effect. Whereas in Scott these shapes have a solidity of presence and an emphatically static placement that derives from their origins as the components of still life, and in Heron they float luminously in atmospheres of saturated colour, elements in a purely abstract painterly drama, in Ayres the shapes are roughly brushed and crudely figured, and deployed with a magnificent insouciance across what is immediately apprehended as brute surface, but might then be read as an atmospheric or aqueous element. Completely absent are the qualities of *belle peinture*, the aesthetic refinement of colour and touch that characterise the work of those

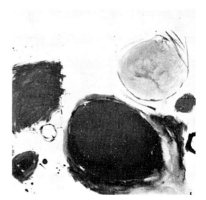

Blimps
1961
oil and ripolin on canvas
152.5 x 152.5 cm

Islands
1961
oil on canvas
152.5 x 213.4 cm

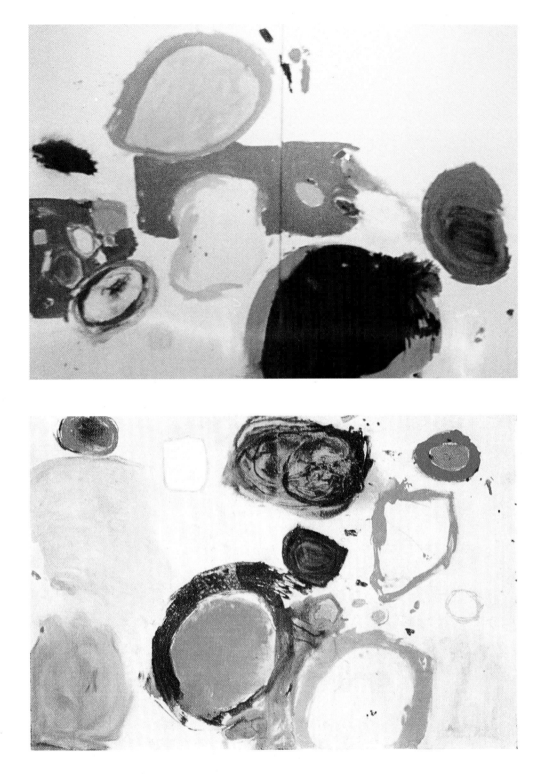

Pivot
1961
oil on canvas
183 x 274.4 cm

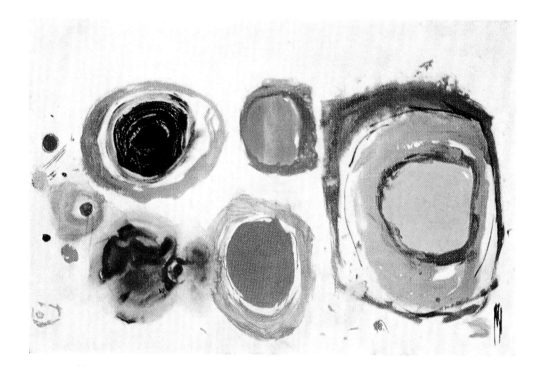

Scud
1961
oil on canvas
183 x 274.4 cm

Sailing off the Edge

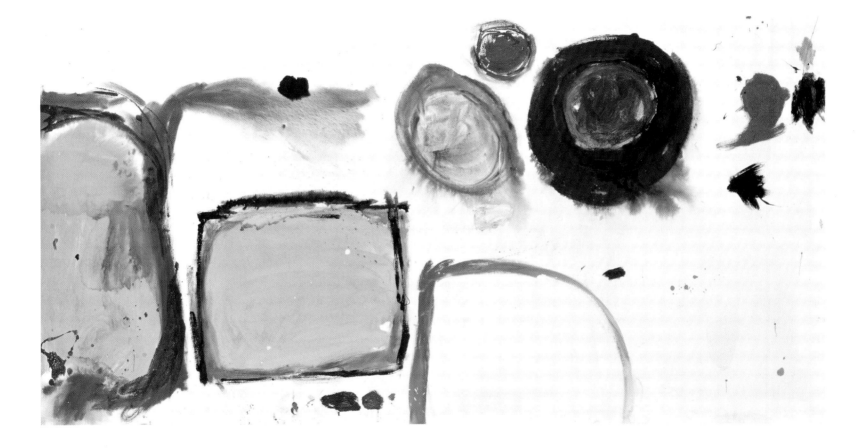

Break-off
1961
oil on canvas
152.5 x 305 cm

older contemporaries, both of whom, incidentally, she greatly admired. 'Something brusque, practical but impatient, is to be found in these paintings', wrote the critic Tim Hilton, in his catalogue introduction to her exhibition at the Serpentine Gallery in 1983. Hilton, who has been Ayres's most perceptively exact critic, continued: 'The palette – sea green next to a Matissean pink, for instance, lemon and a pool of Vandyke brown surrounded by lavender – can feel as though delicacy and effulgence of colour were at odds with the muscle of the work.'

Ayres's titles, often witty and evocative, are intended primarily to identify the paintings, but they nevertheless often provide clues to her own discoveries of associative possibilities in the work, or those of friends. They are never simply descriptive, and always chosen to avoid any closure of associative possibility. *Islands* (1961), the painting she submitted to *New London Situation*, consists of two canvases abutted to create one work, seven feet high and ten feet long, in which several of the colour-shapes seem to be disengaging from a central agglomeration and floating free towards the canvas edges; in *Pivot* and *Blimps* (both 1961), shown at the Molton, something similar is happening. In *Scud* and *Break-off* (both 1961) the disposition of these shapes suggests not so much this gyratory motion as their drift from left to right. Bowness's description of 'pools of colour [lying] more solidly on the surface of the canvas' now seems true only of some of the colour-shapes, for the true dynamic of their relations is as between such static or anchored forms, and the free-wheeling or scudding or floating or sailing or blowing away of insubstantial dissolving shapes such as flames, smoke, clouds, stains in water. In *Break-off*, as in *Nimbus* (1962), the visual anchoring of certain shapes is achieved by their attachment to the canvas edge, tied in, metaphorically, by a quickly brushed linear outline: roundels fly free of these anchored shapes like planetary satellites, balloons, puffs of smoke: titles of other paintings made in 1961 include *Flotilla*, *Smoke Signal*, *Roundels* and *Fire Ball*. *Blimps* took its title from a term current among artists for oval shapes floating in colour fields, which in turn derived from the nickname given to the inflatable anti-aircraft barrage balloons that were a common sight in the wartime London skies.

The quickly brushed linear circumscription of the roundel shapes is also novel. This element of drawing is particularly evident in *Scud* and *Break-off*, and in *Send-off* and *Unvisited* (both 1962). These paintings have a marvellously fresh and direct improvisatory feel, like that of watercolour or oil sketches, an effect achieved by the quick drawing, the free use of turps as a colour thinner and the very speed and dexterity of execution required to fix a colour-shape out of the natural flow and dispersal of pigment. No small part of their impact derives from the contradiction between a provisional manner and a vastness of scale, the impression they give of having been made in the same way as a small sketch, but on a canvas that may have a surface dimension of anything up to seventy square feet. This declares a creative principle that had informed Ayres's work since Hampstead, and which has continued to be central to her practice: *that the work is created by the body in action*. Its imagery is created by the motion of body, arm and wrist in concert with materials in generative flux; it is modified by successive bouts of action interspersed with periods of sustained contemplation. Conscious decisions are made after the act, and determine only whether or not there will be further actions or whether the painting is finished. This is a procedure quite different from that governed by the careful judgement of the eye – what Heron called 'the fine deliberateness' – that determines the placement of the 'square round' shapes in paintings by Scott and Heron, and gives them their poised relation to each other within the canvas rectangle. In Ayres's paintings it is the unpremeditated movement of the body and the unpredictable behaviour of the medium that determines the visual dynamics of cluster and separation that configure the shapes across the canvas surface.

Bowness considered that these drawn shapes – having 'a definition and concreteness' – gave the paintings an 'increased objectivity': '[they] take on a more explicitly figurative quality – not that they are representational in any way, but for the spectator associations and references multiply and their evocative power grows stronger.' He declined to describe what they might have evoked for himself, but a critic's permission to imagine is here added to the artist's own. Those image-shapes, summoned into being by the artist's intuitively spontaneous actions and inseparable from the paint of which they are made, are powerfully present as physical forms

(this is their 'increased objectivity'); they consist, indeed, of matter manipulated with an impulsive vigour and freed from any intention to represent anything but itself. As such they separate out from the matrix element represented by the white or off-white ground and assume an alarming life of their own. It is this vitality that gives them associative power, and yet it is also this that makes them live in the memory as much for themselves as for anything they may resemble. There is a 1962 photograph by Roger Mayne of the artist in her studio, surrounded by canvases (*Break-off* and *Nimbus* are clearly visible): she is pensive, cigarette in hand, and seems touchingly separate from the work, as if the great whorls and stainings of colour had the reality of natural phenomena, were presences for which she claims no more responsibility than she might for clouds or rainbows, and for which she will assert no claims to authorship.

Gillian Ayres at Beverley Road, 1962
(photo: Roger Mayne)

Ayres responded to the Arts Council's invitation to make a brief statement in the catalogue to its touring exhibition, *Situation*, at the end of 1962, with a remarkable and revealing text that perfectly reflects this creative diffidence:

A mark with a brush, on a chosen area of canvas – primed with G.P. Undercoat – dry or wet with turps –, with colour – paint – consistency – size – weight (tone).

A shape – a relationship – a body – oddness – shock – mood – cramped – isolated – acid – sweet – encroaching – pivoting – fading – bruised.

Painting's own nature – a mark making its own image in its own space – the canvas viewed as a whole image and space – an essence – perhaps like a space a sailor of Magellan's would have felt when the world was flat and he had sailed off the edge.

Significantly, and deliberately, this is in no way a 'statement' of the kind provided by the ten fellow-exhibitors who resorted to earnest declarations in the first person. In its determination to deny programme Ayres's text avoids even the syntax of ordered discursive utterance. It is a revelation of a state of being, not of an attitude of mind; it refuses to declare intentions or to define a position. It repays close consideration for the insight it provides into the operation of a special kind of creativity, feminine in nature, which though not confined to women artists is more rare in men. It consists in imaginative action free of assertive ego, whose primal source is in the precipitation and filter through inner experience of what is given by nature and happenstance. It invites a response to something that springs and flows, shines forth, or grows and proliferates. Explosive, exuberant, sensuous, luxuriant, effulgent, radiant, flowing, cornucopia: from the late 1950s to the turn of the century these are words that have recurred constantly in writings on Ayres's work.

The first part of the text hints at the *procedures* out of which the work is created. It begins with 'a mark with a brush, on a chosen area of canvas' and is matter of fact: this is how it is done and with what materials, with what properties. It is characteristic of Ayres to begin with her feet on the ground. The second movement opens with the image thus made – 'a shape' – and its immediate reality in space – 'a relationship'. There follows a sequence of words of different status, concrete and abstract nouns, adjectives, past and present participles: the effect is to create in the reader something of the unpredictable sequence of sensations and feelings in the maker of the work at the time of working. Re-enacting the essential dissolve of psychic, physical and emotional elements in the act of painting – 'oddness – shock – mood' – it reveals the nature of the *process* as felt, its action within the body, its register upon the consciousness. The surprising third section is concerned with the *outcome* of the action on the materials: 'a mark making its own image in its own space – the canvas viewed as a whole image and space.' This is the *work*, an 'essence' distilled, a precipitate of the creative process. It is an autonomous object beyond the control of the artist, on its own in the world. Its space is infinite, into which, like that 'sailor of Magellan's', the viewer's imagination might sail, a space beyond the terra firma of rational selfhood on which we like to stand. It describes not only the experience that awaits the spectator of the painting, but also the experience of the artist in its making, like Hilton's abstract painter 'swinging out into the void'.

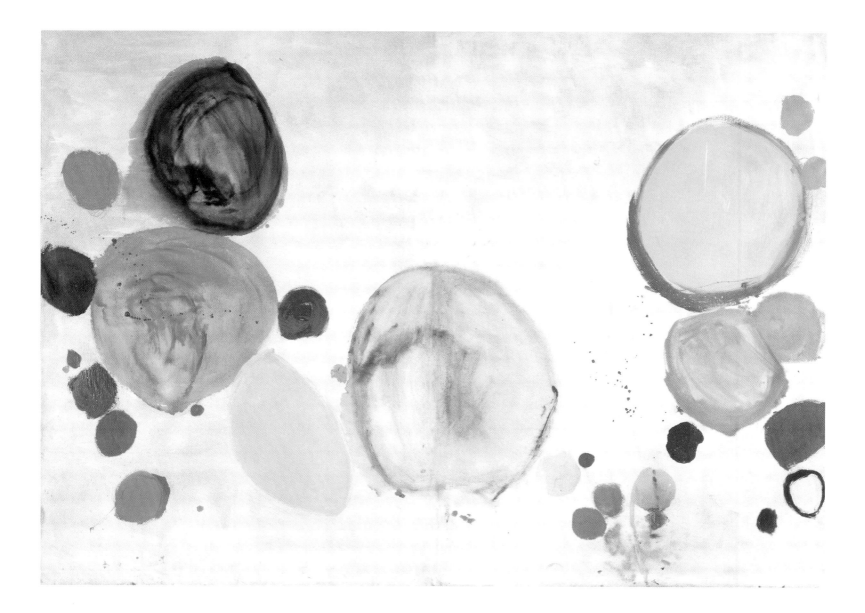

Send-off
1962
oil on canvas
213.4 × 305 cm

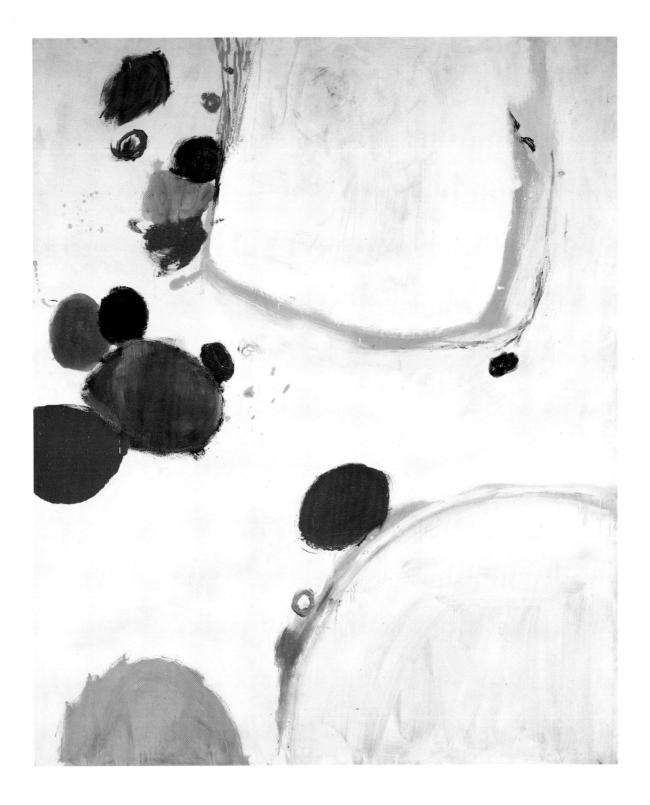

Unvisited
1962
oil on canvas
182.5 x 152.5 cm

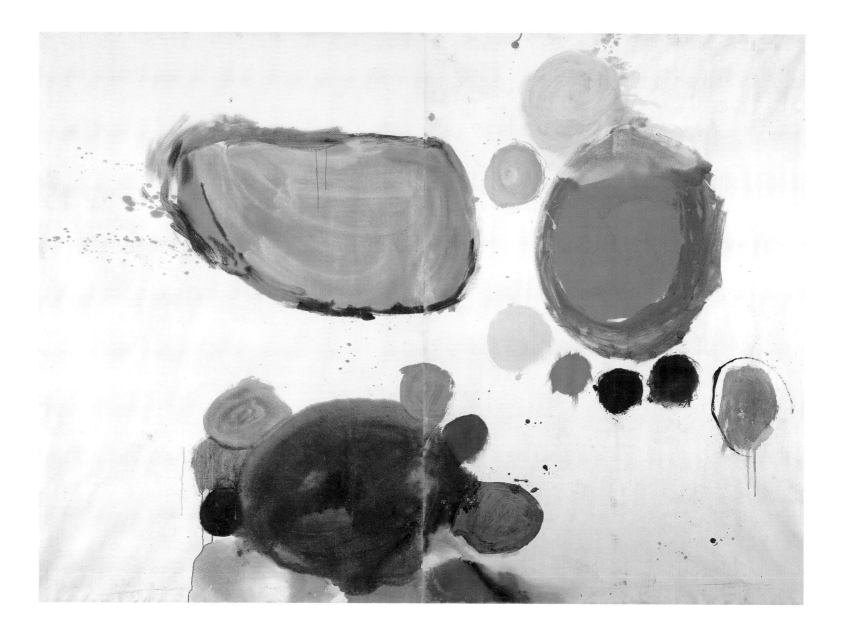

Brood
1962
oil and ripolin on canvas
213.4 x 305 cm

Sailing off the Edge

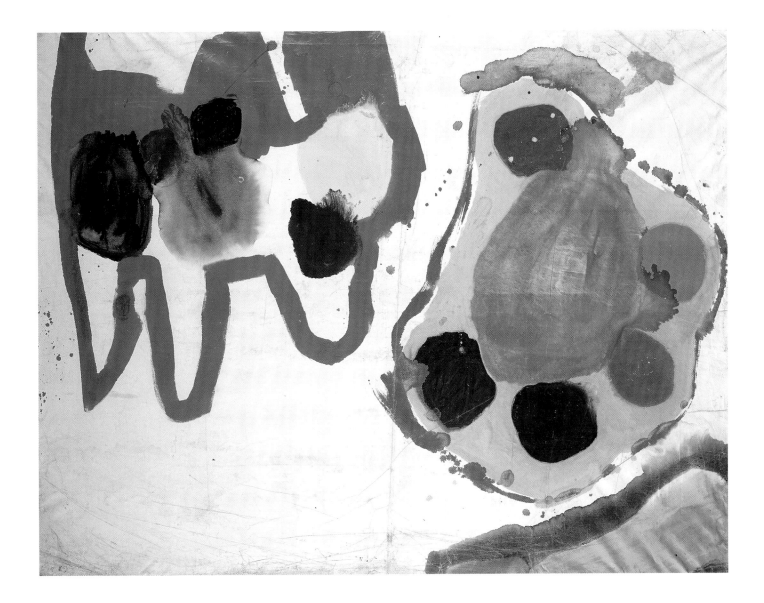

Untitled
1962
oil and ripolin on canvas
171 x 225 cm

Brood and *Untitled* (both 1962) can be seen to exemplify the manner of working and the kind of painting implicit in Ayres's memorable text. *Brood* follows her frequent practice of putting two canvases together to create a larger picture surface, in this case twice times seven feet by five. It combines household paint and oil paint in images on an undercoat ground. Colour is laid in with a wash of turps thinner (described by Ayres as 'throwing turps as a water-colourist uses water') to create stained puddles of colour, or roughly brushed on in opaque discs, thick and thin: two kinds of 'mark making their own images' in a space that is at once lateral, a great off-white plane, and ambiguously recessive, infinite, aerial or aqueous. The figure to the upper left of *Untitled* is created with a peremptory line of brushed green Ripolin, violently delineated, like a monster in a child's drawing, and offset by what appears as a floating diaphanous bag-like shape, created in fact by a similarly opaque household pink: the eye is surprised to register that the contrast of weight is not a matter of texture but of colour. Both figures contain what Ayres calls 'shock weights' – dark roundels that contradict the illusion of space and light created by atmospheric translucency and bring us back to the materiality of the surface. These 'shock weights' also occur as satellite roundels (offspring?) on the right circumference of the bottle-green washed-oil shape at the lower left of *Brood*, and round the brown-ochre planet that floats centre right. In both paintings the optical tensions created by contrasts of texture – granular matt versus shiny, washed oil versus brushed Ripolin – and between the shapes themselves and the primed surface, militate against any settled reading of the imagery. But even as the aspect of texture emphasises the objective, obdurately material, environmental presence of the painting, 'colour – paint – consistency – size', so does 'the canvas viewed as a whole image and space' invite that crucial and inescapable shift in response towards a pictorial imagining.

Ayres insists that it is impossible to take out of painting what she describes as 'the illusionary' aspects of space and light. (*Any* painting? she has long pondered the question, with regard to Mondrian especially. She still has the catalogue of his New York MOMA exhibition in 1948 which she bought that year at Zwemmers bookshop.) Light and space ineluctably bring evocations of the phenomenal world and its moods: the external object conditions the inner subjective response, just as nature does. Ayres has worked with an awareness of this from the beginning of her career, when the critical writing of Patrick Heron, and in particular his continuous emphasis upon *space* as the primary element of painting, made a strong impact on her, as on other artists of her generation. 'Heron', she says, 'was a voice in the dark.' Much of his writing in the early 1950s elaborated his insights into the nature of space in abstract painting, and treated of its centrality to the crucial definition of what was unique to the medium, what it was 'that painting could do' in contradistinction to the other arts. In 1953 he had written:

[what] time is to the composer, space is to the painter – and . . . to the architect too it is possible to argue . . . that a major aim of the painter is, and always has been, to organise space in a new and distinctive manner [for] the non-figurative painter space is the main object of manipulation space itself has become the subject.

Later that year, introducing an exhibition of contemporaries that included Scott, Hitchens, Frost and Hilton, he wrote:

In painting space and form are not actual, as they are in sculpture, but illusory 'pictorial science' is simply that accumulated knowledge which enables the painter to control this illusion, the illusion of forms in space. But the secret of good painting – of whatever age and school, I am tempted to say – lies in its adjustment of an inescapable dualism: on the one hand there is the illusion, indeed the *sensation* of depth; and on the other there is the physical reality of the flat picture surface. Good painting creates an experience which *contains* both.

The paintings that Ayres showed at Hamilton Galleries in September 1963 carried 'the adjustment of [this] inescapable dualism' to a new level of sophistication. *Lure* and *Scott* (both 1963) show no loss of spontaneity, but the extreme roughness of attack of such earlier paintings as *Brood* and *Untitled* has been superseded by a more obviously controlled approach to the canvas. In these paintings the tendency to take the image-shapes to the canvas edge is

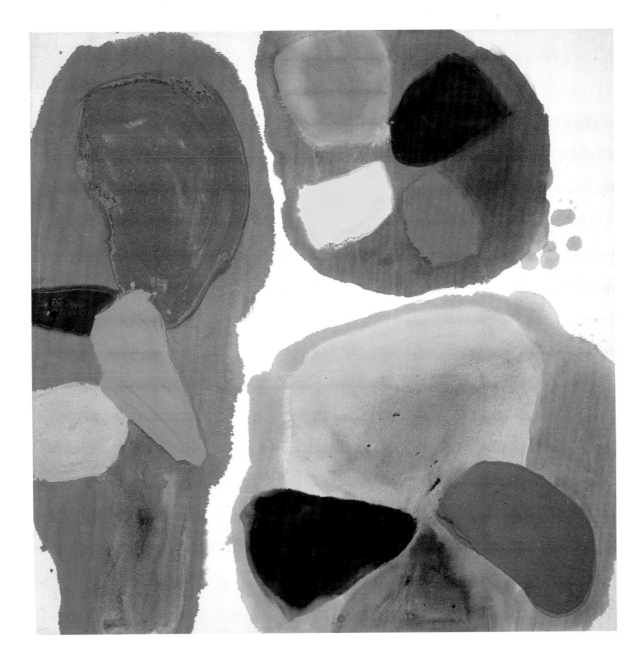

Lure
1963
oil on canvas
152.5 x 152.5 cm

taken to an extreme: brilliantly coloured forms, like the petals of great flowers, are now almost entirely contained within pools of stained colour, which might be flowing out of the rectangle or floating into it; they suggest a continuity with the world beyond the edge. It is as if we are looking at continuously moving amorphous organic forms on a hugely magnified microscope slide through a lens with a delimited field of vision. Gone also is any suggestion of drawing, the colour-forms are purely of 'painting's own nature'; the larger enclosing forms seem to be dissolving at their edges into their surround. Looking at them, or between them, 'the eye *sinks* through the surface' (in Heron's distinctive phrase) or is stopped by the opaque colour of certain of the petal forms. In these paintings ambiguities of 'depth' and 'surface', created by contrasts of texture and colour, of brushwork and stain, are exploited to the maximum: they are works of an extraordinary beauty and vibrancy.

Ayres at this time also made a number of mixed media drawings, using charcoal, crayon, watercolour, oil paint and collage on paper and board. These vigorous small works played games with the square-round and oval shapes that inhabited the large paintings, deploying them with uninhibited freedom across the surface, with contrasts of watercolour-wash translucency and absolute transparency (as when a line creates a shape that shares the colour and texture of the support with the space around it), complete opacity (brushed oil and collage elements) and surface scribble. Both the abstract 'objects' and the space within which they appear to be spinning and wheeling are un-fixed and ambiguous, and the relations between them are contradictory and meaningless. The mixing of media, and the reality of the collage fragments, compound these contradictions, and insist on the physical 'actuality' of the work. It was as if Ayres had decided to demonstrate, with a lively graphic wit, that even when the materials and media of a work declare themselves without disguise, so inveterate is the fantasy of the eye that spatial and kinetic readings, the fictional invention of little cosmic dramas, are impossible to avoid. It is a demonstration that is effective at any scale in her work at this time: go close to the large paintings and test their roughly insistent material actuality; step back, and you are looking into radiant space.

Gillian Ayres in her studio, 1963 (photo: J. S. Lewinski)

Scott
1963
oil on canvas
152.5 x 152.5 cm

Stamboul
1965
acrylic on canvas
122.5 x 122.5 cm

8

Crivelli/Shells/Uccello Hats: A Digression in the Sixties

Dealers, good or bad, play a significant role in most artists' lives. Generally, Gillian Ayres has been lucky. The 1963 Hamilton Gallery exhibition signified the continued support of the redoubtable Annely Juda for Ayres's work, for she had also been responsible for putting on the two previous shows at the Molton Gallery, of which she had been director. In 1964, however, Ayres's art took a decisive and surprising turn, and by the end of that year she was preparing a show of new work to open in February 1965 at Kasmin Limited. Kasmin, who had worked at Gallery One and then, briefly, at Marlborough, had opened his own gallery, designed by Richard Burton, at 118 Bond Street, with the backing of the young Lord Dufferin, a Guinness heir, in the spring of 1963. It was a cool, empty, white room, with evenly diffused light, a high ceiling and rubber floor, the first truly contemporary gallery space in London. The first exhibition was of acrylic 'target paintings' by Kenneth Noland, the most critically fashionable of the younger generation 'post painterly abstractionists', and the principal protégé of Greenberg. Shortly after came *The 118 Show*, which featured Anthony Caro, Helen Frankenthaler, Morris Louis and Ad Reinhardt, among other international stars. Kasmin was to become for some years one of the two most glamorous galleries in London; like the Robert Fraser Gallery, it was a quintessential sixties art venue. Of the younger British artists, as well as Ayres, it represented Richard Smith, David Hockney, Robyn Denny, Bernard Cohen and John Latham.

The change in Ayres's work was not so much a development of manner as an adoption of a new style that denied every aspect of the old. It was clearly in some ways a response to the vogue for an art that was distanced from personal expression, non-committal, controlled and propositional; an art without subject matter or else approaching its subjects with a reflexive irony, or drawing on other art, on architecture or design, or reflecting facets of mass media and advertising. The change was all the more remarkable in the light of her unselfconscious resistance to any influence from the more intellectual and formalistic of her colleagues in *Situation*. Its origins lay, rather, in her teaching. At Corsham, with the introduction of the new curriculum in 1964, Ayres had been assigned to teach foundation students; at a building in Bath, away from the Corsham campus with its lively pedagogic interactions with other artists, Ayres found herself devising a basic programme for seventeen and eighteen year olds. Determined not to resort to the traditional modes of training, predicated on the empiricism of the eye, that she had experienced at Camberwell, she devised formal exercises that would encourage invention within constraints, and that quickly took the students away from the conventions of figurative representation and towards formal pattern and abstraction.

She set up ziggurat-like arrangements of boxes, that were, in effect, geometrically abstract still-lifes; she then drew ribbon-like lines across and down them that disrupted the hard edge cubic structures with an organic counterpoint. Using filtered apertures, she experimented with white light projected on to the box constructions, isolating and truncating sides and edges in alternating strips of bright light and darkness. Making her own drawings along with the students, Ayres began, for the first time ever, to use formalistic generative procedures, by means of which complicated images were created from simple beginnings, one thing leading to another, built up by repetition, counter-change with two colours, or positive and negative, crayon and untouched paper. What was certainly in character was an avoidance of symmetry or geometric regularity: Ayres's drawings would move over the sheet in irregular, lop-sided arrangements, never filling the plane to every edge. She progressed quickly to organic modular shapes like flowers or soft hats, which offered further opportunities for complications of counter-change and pattern generation.

More elaborate exercises, like the two horizontal designs of 1965 now in the Arts Council collection (see p.82), developed the counterpoint interlock in her drawings to almost Escher-like complication, in this case the one below repeating elements of that above in negative. These drawings are of a kind utterly opposed to the free fantasies of those described in the last chapter, that were made not much more than a year before, in 1963. They are, instead, intensely programmatic. Before long, in fact, Ayres, in a logical development, was making drawings on to squared graph paper. The earliest of the paintings shown at Kasmin in 1965 followed on from these various graphic exercises, or related closely to them: this was in itself a significant departure from her natural tendency to make paintings *ab initio*, directly on to the support

Untitled Drawing
1965
graphite and pastel on paper
17.8 x 22.8 cm

Untitled Drawing
1965
graphite and pastel on paper
22.8 x 17.8 cm

Untitled Drawings
1965
chalk on paper
48.3 × 69.9 cm (sheet size)

Crivelli/Shells/Uccello Hats

Greenback
1964
acrylic on canvas
152.5 x 152.5 cm

Untitled Drawing
1965
graphite and pastel on paper
22.7 x 17.5 cm

Untitled Drawing
1965
graphite and pastel on paper
17.5 x 22.7 cm

Gillian Ayres in her studio, 1964
(photo: J. S. Lewinski)

without premeditation. There is a clear relation, for example, between an early painting in the new manner, *Greenback* (1964) and the drawings now in the Gulbenkein Collection (see p.84). The paintings of 1964 shared with the drawings the odd asymmetrical clustering of the depicted configurations of shapes. These shapes, seen in paintings such as *Isfahan*, *Piranha*, *Height* and *Send* (all 1964), are sharply outlined, lyrically allusive, leaf-like, petal-like: they are flatly decorative, using a limited number of undifferentiated contrasting colours; the change of manner had necessitated a change of medium; for the first time Ayres was using the newly fashionable acrylic paints. As in much other painting of the time these new forms can be seen to derive from Matisse's much admired late cut-outs; their fanciful organic proliferation combined record-cover *art nouveau* with psychedelic mannerism.

Several of these drawings might be framed together, as if to emphasise the provisionally schematic nature of the individual pieces. This device of arranging separate items like specimens on a single sheet was exploited by Ayres in an excursion into screen-printing, a medium perfectly suited to this kind of coolly demonstrative presentation, as it was to the juxtaposition of categorically disparate items such as those in collage-drawings, for example *Untitled Drawing No.11* (1967), which were shown in a one-person show with related prints at Alecto Gallery in 1967. *Lorenzo the Magnificent and Niccolo the Gear* was made in 1967 at Kelpra Studios under the supervision of Chris Prater, the inspirational master screen-printer, and published by Editions Alecto, which tapped with such aplomb into the zeitgeist of the decade. ('Gear', incidentally, was a Liverpool-derived sixties slang term of sartorial approbation.) *Lorenzo*, quite unlike anything Ayres had ever done, focuses on the attention-seeking motif of Niccolò da Tolentino's octagonal floral brocade hat in Uccello's famous *Battle of San Romano* in the National Gallery, celebrated as a virtuoso exercise in perspective ever since the painting adorned Lorenzo de Medici's bedroom. Ayres's fascination with his treatment of this piece of headgear, ironic in the light of her previous repudiation of perspective in painting, seems to have preceded its appearance in this print: references to its complex and eye-beguiling shape can be found in the earlier abstract crayon drawings. The agglomeration of motifs in *Lorenzo* is laid on to a screen-printed ground of graph paper, and includes what look like cut-out patterns for parti-coloured jesters' hats, geometric figures (flower stars, hexagons), a Chinese lantern and a detail from Crivelli's *Annunciation*: each element can be seen to refer to the others in a playful round of associations to do with fashion, vanity, folly, floral decoration, pictorial convention and geometric forms. *Crivelli's Room I* and *II*, based on the colour illustration in Berenson's *Italian Painters of the Renaissance* of a detail from the National Gallery *Annunciation* (famous for its spectacular deep perspective), reduce the tonal richness of the original to comic-book linear outline and crude commercial colours. Ayres instructed Prater to colour one 'in the most vulgar colours he could find' and the other in 'Sunday colour supplement colours'. These screen-prints were little more than playful exercises in the Pop Art mode of ironic/celebratory appropriation and transformation; as such they are oddities in Ayres's *œuvre*, notwithstanding her use of borrowed motifs in the abstract paintings of the mid- to late 1960s, or her frequent reference in the titles of later paintings to artistic and poetic sources.

The quirky asymmetries of the earliest paintings in the new 'cool' style, which, like the drawings, left areas of the support uncovered, were quickly left behind. *Stamboul* (1965) is one of the earliest of the all-over, edge to edge pattern paintings, and with similar works from early 1965 it signals a new and increasingly more programmatic preoccupation with an even distribution of tone. The effect of this tonal constraint, particularly when colours in a large painting are sharply complementary and drastically reduced, as in this case, to two colours only, is to create a kind of optical hum, an agitation in the eye. Their sharply defined abutments also present conundrums of visual logic: what is negative, what is positive? What is figure, what is ground? What is form, what is space between forms? What is form, what is shape? Paintings such as *Subterranean* and *Fez* (both 1964), *Shiraz* (1965), *Umbria* and *Tashkent* (both 1966), and *Fountain* (1967) pursue these visual strategies over several years of work. In all of them can be discerned abstract hints and intimations of objects that recur like musical variations on a theme: the splayed formation of a flower or floating lily leaves; shapes of a striped tent and a billowing parachute; waving bands of colour that might be water flows or ribbons; the curved

Gillian Ayres at Beverley Road with Jim Mundy,
1964 (photo: J. S. Lewinski)

Gillian Ayres
Recent paintings

Private view 3-6 Thursday 18 February

Exhibition from 19 February 1965

Mondays-Fridays 10-5.30
Saturdays 10-1

Kasmin Limited
118 New Bond Street
London W1
Telephone : MAY 2821

Send 1964 60 × 60 in.

ABOVE
Isfahan
1964
acrylic on canvas
274.4 × 274.4 cm

ABOVE AND BELOW
Piranha
(Exhibited at Kasmin in 1965 as *Untitled*.
Reproduced here from the front cover of Kasmin catalogue card, 1965)
1964
acrylic on canvas
239 × 152.5 cm

Send
(Reproduced here from the back cover of Kasmin catalogue card, 1965)
1964
acrylic on canvas
152.5 × 152.5 cm

Untitled Drawing No.11
1967
graphite and crayon on paper
54.6 x 75.6 cm

Height
1964
acrylic on canvas
213.4 x 305 cm

Crivelli/Shells/Uccello Hats

LEFT
**Lorenzo the Magnificent
and Niccolo the Gear**
1967
silkscreen print
76.2 x 56 cm

ABOVE AND RIGHT
Crivelli's Room I and **II**
1967
silkscreen prints
76.2 x 56 cm (*Crivelli I*)
56 x 76.2 cm (*Crivelli II*)

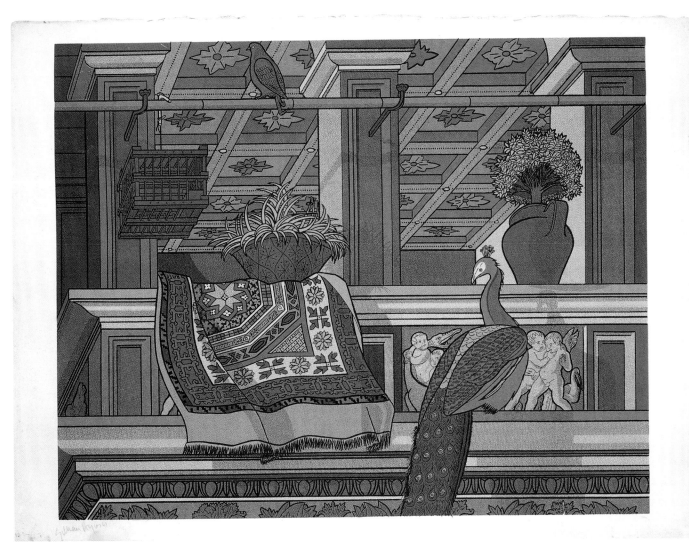

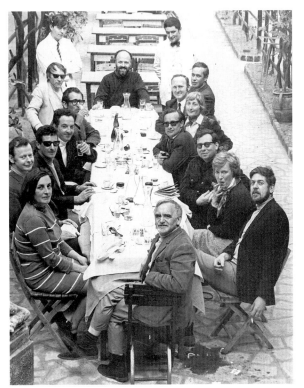

In Venice with Editions Alecto promotional tour to Italy, 1968. Gillian Ayres is second on the right. The party also includes Robyn Denny, Bernard Cohen, Howard Hodgkin, Norbert Lynton, Henry Mundy and William Scott

Subterranean
1964
acrylic on canvas
152.5 x 152.5 cm

Crivelli/Shells/Uccello Hats

Shiraz
1965
acrylic on canvas
152.5 x 152.5 cm

Umbria
1966
acrylic on canvas
152.5 x 152.5 cm

Crivelli/Shells/Uccello Hats

Tashkent
1966
acrylic on canvas
122 x 122 cm

Fountain
1967
acrylic on canvas
213.4 × 152.5 cm

Crivelli/Shells/Uccello Hats

outline of a baroque fountain. Evocative titles are matched by appropriate colour moods, and optically beguiling contrasts of shapes: *Umbria* has sky blue and earth browns; *Tashkent* and *Stamboul* have vibrant ceramic tones and arabesque references to Islamic calligraphy; the graceful lines of *Fountain* recall the forms of the Renaissance object and of the jugs brought to fetch its overflowing water. In an era that excitedly proclaimed its liberation from austerity and embraced diversity, when young artists played no small part in creating the prevailing spirit of an exuberant optimism and creative buoyancy, it is not surprising that these brilliantly eclectic and witty decorations should have been critically and commercially successful. What *is* surprising is that Ayres should have painted them.

Her recent work, represented by three big paintings, looked very much of its time in a major exhibition of the Peter Stuyvesant Foundation Collection at the Tate Gallery in late 1967. The Stuyvesant Collection had been put together over the previous three years; it was, in critical terms, a remarkably successful attempt 'to form a collection representative of its period', and Alan Bowness, a member of the purchasing committee, could justly claim, in his introductory notes to the catalogue, that it had grown 'to encompass . . . the range and eloquence of recent British painting'. Bowness associated Ayres, significantly, with those *Situation* colleagues from whose practice in 1960 her own had been most at odds: '[she] shares [Robyn] Denny's taste for close colour relationships and visual ambiguities within the composition, although her forms are altogether different' (he had described Denny's paintings as 'austere and hieratic'). '[Her] recent experiments with monochromatic paintings', he continued, 'are paralleled by those of Bernard Cohen' (Cohen's own notes described in detail the highly programmatic 'technical processes' he employed in making his paintings).

Ayres responded to the invitation to write about her work with a text that contained a bizarre and dream-like list of things that interested her as a painter:

Often objects of diverse origins seem to me to have something exotic, unfamiliar, although they are basic enough:

Crivelli
Jelly moulds
Mrs Beeton's ice cream and cakes
Finials and crockets
Lichens and seaweeds and cupcoral and urchins
Islamic
Shells
Uccello hats and plumed helmets

I use a linear perspective and equal or almost equal tone which should flatten the painting from edge to edge.

It would be possible, no doubt, in addition to those already traced and described, to detect references in the paintings to aspects of what she describes as these 'exotic, unfamiliar . . . though basic' items: it is part of the game they invite the spectator to play; and, as the list itself suggests, there is a strongly ludic motivation behind these works. As for the final, oddly uncertain and contradictory declaration, it may be granted that the tonal constraints are a visible constant, but it is difficult to discern perspective of any kind in these paintings, even if it is allowed that any shape against another on a flat surface will propose recessive space. The statement as a whole seems strangely arbitrary and dissociated, as if written in a trance.

Indeed, there is something trance-like about Ayres's commitment over the years of the late 1960s to an art that was so uncongenial to her essential impulses as an artist. It is as if, enchanted by the glamour of the time, she found herself brilliantly capable of putting on the style to meet 'what the age demanded': colour, spectacle, beauty, wit, flamboyance, surprise, surface closure and minimal content, untroubled and untroubling. Jeremy Moon, an artist preoccupied, as was Ayres, with the generation of disconcerting images out of deliberative formal procedures, was a friend at this time with whose work she felt sympathetic. A description by the critic Guy Brett of his work in 1962 might have applied as well to Ayres's own two and three years later, and catches the cool critical flavour of the period: '[it is] tight-lipped and demonstrative, the colours clean and flat, the statement on the canvas complete. The

effect on the spectator may be one of energy or tranquillity, but [the artist's] role remains passive' Precisely. Ayres's paintings of this period were coolly formulaic and carefully considered. They were not created, as her earlier works had been, out of a brave and compulsive engagement of body and mind with the medium, an *active* identification with the material properties and processes that might lead to the discovery of an unpredictable and unprecedented image, an image of nature, out of nature, entrapped in a thrilling space at once real and fictive.

In paintings she made in 1968 and 1969 Ayres began to seek a way out of the formal impasse of equal tone, even surface and evenly distributed linear forms, but her methodologies continued to be deliberate and schematically premeditated. *Untitled (Green Pools)* (1968), for example, plays an all-over pointillist dazzle against an approximate grid of pink and yellow dots, creating what is in effect a double optical screen behind which the green pools appear to glow, enclosed by a *via lactea* of clustered pale blue dots. The grid, so far from being the essential compositional frame of modernist abstraction, is actually painted on top of the dizzying constellation of coloured points: it is a reflexive formal joke, the wittier for its occurrence in a painting that evokes the evanescent shimmer of light on water. *Untitled (Scatter)* (1969) is freer in conception, the oddly comic motifs tumbling down the canvas like leaves on a stream. The 'ice cream and cakes, lichen, cup-coral and shells' of the Stuyvesant statement here make a reappearance, perhaps in ironic reference to the ordered distribution across a grid of the more orderly, purely abstract ovals of Larry Poons.

Like the paintings of the previous four or five years, these late-sixties works were sustained by no theory, but they were governed by arbitrary rules and constraints, like playful visual exercises. Ayres, prolific and virtuosic, made many paintings of these kinds, experiments with colour and motif, inviting associations of an artful kind, seeming to seek to do little more than please and entertain. Their ambition was limited more in the direction of Burke's 'beauty' than towards the terrible sublime: 'beauty should not be obscure . . . beauty should be light and delicate' They sought to be enjoyed by the operation of Kantian 'taste': 'the faculty of estimating an object or a mode of representation by means of a delight or aversion *apart from any interest*. The object of such a delight is called *beautiful*.' At the end of the 1960s Ayres awakened from the enchantment of the beautiful.

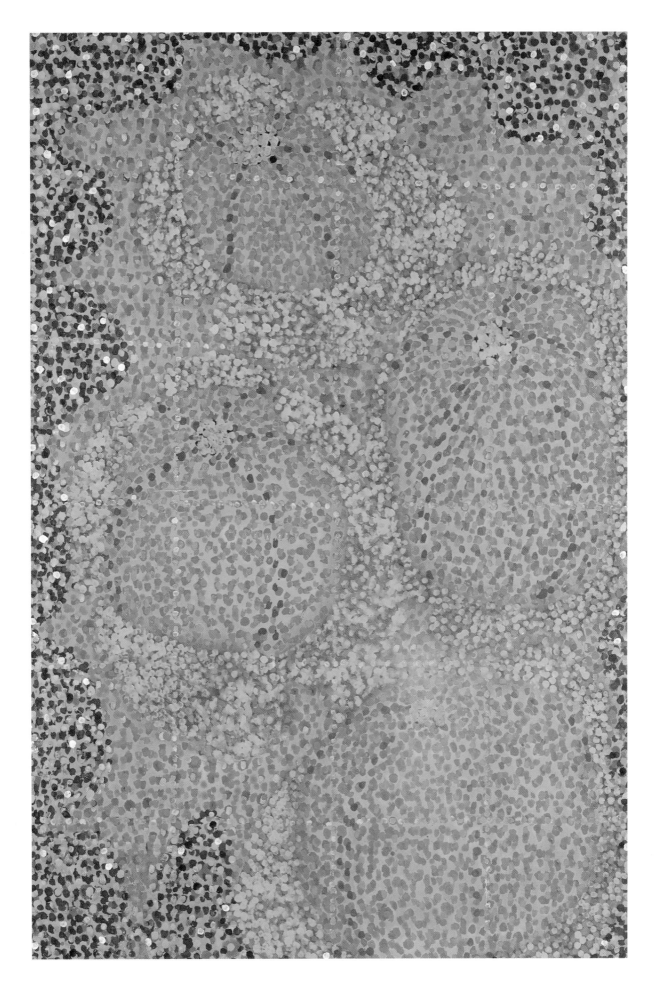

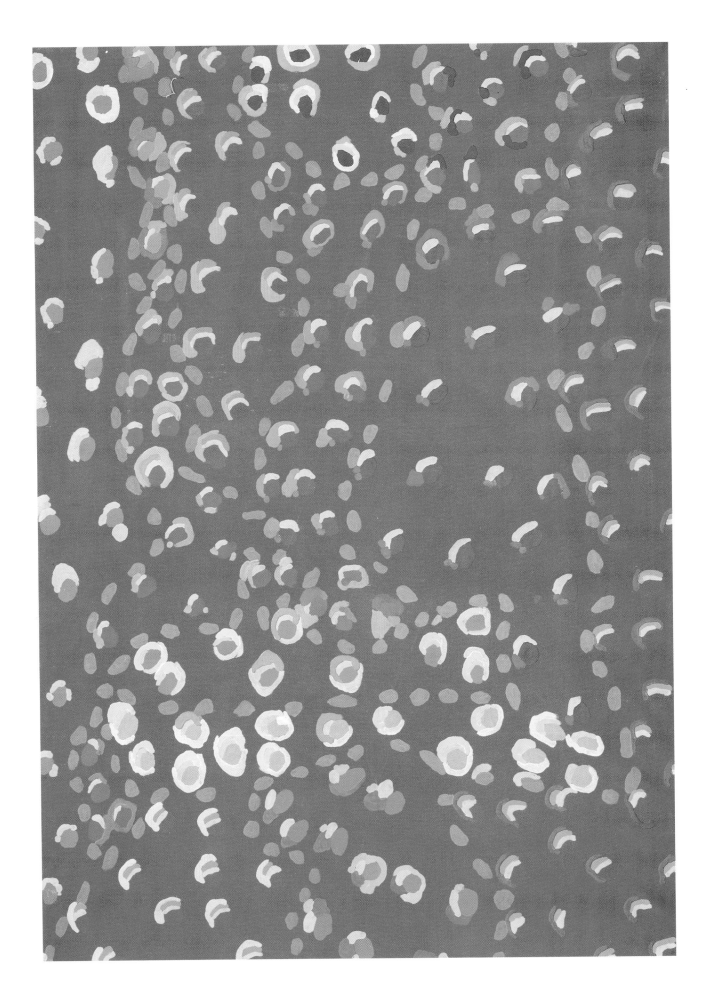

Crivelli/Shells/Uccello Hats

Gillian Ayres in her studio with Sam Mundy,
1969
(photo: J. S. Lewinski)

Untitled (Scatter)
1969
acrylic on canvas
213.4 x 152.5 cm

9

The Questionable Limits of Painting: The 1970s

In 1966, after the birth of her younger son, Sam, Ayres had left Corsham and taken up a post as tutor in painting at St Martin's School of Art in London. She was to teach there until 1978. St Martin's was a remarkable place in the 1960s. It was there, around 1959–60, that Anthony Caro and his followers had initiated what became known as 'new generation sculpture'. This was floor-based, colourful and abstract, utilising such new materials as painted aluminium and plate steel, plastic, fibreglass and polyurethane. Most of those who participated in the famously definitive Whitechapel exhibition, *New Generation: 1965*, were teaching, or had recently taught or been taught in the sculpture department at St Martin's; these included William Tucker, David Annesley, Philip King, Tim Scott and Michael Bolus. And it was there that the even more brilliant generation of conceptualist 'sculptors' was to spring up in the early to mid-sixties, working in direct reaction to the 'object-sculpture' abstract formalism of their teachers. Among those who studied at St Martin's on the revolutionary 'vocational course' in the Sculpture School at this time were Richard Long, Gilbert and George, Bruce McLean, Barry Flanagan, David Bainbridge and John Hilliard. Head of Painting was Frederick Gore, who, though a traditional painter himself, was quietly progressive and permissive of experiment, and among Ayres's colleagues on the staff in the early years were John Latham, Jeremy Moon, Henry Mundy and Jon Thompson. After the comparative quiet of Corsham, these were heady times. Ayres was now teaching at a vital centre of educational and creative ferment in the heart of a London that laid claim to be 'one of the world's three capitals of art'.

Ayres's work in the very late 1960s and early 1970s marks a return to a freer relation to her chosen materials and their use. She continued to use acrylic paint but its application was less even, more spontaneous and unpremeditated. Paintings such as *Green Pools* and *Scatter* register a lively directness and variation of local attack based on a general pictorial strategy: the over-all approach is determined, but the detail extemporised, the forms and distribution of motifs – dots or lozenges – a matter of quick impulse and repetitive action in the arena of the canvas. The modus of their making signalled a reassertion of what Tim Hilton, writing sometime later of a 1969 dot painting of this kind, nicely described as Ayres's 'general preference for experience over design'. 'Design' here might neatly refer to both predetermined intention and compositional device. Events and actions accompanied by reflection may be said to constitute 'experience': a definition that precisely characterises Ayres's working procedures on either side of the 'digression' of the mid- to late sixties.

By 1971 Ayres was making paintings so large and so free of 'design' that they carried her beyond the determinations of any kind of pre-ordained compositional closure. They were, in terms of technique, a return to tachism, being made of innumerable strokes or blots of colour applied with an automatic freedom over the canvas and serving no function beyond the establishment of a field of colour-texture, which at a certain moment in the process coheres into expressive purpose. William Turnbull's 1957 essay 'Nature into Art' describes this kind of painting process perfectly: 'by projection or extension a dialogue takes place between the artist and his material; and like a conversation it stops when one of the parties involved has nothing more to say to the other. It is impossible to pre-plan – it is a live performance.' *Untitled (Purples)* (1971) was one of three paintings selected that year by Norbert Lynton for *Large Paintings: Three Painters* at the Hayward Gallery. (The other artists were John Golding and Alan Gouk.) This painting and *Untitled (Lily Pond)* (c.1971–2) were among a number that Ayres painted at this time on the floor, or in the case of those too big for the studio rooms in the house (some were up to thirty feet long) on the ground in the garden at Beverley Road. It may be that certain effects in *Lily Pond* are in fact the result of the work's exposure to rain during the period of its execution, effects welcomed by Ayres into the 'live performance' as a direct register of the natural phenomena that the painting itself was imitating and celebrating. When she unrolled them in Kasmin's they stretched the entire length of the gallery, and leaves, twigs and earwigs fell out on to the floor. Kasmin was in process of moving to a smaller space; it would be impossible for him to show such work. He saw also that they were probably un-saleable. 'What am I meant to do with them?' he asked. Ayres replied: 'You're a dealer; I'm a painter. I must get on with what I want to do.' Once again, for several years she was without a gallery.

In making these extraordinary works Ayres was certainly aware of Monet's great late

Untitled (Lily Pond)
c.1971–2
acrylic on canvas
213.4 x 820 cm (approx)
(All details. Photographs
taken by the author at
Tall Trees, June 2000)

The Questionable Limits of Painting

Nymphéas, which she had studied at the Orangerie in Paris; she had also long admired and studied the version in the National Gallery. There had been a great revival of interest in Monet since the late 1950s, when the late paintings especially had been re-evaluated in the light of the vogue for painting on an 'environmental' scale and the explosion of interest in texture and 'all-over' abstract surface values that had come in with 'informal' and 'action' painting. (Major exhibitions of Monet, in London and in the USA in 1957, responded to this revived interest, and intensified it, and were highly appreciated by artists.) It was not that these new paintings of Ayres's had an external 'subject' in the way of the Monets; it was not that she shared to any degree Monet's primary interest, the translation of visual sensation, with all its affective complexity, into the objective reality of paint on canvas that captures what the eye sees in nature and re-creates it for the viewer. As in her work of the late 1950s and early 1960s, she was once more engaged with nature *as being herself part of it*, and committed to painting as having a reality parallel to nature, as a sign for it, not an imitation of it. But what she shared with Monet, apart from scale and surface complexity, was the conviction that it is the hand and eye of the artist that makes the work what it is, and not any criterion of likeness to nature, or exactitude of response to external factors: *painting is invention*. Douglas Cooper, in his introduction to the 1957 exhibition at the Tate, which she had read, quoted the old master of Giverny on the significance or otherwise of painting from memory or from nature: 'Le résultat est tout'. Nature is nature and art is art.

Inevitably, in looking like themselves paintings resemble other things, including other works of art; and these works of Ayres's, having particular colours, forms and textures, will bring to mind natural objects, their mood and movement, and the effects of light on them. In *Untitled (Purples)* there is a strong resemblance to certain works of Sam Francis, an artist that Ayres had, incidentally, long admired. This is to be remarked at first in the predominant purple, and the relation to it of accents of strong magenta pink, green, blue and orange, and then in the eye-beguiling lateral spread over a huge surface of what Patrick Heron, writing of Francis, described as 'archipelagos of separated touches' and 'a luminosity of "colour stain" and "colour skin" configurations'. If the over-all effect is of a dapple of purple blots, a detail will disclose emphatic variations of weight and translucency, from the palest stain to the darkest opacity, and it is this variegation that imparts to the whole its unceasing flicker. At extreme right there rises, in an area of untouched canvas, a column, like bubbles in air or water, of predominantly pink blots. There is something at once arbitrary and inevitable, something utterly *natural*, about the shifting relations of form and colour between these two ragged-edged constellations of purple and pink: they seem at once to attract and repel each other, like the motions of a current and a tide, or of molecules in the process of differentiation.

Untitled (Lily Pond) is an enormous painting of breathtaking refinement and beauty; neither its scale nor its manner, however, are calculated to evoke the sublime. Indeed, paradoxically, its scale works to limit its impact on the viewer to that of a natural event commensurate with its own dimensions. In this it is truly akin to Monet's very largest water-lily paintings, the primary purpose of which is to match their subject in scale as well as in their complexity of visual effect, their dynamics of light and colour. To put it simply: its variegations of colour and lucency work upon the eye of the viewer with a capacity to delight that is directly analogous to that which might be experienced by a pond of just such a size. To walk its length – it is twenty-seven feet long and ten feet high – is to be entranced directly: by the changing response of the acrylic surface to the fall of light upon its surface, now iridescent, now matt; by its apparent imitation of light and shadow on and in water; by the magical suggestion of natural objects, now a leaf on the surface, now pebbles shimmering in the refracting depths. No small part of the pleasure the painting gives is in its subtle colour configurations: green and yellow dabs, the rhythmically repeated marks of a particular brush; *taches* of turquoise, bright cobalt and copper-sulphate blue; the all-over transparency of an aqueous mauve. Seen in this way, the scale of the painting may be regarded as far from perverse; rather, as necessary to its purposes. Ayres is adamant in response to the charge of self-indulgence: 'Yes, I did what I *wanted* to do. You've got to go for your own truth. You hope to give something, but only by finding something, and being honest.'

Untitled pastel and crayon drawings of 1972 (those illustrated on p.108 are two of many similar made at this time) have the aleatory playfulness of the larger works. Unlike the drawings of the mid-sixties they are neither a prelude to nor 'studies towards' works in other media. Typical of Ayres's works on paper (including prints) from this time on, they are clearly independent of the paintings, exploiting as they do the nature of the media in which they are executed; they explore the themes of the moment, but as small variations and bagatelles. The tonal relations of the scattered pastel and crayon dabs to each other and to the brown paper ground are skilfully managed to deny, in appearance, the actual opacity of the medium. In *Pinks with blue border* (1973), the colour touches cover the support from edge to edge in a water-colour version of the all-over abstract acrylics that she was painting during this year.

Untitled (Cerise) (1972), which is among a number of very large paintings made at the time (it is seven feet by twenty), initiated a lengthy series of works painted on the vertical, the canvases pinned to the wall of the attic at Beverley Road, which stretched the length of the house. The attack in these paintings, as in *Cerise*, was with brushes generously loaded with thick but viscous liquid acrylic. Great brush-loads were laid into the top of the canvas and swept down, to end in runs and dribbles. Their effects are, however, far from those of large-scale colour-field painting exemplified by that of Barnett Newman, the formal success of whose bigger paintings must surely have encouraged Ayres to push her own paintings to their ultimate dimensions. She had seen Newman's work in the 1959 Tate show and continued to admire it; she was familiar with his great *Uriel* (1955), now in the Museum Folkwang, Essen, which was featured in the February 1970 issue of *Studio International* largely devoted to a celebration of Newman. It was from Alan Power, who owned it at that time, that she had heard Newman's remark about the painting, which was eight feet by almost eighteen: 'I wanted to see how far the blue could carry'. *Untitled (Cerise)* certainly sets out to carry the pink of the title as far as possible: it presents a great light-absorbing wall of it. In *Uriel*, the fourteen-foot blue field is, typically, a monotone radiance: Barbara Reise, in *Studio International*, described it as having 'a thin, opaque, very shiny surface that reflects as well as materialises light' and as 'glistening outwards like the Angel of Light' The pink of Ayres's wall is not seeking the transcendent immateriality of coloured light so much as revelling in its own brute physical actuality. Its thickly viscous brushed and poured surface is never pure of other colour touches, and at intervals it is crudely brush-splashed with red, brown and yellow. It is an obdurate object.

There were many more paintings made in this manner, in various dimensions. One such, *Untitled* (1973–4), selected for the second Hayward Annual, *British Painting '74*, was photographed in black and white for the catalogue, unstretched, in the studio; measuring ten feet by

Rolled up canvases, top floor at Beverley Road, mid-1970s

RIGHT
Untitled
1973–4
acrylic on canvas
305 × 457.5 cm

Untitled
1972
pastel and crayon on paper
20.5 × 37 cm

Untitled
1972
pastel on paper
24 × 37 cm

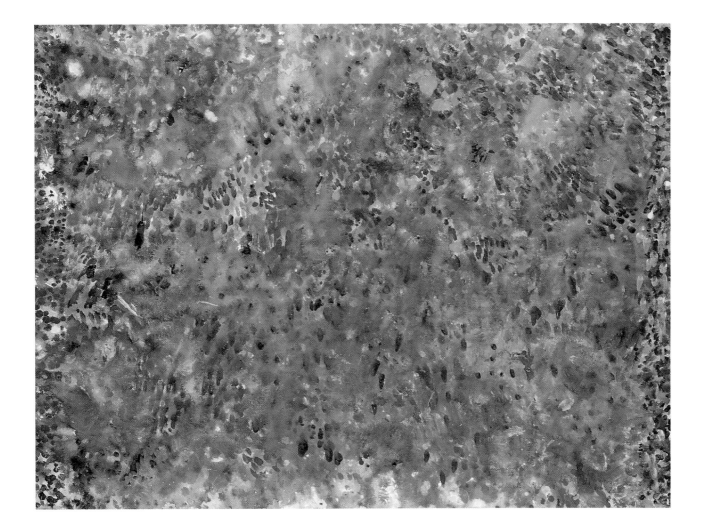

Pinks with blue border
1973
watercolour on paper
56 x 76.2 cm

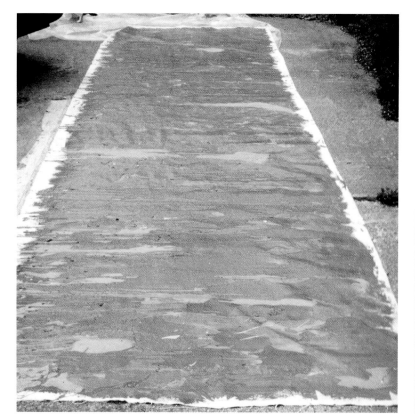

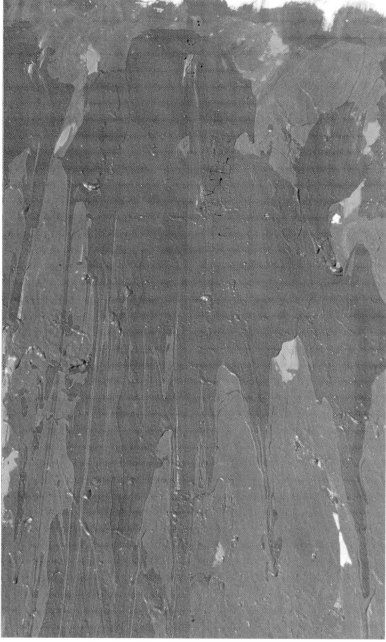

ABOVE AND RIGHT
Untitled (Cerise)
1972
acrylic on canvas
(details)
213.4 x 610 cm
(Photographs taken
by the author at
Tall Trees, June 2000)

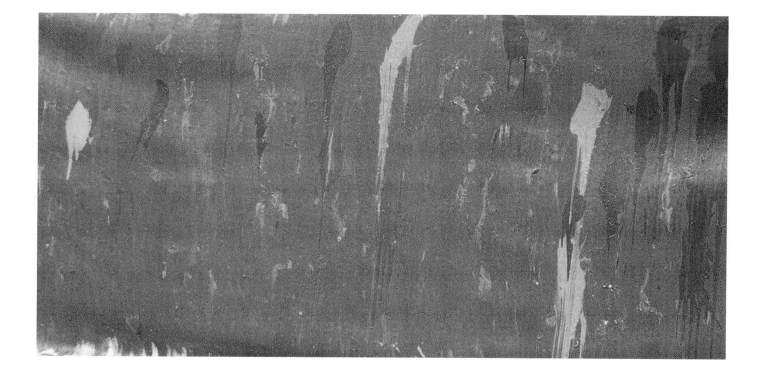

fifteen, the canvas totally occupies the wall to which it is pinned: it is a great curtain of thick pure acrylic, roughly brushed and thickly applied, almost glutinous, gleaming in a filtered side-light from the window to its left. It hangs like a stained and oily pelt. It stops the eye in its tracks; it is an opaque curtain not a window; it is an object not a picture. Many paintings like this from the 1970s were destroyed or lost: unwieldy, uncompromising, absolutely un-commercial, they were rolled up and piled on to the studio floor. Rising to a level that made working difficult, they would be pitched out and thrown away. Some (including *Lily Pond* and *Cerise*) have survived unseen since they were painted. There was something heroically perverse, or perversely heroic, about this effort: Ayres was simply and bravely committed to doing 'what she wanted to do – going for her own truth'. At a time when painting, especially painterly abstraction, was deeply out of fashion, and a great deal of contemporary artistic practice was conceptual, reflexively critical and propositional, she developed a manner that was profoundly abstract and material, defying formal analysis and referential readings, and persisted in it for several years, making paintings of the most basic and obdurate objectivity.

Ayres's titles are always revealing in one way or another. *Weddell* (*c*.1973–4) was one of several painted between this time and 1976 whose arbitrary titles were found by the simple procedure of looking into a world atlas. Where the place-name titles of the late sixties (*Isfahan*, *Stamboul*, *Tashkent*, *Umbria*, etc.) were selected for their fancifully evocative or exotic associations, these were deliberately adopted from remote locations, bleak seas and barren deserts, places cold and empty, and without the distinctive human character of settled and civilised places: *Baffin*, *Gobi*, *Biscay*, *Rockall*, *Bering*. Such titles serve the simple purpose of identifying the painting while avoiding impertinent associations or irrelevant allusions. During these years Ayres, who had separated from Harry Mundy in 1971 and divorced in 1976, spent long summer holidays, usually alone with the two boys, on the island of Luing in the Western Isles, below Mull of Kintyre and beyond Seal towards Jura. Endless hours were spent in a small boat belonging to a local fisherman, in great expanses of sea, formless infinitudes of space and light: 'you see the world differently if you look from a small boat back at an island' Something of that oceanic emptiness found its way into the paintings of the mid-seventies, and the geographic titles she found for them reflected that experience.

Yellow Painting (1976), *Red Painting* (1975–6), *Untitled (Eau de Nil)* (1974–5), *Winter Work* (1975–6) and *Winter's Traces* (*c*.1976) are typical of the works of this period. Ayres exhibited paintings of this style at the William Darby Gallery in New Bond Street in early 1976 (for Darby this show was a gallant excursion outside his more conventional territory), at a British Council sponsored exhibition in Portugal later in the same year, and at the Women's Interart Center in New York in November. These paintings represent an ultimate reductiveness in form and content, being nothing more, or less, than pure paint speaking for itself as substance and colour unified, *material* colour. They are without the transcendental or the metaphysical aspirations of idealist abstraction, and they lack both the mythopoeic ambitions of American abstraction and the existential freight of *art informel*. They are neither expressionist nor coolly minimal. Above all they are not premeditated 'modernist' demonstrations of the ultimate evolutionary climax of painting, of its absolute contradistinction from any other medium. They are far from being declarations of the end of painting. Their superb emptiness and austere grandeur are, rather, outcomes of a solitary and courageous creative effort, over several years, to sound painting to its depths, to define objectively its basic expressive powers, to rediscover its potentialities as a medium while eliminating every redundancy of reference and every device of traditional order and form.

Ayres persisted in her fundamental belief that painting was a viable and valid medium of communication: her work in the early to mid-1970s set out to test this belief to destruction. It was an extreme reaction as much to her own lightly allusive and decorative style of the late 1960s as to the current mood against painting altogether. The true potential of painting was philosophical and ecstatic: 'Painting', she wrote in a typically idiosyncratic 'statement (text)' for the catalogue to the exhibition at Galeria Alvarez, Oporto, Portugal, in 1976, 'is a visual, two dimensional Art medium and language. Not similar at all to a literary language, but at the same time is there to communicate and express our sublime state, our luminous explosion

Red Painting
1975–6
acrylic on canvas
244 × 152.5 cm

Untitled (Eau de Nil)

1974–5
acrylic on canvas
152.5 x 183 cm

The Questionable Limits of Painting

Winter Work
1975–6
acrylic on canvas
152.5 x 213.4 cm

in space. Through colour can be created a saturated vision of human scale and sense of experience of place.' It must, however, define its boundaries. In a slightly expanded typescript in 1978 she elaborated, with a particular emphasis on *material* and *colour* as its irreducible elements: 'The wordless, non-literary, two dimensional and marvellously silent medium of paint and pigment, colour which is used to make line, shape, intensity, weight, tone, structure, composition, content, area with materials chosen, are the questionable limits of painting.' Ayres wrote, in a kind of shorthand, in terms that referred back to her reading of Kant, of 'an actual sublime experience from form' (in art) that was a response to the 'shock' experienced in the face of 'nature's lack of form'. Her recent painting had derived from repeated experience of that 'shock', and from the desire to find form in painting that transcended it, without mimesis, without direct reference, without easy evocations of the natural. Such form was found in the painting-as-object, differentiated from other objects in the world, rather than in the internal relations of 'pictorial' elements of colour, texture and shape. The image carried by the object in its disposition of paint across the surface was precisely *of* nature's 'lack of form'.

Towards the end of 1976 Ayres travelled to New York to attend the opening of her show at the Women's Interart Center, a feminist gallery in a warehouse on the waterfront. Her paintings, rolled up like carpets, had been shipped earlier but their arrival in New York was delayed. Ayres used the extra time to see as much of New York and its art as possible. For one memorable day she took off with her son Sammy to Washington. At the Hirshhorn Museum she came across, unexpectedly, a retrospective of Hans Hofmann organised by the painter Walter Darby Bannard. It was a revelation. The work of Hofmann, a great and original European painter, whose status as mentor to successive generations of New York artists for over thirty years was legendary, was virtually unknown in this country. Encountering it for the first time, broadly selected to demonstrate its depth and diversity, Ayres was overwhelmed above all by Hofmann's colour, and by the sheer vitality and variety of his attack.

Seeing Hofmann's work in strength in Washington in November 1976 had the most profound effect upon Ayres. It brought a renewed confidence in her powers and released new imaginative energies. She had taken painting out into the uncharted waters of a sublimely empty, formless and mute monochrome; Hofmann's work had an exuberance and a formal inventiveness that suggested a direction back to a more direct and celebratory engagement with the diverse and beautiful forms and colours on the shores of the everyday world. It was an influence that was immediately effective; on her return to London Ayres at once reverted to painting in oil, and a new colour dynamic of chromatic variegation entered her work.

RIGHT
Winter's Traces
c.1976
acrylic on canvas
244 x 213.4 cm

10

A Complete Combination of Heart and Mind: To Wales, 1977–1983

Mons Graupius
1979–80
oil on canvas
244 × 274.4 cm

The late 1970s was a period of extraordinary eventfulness and great change for Gillian Ayres, in her life as in her art. In 1976 she was made Senior Lecturer at St Martin's and in 1978 she became the first woman in this country to be appointed as Head of Painting, the post she held at Winchester School of Art until she finally left teaching in 1981. Although Ayres possessed an aptitude for administration she had little taste for it, and she certainly had no personal or professional ambition in art education: painting always came first in the order of things. But she loved teaching and, as always since Corsham days, she greatly enjoyed contact with student artists. For staff careerists with a sharp eye to the political weather, and the unimaginative bureaucrats of educational administration who had no real care for art, she had little but contempt. Ayres took the post at Winchester with a confidence bred of incautious enthusiasm – 'Oh I was wildly enthusiastic!' – knowing that the school was scheduled for likely closure. She led the fight for its survival, and won it. Her uncompromising integrity as an artist had long been widely recognised by fellow professionals; to this was now added their respect for her doughty professionalism and political skill. Painting at Winchester thrived under her leadership, and under the benign and encouraging influence of visiting artists who were themselves committed primarily to abstract painting, among them the best of her contemporaries, Patrick Heron, John Hoyland, John McLean and Basil Beattie. But Ayres felt increasingly ill at ease within the structures of regulation that are intrinsic to institutional systems. In 1981, having done much to establish a new reputation for the department and the school, she resigned. There were immediate offers of posts elsewhere, but she had determined never to work in art schools again.

Ayres was prepared, as always, to live with the consequences of her actions, however unpredictable. With no certainty of regular income, she realised that she would have to sell the house in Barnes, and with a close companion, the Welsh painter Gareth Williams, she began to look for somewhere to live and work in Wales. At first she had thought of the Scottish islands where she had spent long periods of creative reflection and spiritual repair in the past ten years. 'I did actually think, if you're going to get out of the city, go somewhere very wild, not like the Home Counties.' But old affections for Wales had survived from the walking and climbing days of the 1950s, and Williams, who had also resigned from Winchester, felt attracted back to his native land. In November 1981 they moved into the handsome rambling eighteenth-century rectory at Llaniestyn on the Lleyn Peninsula in the extreme north-west of Wales. Ayres had estimated that with what remained from the sale of Beverley Road, and with what might be grown and tended on the land, she could survive for perhaps three years before needing to do anything but paint and maintain an idyllic self-sufficiency.

The summer of 1981 was shadowed by another event, of incalculable significance to her thinking and feeling at this time. Shortly after finishing at Winchester Ayres was taken seriously ill with pancreatitis. Rushed into hospital she went into a coma for four days, and was near to death. Slowly recovering through the autumn and winter, removed from the London she loved to a remote place in the steep hills of North Wales, Ayres experienced things with a rare intensity of complicated emotion: she felt jubilant, anxious, liberated and apprehensive by turn. 'Then you wake up, you're not only alive but you don't have to go back to work, and, my God! I can just paint every day. And so one got better. I mean, we should feel like this every day, all of us, we should have these feelings – *I'm actually alive at this moment!* – but certainly at that moment, for me, it was like that.'

During this time of multiple crisis, resigning from teaching, a sudden and desperate illness and a slow recovery, the removal to remote North Wales, Ayres was also preparing for a major solo exhibition, at the Oxford Museum of Modern Art in October 1981, where, of thirty-one paintings shown (four dated from the late 1950s and early 1960s), no fewer than twenty-six were completed between 1980 and 1981. It was a period of extraordinary creative productivity, and of a continuing passage through a crucial transformation in the manner and style of her art. A number of paintings shown at Oxford announced what was to persist and develop as the distinctive and wonderfully flexible style that is now immediately recognisable as uniquely her own. But this is to anticipate. To trace her progress to that point it is necessary to go back to early 1977, when, directly in response to her thrilling discovery of Hofmann, she had come back

Gillian Ayres at Winchester School of Art, 1980
(photo: John Miles)

from New York determined to return to oil paint as the medium that might give her a vitality and a subtlety of touch and colour, especially in local emphasis, that her own use of acrylic had seemed to deny her.

Bellona (1976–8) and *Hinba* (1977–8) are among the first completed oil paintings in what was discernibly a new manner. *Bellona* was actually started in acrylic before the New York trip, and completed in oil after it. There is in these new paintings a richness of colour and diversity of incident that immediately forces the attention. It is not that acrylic paintings such as *Weddell*, *Yellow Painting* and *Winter's Traces* lack surface interest so much as that the interest they offer is different in kind. They have a mute absolute factuality, a thick, snagged, inexpressive object-ness: they are what they are and nothing more, or less. We look at them as we might at a rock face, a weathered wall or a waterfall. *Hinba* and *Bellona* present, instead, a dynamic event to the eye; a picture of something *happening*, something that in the next imagined moment might be different. As the eye moves across and from top to bottom of the mid-1970s acrylic paintings (and that is how they tend to direct the attention), it is stopped at the canvas edges: the painting is registered as an inert object in real space; its field conterminous with its frontal façade, it denies fantasy. The invitation of *Hinba* or *Bellona* is to the imaginative invention of a happening in time *inside* the space of the painting, and its spatial complexities refer to, and remind us of, those in nature. The eye moves in every direction, finds no point of rest. These paintings are not simply pictorial, however, and their titles (*Hinba* is the archaic name of a small Scottish holy isle, *Bellona* is a Roman goddess) are by no means to be taken as clues to depiction or theme. They are purely abstract in the sense that they represent no recognisable forms or actual spaces; those we descry in the paintings are of our own making, and intrinsic to the experience the paintings offer the eye.

In each case it is an enthrallingly specific experience. As with other paintings of this period and style, such as *Orlando Furioso* (1977–9), *Pala d'Oro* (1977–9), *Achnabreck* (1978–9), and *Ultima Thule* (1978–80), some large part of the pleasure they give has to do with a characteristic physical richness of surface, with encrusted layers of colour strokes, dashes and stains, twists and resists. Their complexity of effect is a function of this material presence manifest in the thickness of the painting, with its build-up of diverse touch and texture, in its complications of colour relation, in the furious drama of colour-forms caught up in ecstasies of paint laid on paint, of mark and matter fused. Oil paint made all this possible, allowing colours to merge and mingle subtly, or to maintain a chromatic purity as the touch and movement of brush, hand and fingers determined. A remarkable feature of these paintings is the play between a complex all-over tonality of effect and the startling accents of pure sharp colour that sing out from every point on the surface. This contrast of general shimmer with local chromatic touch recalls the late Monet *Nymphéas* and Giverny garden paintings in both technique and mood, although their surface texture, of brilliant and reflective complex impasto, is quite different from the chalky matt finish of Monet. There is, of course, a more profound difference to be remarked: Monet's paintings seek a kind of equivalence in colour and form, in an essentially optical evocation of things seen and remembered; Ayres invents visual-tactile worlds whose features are summoned by automatic gesture, and where the marks thus made have no specifically referential purpose. Theirs is not the natural space of pond or garden, but a space for the play of the eye, the mind and the imagination, the space of the painting itself, an abstract *metaphor* for the space of the world.

As the dating of these works implies, their thick encrustations of paint were achieved over long periods of attention and action, through prolonged procedures of accretion and accumulation. The return to oil paint was, then, to a usage quite different to that of her practice in the late 1950s and early 1960s, when it was thinned and puddled, deployed in arbitrary combination with housepaint, and applied with a speed and unpredictable im-precision of stain and flow that gave large paintings something of the improvisatory and provisional feel of watercolours. Where before Ayres had resorted to impulsive and un-premeditated actions, now she adopted a *modus operandi* that was deeply considered, painstaking and slow, even if the individual acts of application continued to be instinctively gestural. Its outcome was a new kind of pictorial dynamic, of complex painterly *passages*, with

RIGHT
Bellona
1976–8
acrylic and oil on canvas
152.5 x 244 cm

Hinba
1977–8
oil on canvas
213.4 x 305 cm

RIGHT
Orlando Furioso
1977–9
oil on canvas
233 x 233 cm

A Complete Combination of Heart and Mind

A Complete Combination of Heart and Mind 125

Pala d'Oro
1977–9
oil on canvas
244 x 264 cm

A Complete Combination of Heart and Mind

Achnabreck
1978–9
oil on canvas
244 × 152.5 cm

Ultima Thule
1978–80
oil on canvas
366 x 228 cm

A Complete Combination of Heart and Mind

no islands of form, no floating blimps or roundels breaking away to spin in empty space, no points of focus, no figure against ground, but rather a structural weave and overlay, of stroke over stroke, colour against colour, light against dark, dark against flashes of back-light.

The colour-forms within the ambiguous pictorial space of these paintings are at one with painted marks; and it is proper to call them 'forms' rather than 'colour-shapes' for they are bodied of the paint itself, visible and touchable as such, and the more emphatically so as this style develops, in paintings such as *Mons Graupius* (1979–80) and *Ultima Thule*. It is another of the sensuous pleasures these paintings offer that as the viewer moves in relation to them the interrelation of raised relief and subtle declivity changes constantly and unpredictably. 'In these surfaces', Hilton remarked in the 1981 Oxford catalogue, 'the light finds its way in and out of the small valleys and crags of the impasto.' And to the paradox of realised space, here deep, here shallow, in paintings so thickly material, there is added the mystery of their light, emphasised in many of them – *Angelus ad Pastores* (1980–1), *Hinba*, *Pala d'Oro*, *Orlando Furioso* – by the use of metallic gold and silver paint, and a nacreous catch-the-light finish.

In these years Ayres was thinking deeply about the nature and history of oil painting, and looking with the most avid concentration at the work of some of its major exponents. The revelatory surprise of Hofmann, and her subsequent – and consequent – desire to work in the major medium of classical European painting, demanded of her an engagement with its greatest manifestations. 'Titian, Rubens and Matisse are the greatest painters; unashamedly, of sheer beauty' she declared in a talk given in 1980 at Winchester, 'but they also used the medium to the fullest in every sense . . . [with] a complete combination of heart and mind.' The rich visual sonorities and jewel-like detail of the paintings of the late seventies without doubt were affected in their making by an ever-deepening subtle consciousness of Venetian painting, especially that of Titian, which she had long studied in the National Gallery. In early 1979 Ayres made what was to prove a crucially important visit to Venice, staying with a group of Winchester students in a small palazzo on the Grand Canal opposite the Ca' d'Oro. While there she looked with unabashed wonder at the great Pala d'Oro in St Mark's and at the Tintorettos in the Scuola Grande di San Rocco. Above all she closely studied Titian's astounding *Assumption* in the church of the Frari. It is an image to which her thought has often returned, one of the rare works by another artist to which Ayres has paid the homage of paraphrase, not once but twice, in *Fairest of Stars* (1984/5) and *Peacockis Papingais and Cranus* (1984).

Behind her definition of Titian's greatness in the Winchester talk was Ayres's recognition of his essential significance for precisely the kind of painting she was at that very moment developing: 'Titian raised colour to the level that drawing had held, and liberated painting from filling up line with colour, which before him, in the Renaissance, was translated from classical sculpture his forms could not be translated into any other medium. He thought wholly in terms of paint.' We see in this that painters speak to each other over centuries, and that the creative preoccupations and expressive procedures of one historical moment may be surprisingly close to those of another far removed. Those 'colour-forms at one with the painted marks' in her painting at this time (around 1980) remind us of Bernard Berenson's analysis of Titian's assimilation of drawing into the act of painting itself, in a passage with which Ayres was clearly familiar: 'Titian attains [the greater effect of reality] by the almost total suppression of outlines, by the harmonising of his colours, and by the largeness and vigour of his brush-work.' Ayres's heightened awareness of Venetian painting extended beyond Titian to take account of the spectacular tragic theatre of Tintoretto and to the enjoyment of what Berenson characterised as the 'ceremony and splendour . . . the frank and joyous worldliness' of Veronese. For her own purposes in the future she would take from Tintoretto the drama of contrasts of light and dark, from Veronese the exuberant compositional device of the disguised, or broken, arabesque.

In Ayres's paintings of the late seventies there can be traced, then, a progressive move-ment, in manner and style, towards the greater clarity of light and colour, and the distinct definition of painterly forms that characterise her later style. The components of that development are inseparable, for the increasingly distinct colour-forms that can be seen emerging from the plastic matrix of thickly applied paint in works begun immediately after

Angelus and Pastores
1980–1
oil on board
76.2 x 61 cm

A Complete Combination of Heart and Mind

Cairnbaan
1979–81
oil on canvas
206 x 213.4 cm

Ayres's resumption of oil painting in 1977, and often not completed until 1979, clearly anticipate the more distinctly recognisable signs and shapes in high colour that feature in the more thinly painted works that were begun in 1979. There is an overlap, in the period between 1979 and 1981, when certain paintings, highly successful in themselves, have a transitional character, looking back to the more undifferentiated all-over images of the new-style oils of 1977 onwards, and forward to the chromatic sharpness and formal definition of the paintings of the 1980s and 1990s. *Mons Graupius* is one such work, with its suggestion of a brilliant yellow back-light, its embedded curved forms and foregrounded disc and half-circle shapes. In *Cairnbaarn* and *Flow Not so Fast ye Fountains* (both 1979–81), the firework- or fountain-like spray and scatter of flakes and lines of pure colour, and the rhymes and repetitions of distinct semicircular shapes together propose a rhythmic reading of the images that is quite new. The pace and complexity of this transition, during which the paintings were worked and reworked over many months (most of the paintings of this period have dates staggered over two years) suggests that Ayres's progress to what Hilton described in 1983 as 'the seemingly effortless creation' of the paintings made in the first two years in Wales was one of prolonged and intensive creative discovery and renewal.

An impressive exhibition of the early, thickly painted oils (including *Hinba* and *Bellona*) at Kettle's Yard in Cambridge in late 1978, followed by a show in 1979 at the Knoedler Gallery, recently opened by Kasmin in Cork Street, and representation in John Hoyland's spectacular selection of British abstractionists for the Hayward Annual of 1980 had registered critical recognition for her new work, especially from fellow painters. The Oxford MOMA exhibition, which toured to Rochdale and Birmingham, was followed, at the end of 1983, by an Arts Council exhibition at the Serpentine Gallery in London, which also toured to four other venues. These exhibitions now established Ayres's presence on the wider scene, as an artist whose appeal was to a broader public than she had ever known before. She had won through to an expressive style which seemed capable of the most extraordinary diversity of performance, could surprise and delight, and which engaged in the most direct and masterly way with nature and with art. In the paintings made at the Rectory in Llaniestyn in the early 1980s, Ayres had arrived at a freedom of creative invention that combined the painterly with the graphic, embedding drawing in the matter of paint itself, and admitting the play of recognisable motifs into the picture without compromising its essential abstractness.

Ayres had made a great many works on paper during the 1970s, especially at times, such as those spent on Luing, when it was not possible to paint on canvas, but they were never exhibited. At Oxford, however, she showed a number of drawings, executed in 1979 and 1980, in which she experimented with playful relations of linear forms and painted shapes contained within the frame of the sheet. In some this pictorial containment is further emphasised by framing devices around the edges of the drawing. (These anticipate similar devices in many later paintings, being seen first at the top edge of *Ariadne on Naxos* in 1979–81, *Anthony and Cleopatra* in 1982 and *Papagena* in 1983.) It is immediately evident that these works were created at great speed, in contrast to the often protracted working on the oil paintings during this period. The quick invention of free drawing often reveals the directions of creative thought, prefiguring later, more considered, realisations. In this case we can clearly discern a move towards the confined pictorial dynamic and complicated interplay of painterly motifs that characterise 'the Welsh style' of the early eighties, in which was perfected the singular visual music of forms and colours that has persisted with endless variations to the present.

RIGHT
Flow Not so Fast ye Fountains
1979–81
oil on canvas
228 x 114 cm

A Complete Combination of Heart and Mind

Untitled drawings 1979–80
watercolour on paper
above, right and opposite right
approx 63 x 51 cm
opposite left approx 51 x 63 cm

A Complete Combination of Heart and Mind

11

The Paintings That You Want to See: The Late Style

Lume del Sol
1986–7
oil on canvas
112 x 112 cm

In the tangle of predetermination, desire, ambition, inspiration, intention and external circumstance, it is impossible to determine what it is that primarily shapes the direction of artistic action in the creative moment. Certainly the move to Llaniestyn appears to have released imaginative energies that finally enabled Ayres to consolidate a distinctive style with an exuberance of invention and mastery of means that seems to have been nothing less than the realisation of a destiny. It is proper here to recall the extraordinary dedication with which she had from the very beginnings of her career followed her own instincts, regardless of critical opinion (though not, at any point, without critical support) or personal circumstance. This was first evident in her full-blooded and highly individual adaptations of tachism and informal painting in the mid- to late-1950s. The deviation, in the 1960s, from her most characteristic commitment – to modes of freely expressive painterly abstraction – was remarkable for its diverse experiments with decorative composition on a large scale, a practice in itself which no doubt sharpened her feeling for the proliferating decorative organisation that underpins the surface image of her paintings in the 1980s and 1990s. This was followed by a prolonged solitary struggle, extreme and courageous, with the intractable problem of painting without any image, without pictorial structure of any kind. After her return to oil painting after 1976 Ayres moved piecemeal but progressively from the thickly textured chaotic sonorities of the late-1970s paintings to the chromatic richness and melodic brilliance of the 'Welsh' paintings in the early 1980s. In this period she finally found a style that was capable of the expression of a new-found joy and freedom of spirit, that was complex without being obscure, playful and profound, allusive and poetic but utterly abstract.

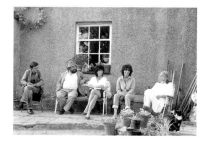

Gillian Ayres with friends at the Rectory, Llaniestyn, mid-1980s (l to r: Gareth Williams, David Brown, Antoinette Godkin, Isabel Johnstone and Gillian Ayres) (photo: Sam Mundy)

Life at the Rectory was for some time as intermittently idyllic as Ayres had dreamed it might be. Chickens, and, for a while, peacocks had the run of the grounds, there was an abundance of eggs and home-grown vegetables. Behind the house rose the great hill of Garnfadryn, and there were beautiful bays and beaches not far away. Ayres made trips to London to attend meetings of the Arts Council, and to the various art schools where, in spite of her misgivings, she accepted appointments as external examiner. Visitors came and stayed, loving the slightly chaotic atmosphere of the Rectory and the generosity of its ruling spirit, and enjoying the remote wildness of the Lleyn Peninsula. The house was capacious and Ayres was able to use several rooms as studios. After the solitude necessary to work, there was the companionship of artists, writers and friends: Gareth Williams lived and worked in the house, and Harry Mundy, who had remained a friend, arrived soon after the move, and stayed to occupy rooms in one of the wings. Tim Hilton, Angela Carter, Alexandra Pringle, Kasmin, Julian Andrews and David Brown were among frequent visitors. There can be no doubt that the alternating quietude and busy conviviality of life at the Rectory contributed to Ayres's recovery from her illness, and that her emergence from a dark crisis to serenity, in a place close to nature, in bright peninsular light, was visibly manifest in the comedic *jouissance* of the paintings she made in the first years at Llaniestyn.

Garnfadryn, the mountain behind the Rectory, Llaniestyn (photo: Gillian Ayres)

Something of that comedic spirit can already be found, in *Ariadne on Naxos* (1979–81), which was completed shortly before the move from Beverley Road. In this and other paintings on which Ayres was working in those last months in London there can be seen the emergence of the more distinct forms and the patterned rhythms and repetitions of the later work. What is newly remarkable about the Welsh paintings is the speed of their execution, a sign of the greater certainty with which they were made, and of the new and justified confidence of the artist in the procedures of their making. Of twenty-seven recent paintings in the catalogue of the Oxford exhibition in the autumn of 1981, only seven are given a single year as the date of composition; in the Serpentine exhibition in late 1983 no fewer than twenty-eight paintings are catalogued as dating from *either* 1982 *or* 1983. It is not that Ayres was more prolific in those years (though this was the case, if only marginally so) but that she was finishing paintings more quickly and more decisively: she had arrived at a manner of expression that made possible visual statements that had the poise and elegance of equations in which each term seems to answer to another.

The Rectory, Llaniestyn, the 1980s (photo: Gillian Ayres)

Anthony and Cleopatra (1982), was the first painting made in Wales, and its scale alone gives earnest of the artist's new lease of ambition. Like *Ariadne on Naxos* it is comparatively

Gillian Ayres in the garden at the Rectory, 1983 (photo: Paul Kasmin)

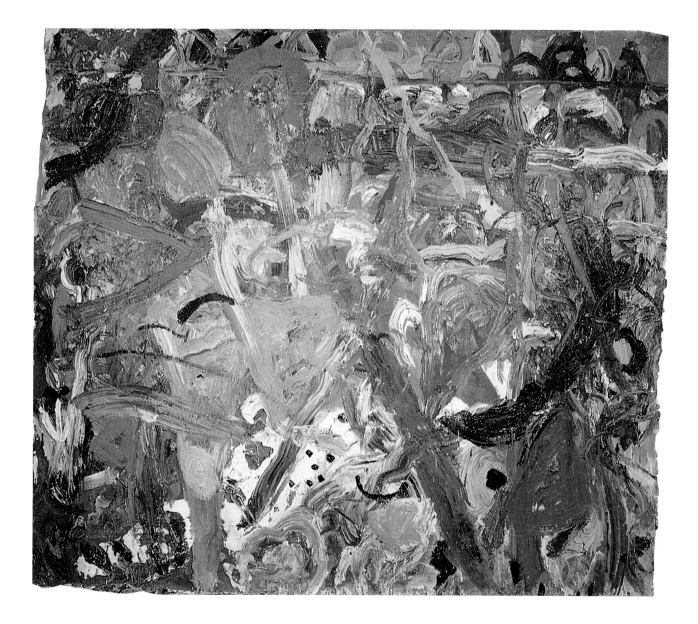

ABOVE
Ariadne on Naxos
1979–81
oil on canvas
274.4 × 315 cm

RIGHT
Piva
1981
oil on canvas
91.5 cm (diameter)

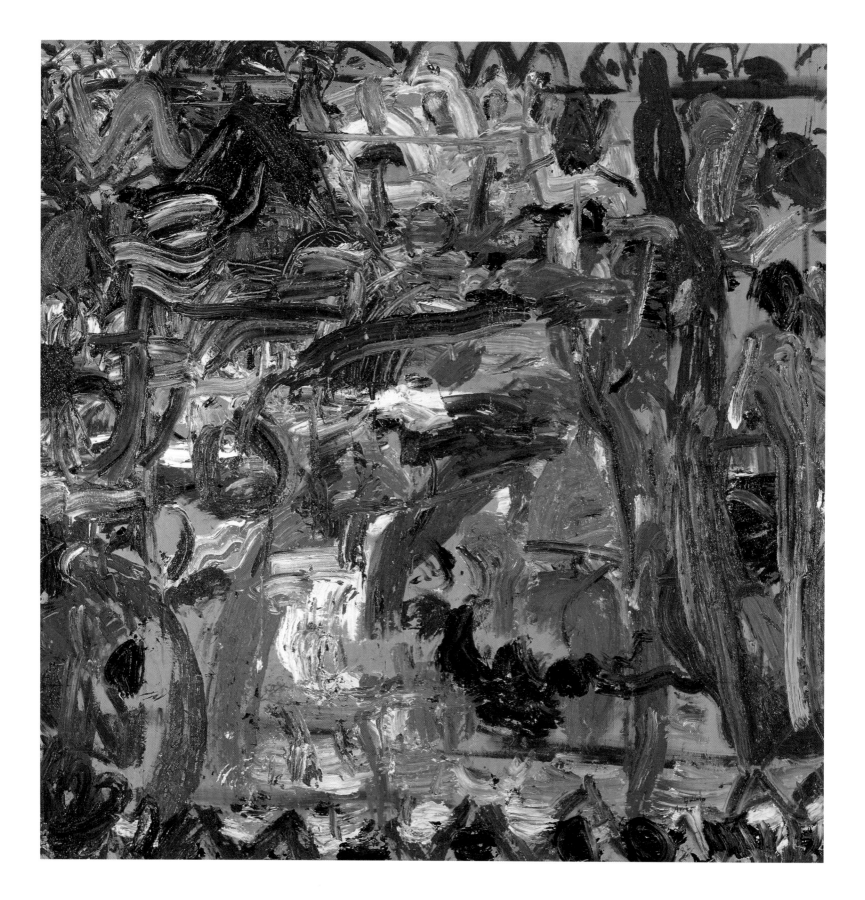

Anthony and Cleopatra
1982
oil on canvas
289.3 x 287.2 cm

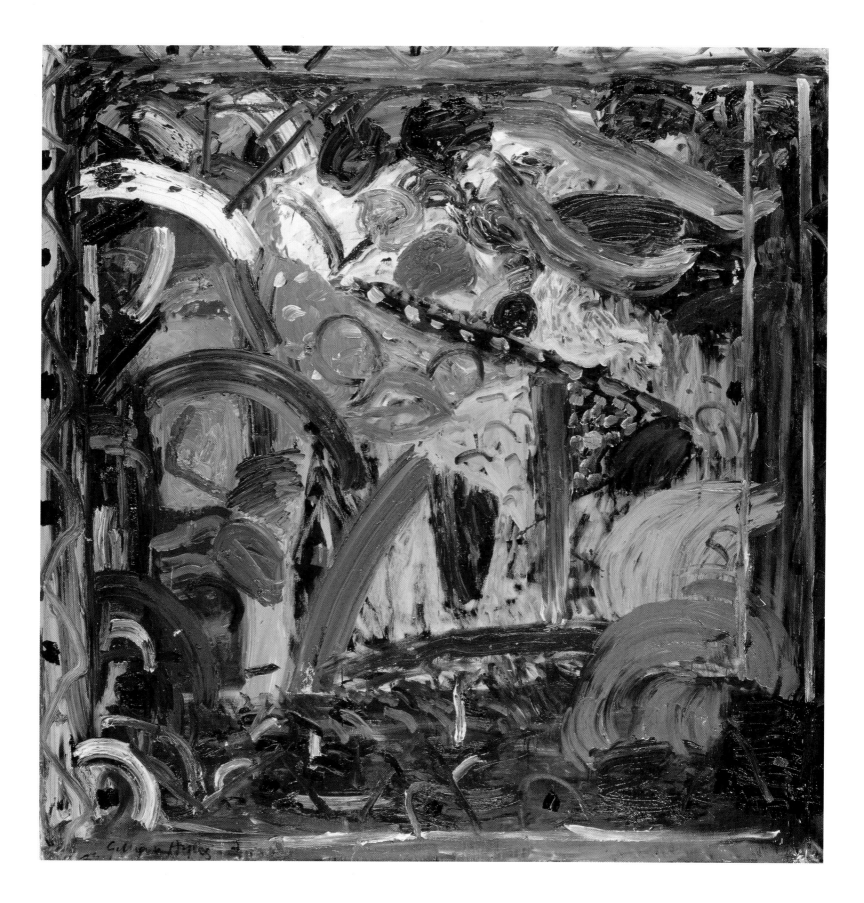

Papagena
1983
oil on canvas
213.4 x 213.4 cm

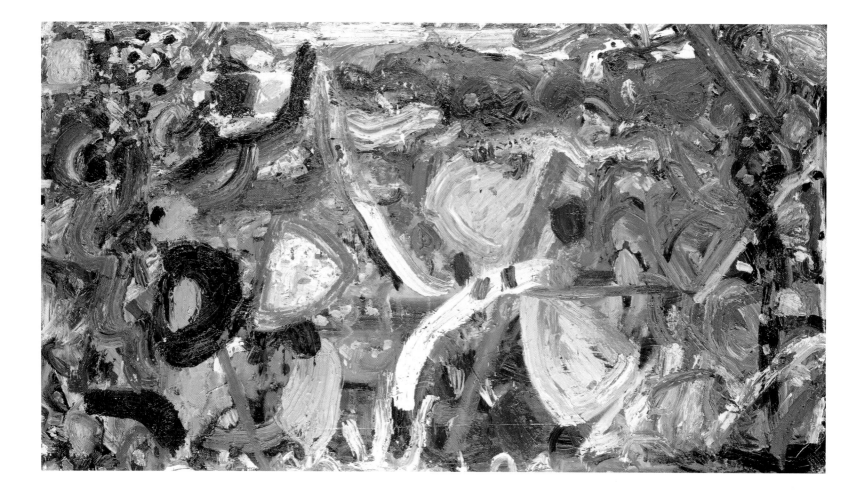

Prometheus
1983
oil on canvas
182.9 x 327.6 cm

The Paintings That You Want to See

A Belt of Straw and Ivy Buds
1983
oil on canvas
310 x 167.6 cm

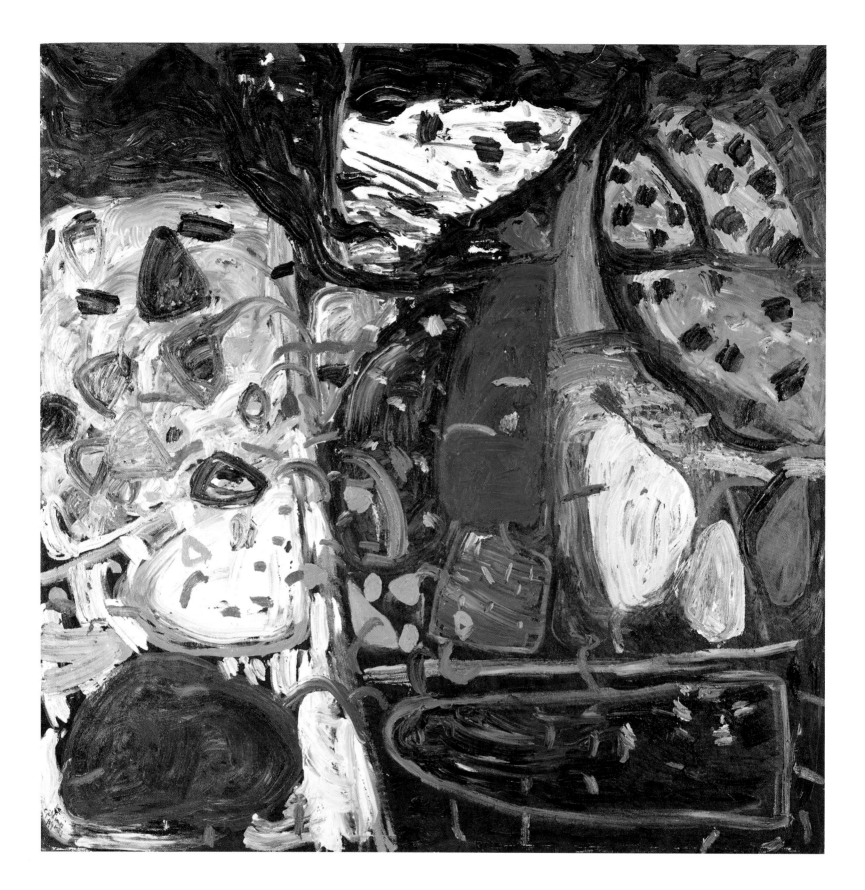

Black Mountains
1983
oil on canvas
287 x 287 cm

The Paintings That You Want to See

Dowland's Book of Ayres
1984
oil on canvas
106.8 x 76.4 cm (oval)

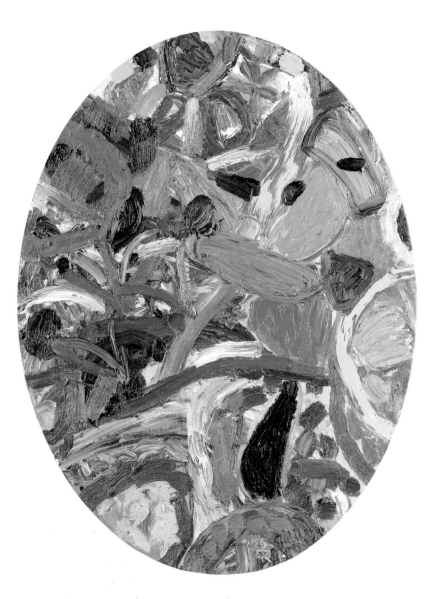

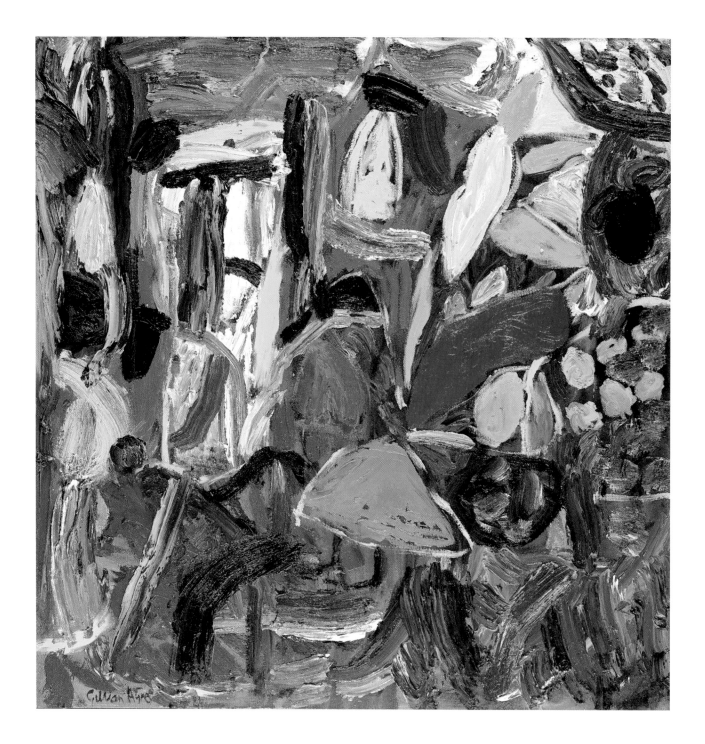

Quito
1984
oil on canvas
122 x 122 cm

RIGHT
Fairest of Stars
1984
oil on canvas
335 x 183 cm

The Paintings That You Want to See

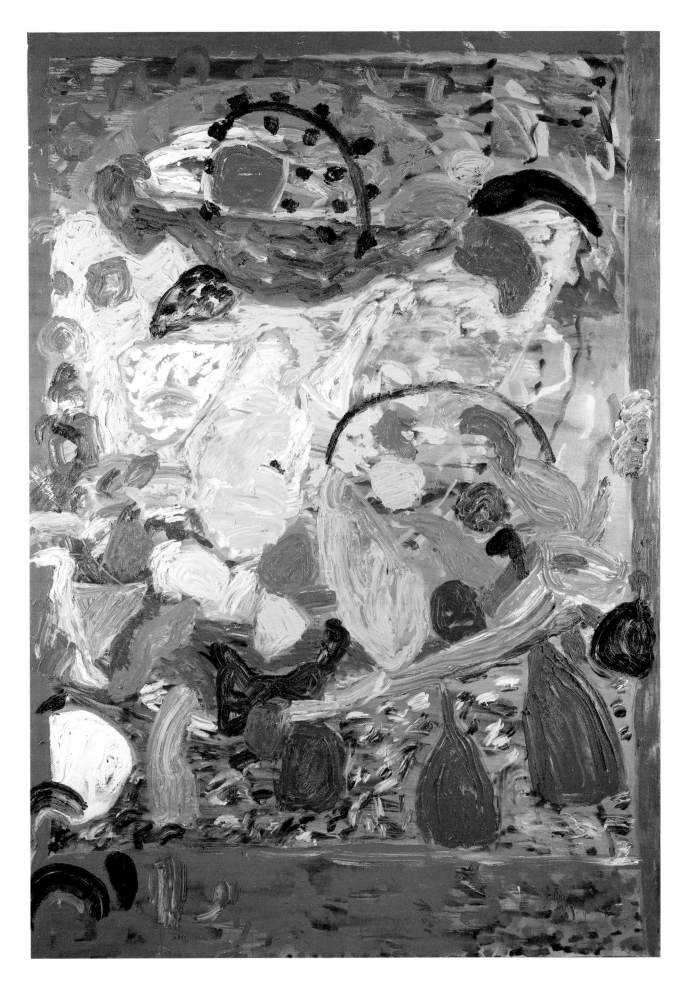

thinly painted, though it shares that painting's vigorous impasto and generosity of brush-load, but it lacks the contained and tightly orchestrated completeness of such paintings made in the following year, for example *Papagena* and *Prometheus*, in which the new 'late' style can be seen at last fully developed. *Anthony and Cleopatra* offers a more frenetic pleasure, a vast kinetic spectacle in which colours and shapes, writhing strokes of uneasy violets, crimsons, magentas, browns and blues, writhe and criss-cross in a shallow space created by the uniform yellow ochre of the underlying ground, and are barely contained by the roughly painted dog's-tooth frieze at top and bottom of the picture. It is a painting that holds a special place in Ayres's affections, partly no doubt for its Welsh priority, but also for its quality of openness, its reach for a wild and uncontrolled sublime, which most surely registers her response to the stark midwinter landscape of the place and time of its making.

With *Papagena*, on the other hand, we come indoors, as to a performance in a theatre. Its enclosed unity on the plane might be imagined as a metaphor for the unity of time in classical drama. The pictorial action is of subtle, never-exact repetitions, mirrorings and reversals, such as those of the diminishing arcs that descend on the left, countered by the arch of blue-green up-reaching from lower left to centre, which takes the eye to a small concert of little arcs contained within the pale blue triangle just off-centre, itself caught in the fan-like fall of three long bars of colour, from the blue stroke at the top right to the dark spotted diagonal above the centre to the Venetian red horizontal across the lower centre. The colour chords of *Papagena* echo and combine into an harmonic richness that matches that of the stroke-shapes and of their rhyming brush- and finger-stroke textures. All this complexity of dramatic effect is contained, and, paradoxically, held still and poised in *perpetuum mobile*, within a proscenium-like frame.

Prometheus, though it lacks the framing device, works in a directly similar way, setting proposed forms – the tonally modified blue, pink and ochre triangular forms just right of centre, for example – against such purely flat shapes as the diagrammatic outlined triangle to the left of centre. Apprehended as a whole, its dynamics, like those of *Papagena*, are of rhythmic repetition, rhyme and counter-rhyme, of swerve and counter-swerve, straight line and curve. There are, in this painting, however, features that act to jolt the balance, threaten its equanimity. The blue-black ring at lower left, with its decisive black companion stroke, together create a pictorial disruption that recalls those effected by the 'shock weights' in Ayres's paintings of the early 1960s. This is also to be a recurring compositional – or, rather, *anti*-compositional – device in the later work.

The titles of these paintings, and of many others similar, invite theatrical, operatic and musical metaphors in their description, but such figures are by no means to be taken to suggest any element of illustrative imagery in the works themselves. Language needs must find a way to encounter the purely visual dynamics that give paintings such as *Papagena*, *Dowland's Book of Ayres* (1984), *End Game* (1985), *Full Fathom Five* (1987) or *Dido and Aeneas* (1988) their impact upon the apperceptive imagination. In a similar way, titles that derive from poetry and song, such as *A Belt of Straw and Ivy Buds* (1983), *It was a time* (1982), *Whan that April with his shoures soote* (1984) or *Lily of Laguna* (1991–2), bring home to the viewer the essentially poetic cast of the artist's imagination. The term 'poetic' registers that character-istic of the work that is analogical, its tendency to find not merely vivid visual signs but independently marvellous parallels, or *enactments*, in colour, shape, form and texture, for aspects of the world as given. These purely visual metaphors are always 'embedded' in the physical actuality of paint; they work by a principle of allusive *abstract* resemblance rather than by resort to imitation or direct reference. As always, such titles were given, often by friends, to the paintings after their completion, in what Ayres once likened to 'a christening'. 'I like the titles and care about them but they do not describe the paintings.' What they do indicate is that she is an artist with a profound sense of the vital connection between painting and an imaginative life lived fully through the sister arts of poetry, fiction, music and drama. There is a friendly irony in the practice that names one work by reference to another whose mode of operation is definitively different.

Taken together, the similarities and contrasts of *Papagena* to *Prometheus* demonstrate

RIGHT
Whan that April
1984
oil on canvas
305 x 305 cm

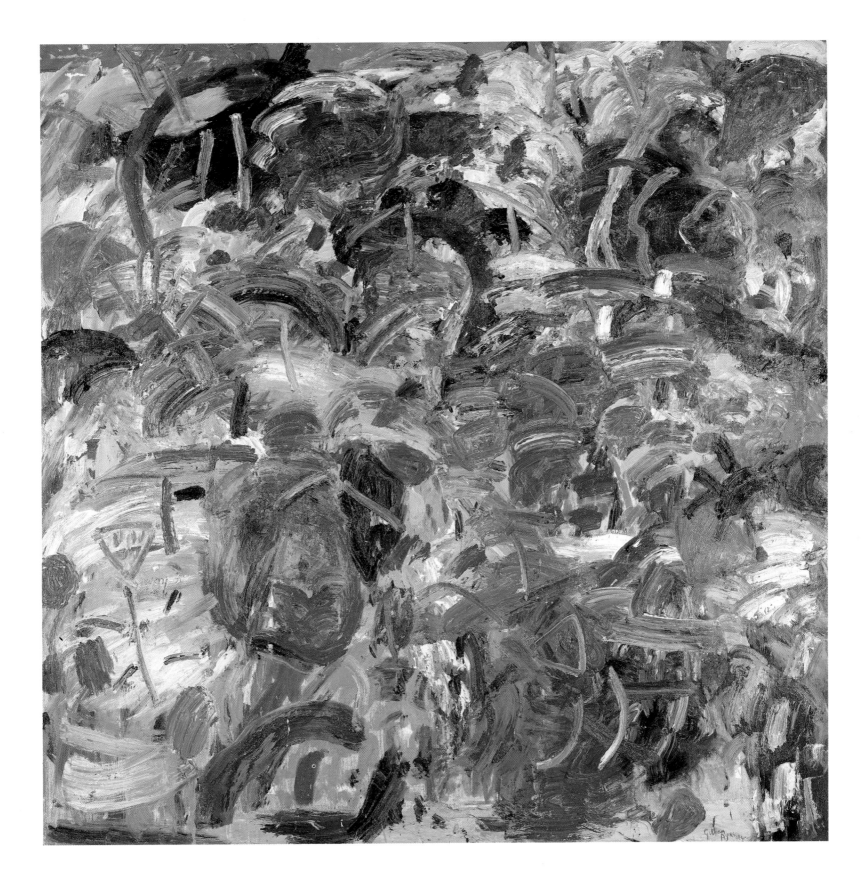

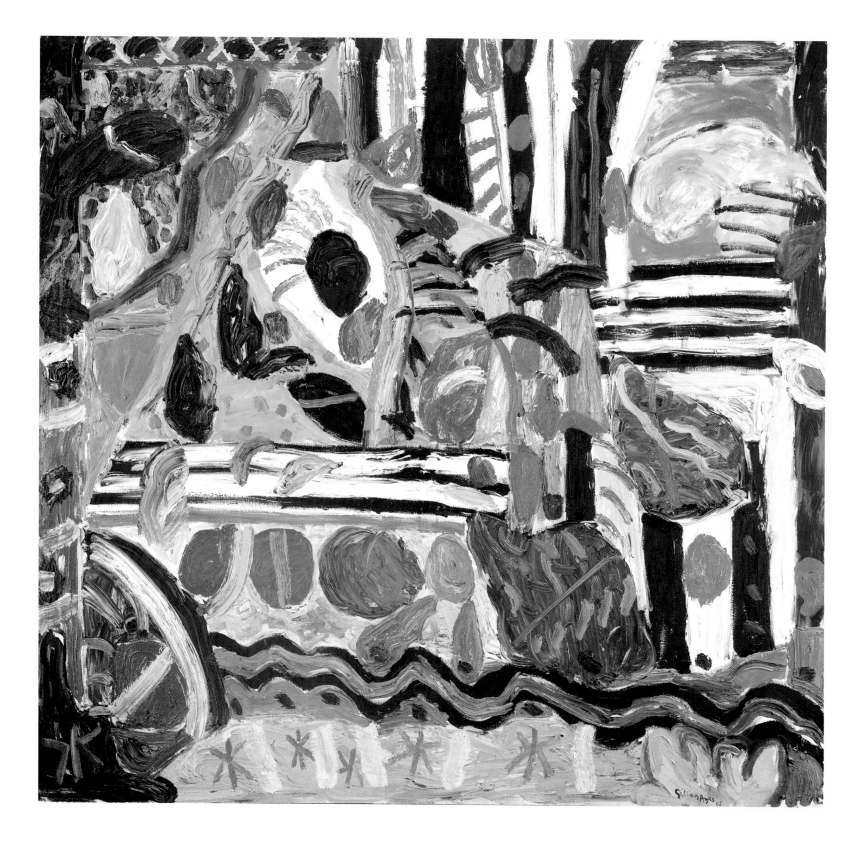

End Game
1985
oil on canvas
275 x 260 cm

The Paintings That You Want to See

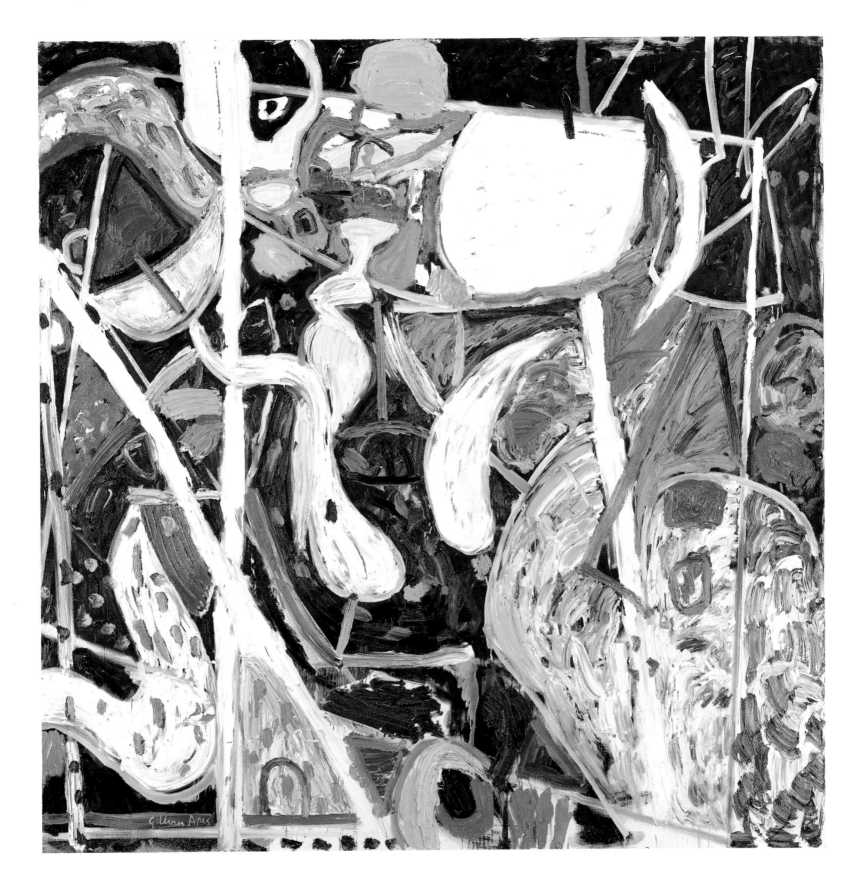

Dido and Aeneas
1988
oil on canvas
274 x 305 cm

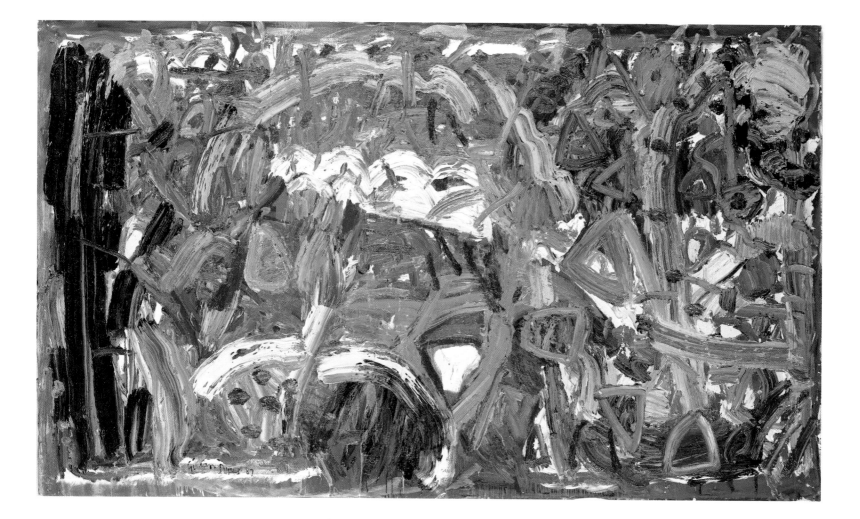

Full Fathom Five
1987
oil on canvas
198 x 350 cm

The Paintings That You Want to See

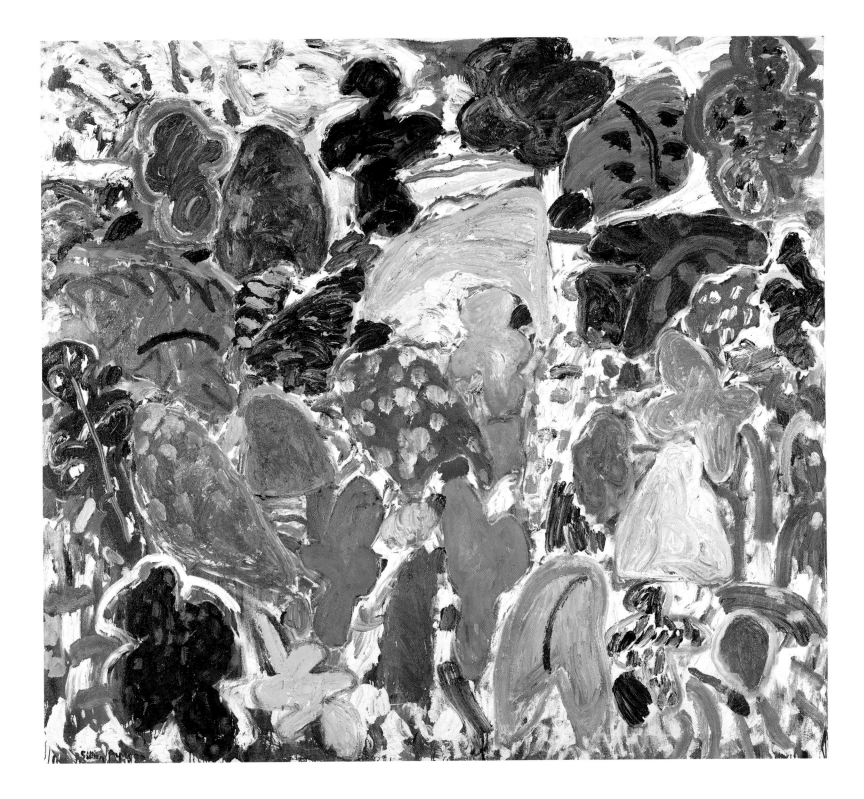

A Painted Tale
*c.*1984
oil on canvas
244 x 274.4 cm

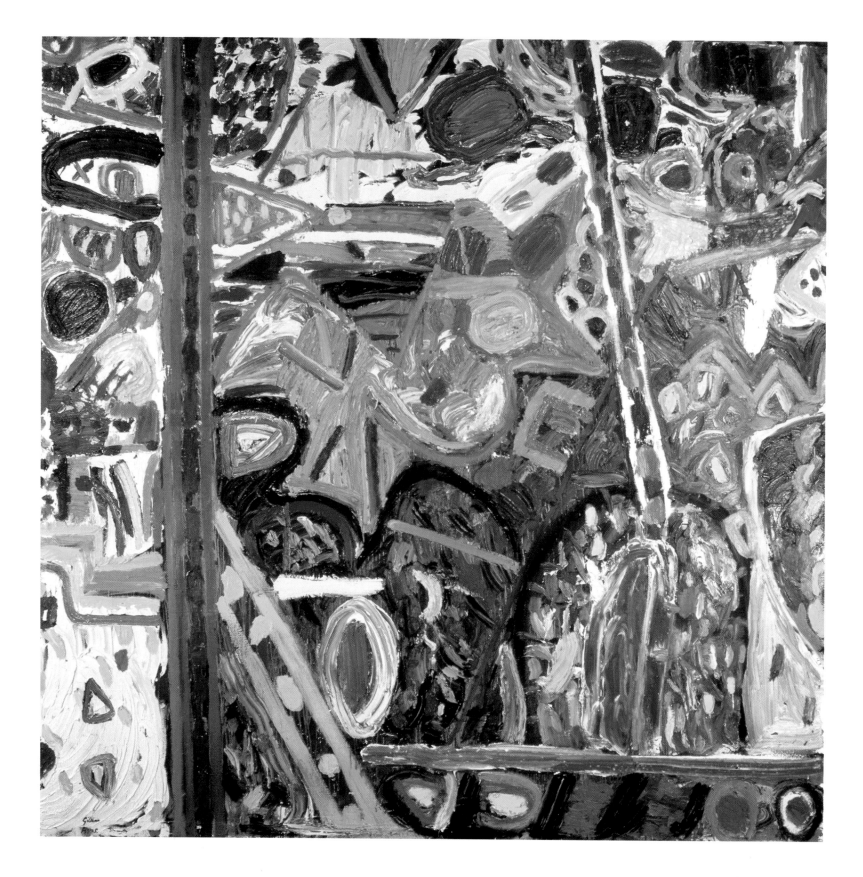

Selene, Sylvan and Fauns
1989–90
oil on canvas
274.4 × 274.4 cm

The Paintings That You Want to See

Indian Summer
1990
oil on canvas
152.5 × 152.5 cm

OVERLEAF
Altair
1989
oil on canvas
243 × 426 cm (two canvases)

The Paintings That You Want to See

Sun Stars
1990
oil on canvas
305 x 305 cm

The Paintings That You Want to See

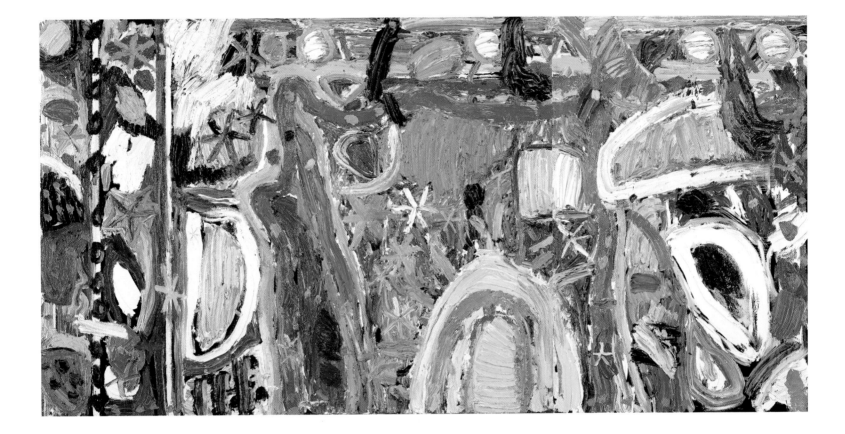

A Midsummer Night
1990
oil on canvas (triptych)
183 x 122 cm (each canvas)

the flexibility and versatility of the symbolic language Ayres had developed in the crucial period of 1977 to 1982. And in these paintings and those of 1983 and 1984 can be discerned all the essential components of the artist's late style. This would prove itself capable of seemingly infinite variations, rather as the formal and affective possibilities of a musical mode based upon a set of general principles might never be exhausted. Before those principles are defined, however, it will be useful to consider what Yve-Alain Bois has termed 'the technical model' of the work's making, to give 'attention to the process of the work as a place of formation, prior to its effects'. Ayres's native predisposition is to a creative and philosophical *modus operandi* that begins with an automatic mark, continues with the alternation of sustained contemplation and free painterly invention, and ends when this *systematic* process discovers an image – the image of *the painting as painting* – that satisfies the eye and the mind. 'It's a process of looking for something to happen in the painting I *look* for longer than I paint. I might work hard for half an hour, and then get back from the painting and simply look at it, and this can go on for a long time. I mean I have no idea how much one sits back and looks.' There is nothing merely chancy about this operation, though a great deal is discovered by chance in the trace of a gesture. These procedures of Ayres's amount to a deliberative creative-critical watchfulness: 'Painting,' wrote Hubert Damisch, 'for the one who produces it as for the one who consumes it, is always a matter of perception.'

Gillian Ayres and Kasmin in the studio at the Rectory, 1983 (photo: Paul Kasmin)

The visual and mental satisfaction that allows a painting to be 'finished' (such closure is always provisional for Ayres: no painting could ever, by definition, be definitive; her mode of operation precludes that possibility) is defined by intuitive reference to the actualities of nature, its shapes and forms, its variegations of light, shadow and colour, its dynamics of movement, its irrepressible exuberance of invention and proliferation. To this is matched the imaginative vision of art, which through physical action upon material substances translates those thrilling actualities of nature into beautiful objects, symbolic analogies. It is the artistic vision that answers to the requirements of a truth to nature, *considered in abstract*, on the one hand, and to the necessity of formal coherence – an imaginative *reality* – on the other. 'Truth to nature' does not imply any mimetic function, any illusionistic representation of its appearances, but rather an attention to the abstract properties of its objects and events. To borrow a phrase from Mondrian (whose example is of closer relevance to a consideration of the radical nature of Ayres's practice in the 1980s and 1990s than might first appear), what the paintings present is an image of 'nature and non-nature in equilibrium'. 'Formal coherence' here comprises the disposition of the material elements – paint and support – as well as the play of the depicted abstract shapes, forms and spaces. This is the first principle of Ayres's creative practice.

Gillian Ayres in Wales, mid-1980s (photo: Sam Mundy)

There is a second 'general principle' that constrains the invention of the over-all image, an image, it must be once more emphasised, that is conterminous with the canvas itself, the edges of which are its containing frame, the determinant of its essential form. It is the operative principle that demands a pictorial space proper to an art that seeks to affirm its continued necessity to philosophical and cultural discourse by its contradistinction to any other. What is the nature of the space created in such paintings as *A Belt of Straw and Ivy Buds*, or *A Painted Tale* (c.1984), the magisterially grand *Altair* (1989), *Sundark Blues* (1993–4) and *Turkish Blue and Emerald Green that in the Channel Stray* (1996), or the more modestly playful *Midnight Shout* (1996) (to select works at random from across the later years for their variousness of image and range of ambition)? It is a space that is complex, multi-dimensional, and utterly unfixed, within which diverse painterly elements – lines, strokes, squiggles, rounded triangles, rings and blobs, signs and motifs – interweave in varying spatial relation to each other, a relativity perceived in the momentary fixing of the viewer's attention to a given locality of touches and marks.

The proposal of spatial depth, inextricably intertwined with the persistent layering of stroke over stroke, evades the cliché prescription of paradigmatic flatness associated with the compromised 'modernism' of Greenberg, but it is a space, nevertheless, that could exist *only* in painting. It is, that is to say, a space that exists for the viewer not as a descriptive component of an image within the windowing frame of the picture but as an imaginative proposition that goes beyond the perception of an illusion. Not at all fictional, it locks the viewer into the

RIGHT
Lily of Laguna
1991–2
oil on canvas
244 × 213.4 cm

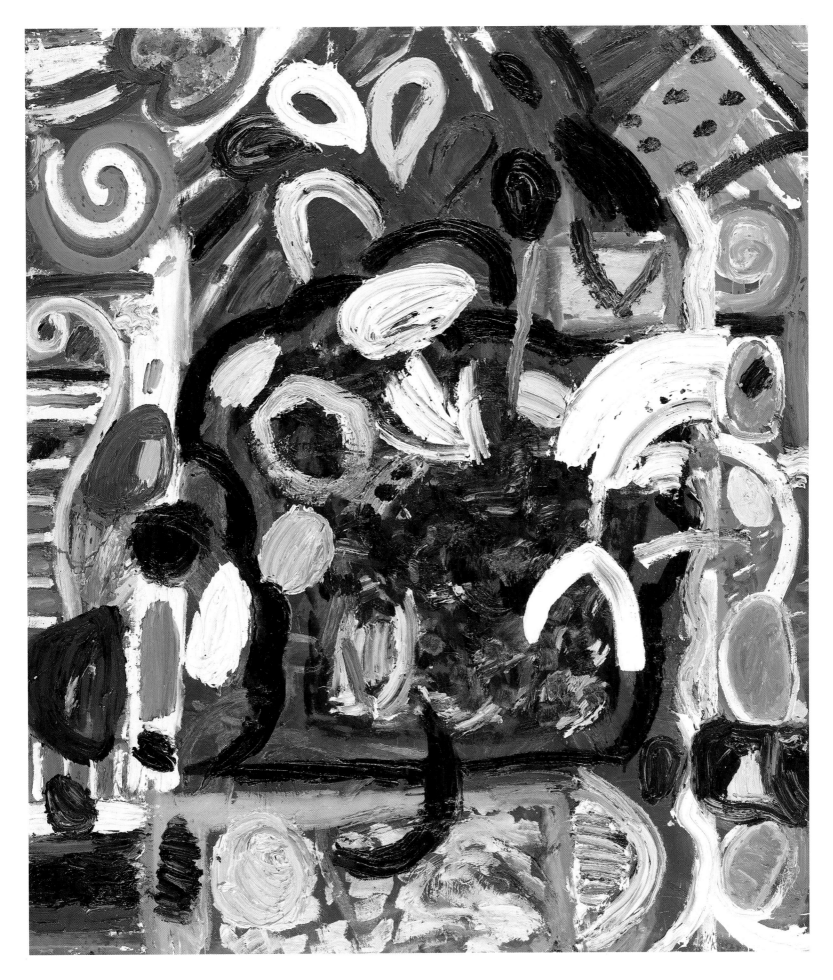

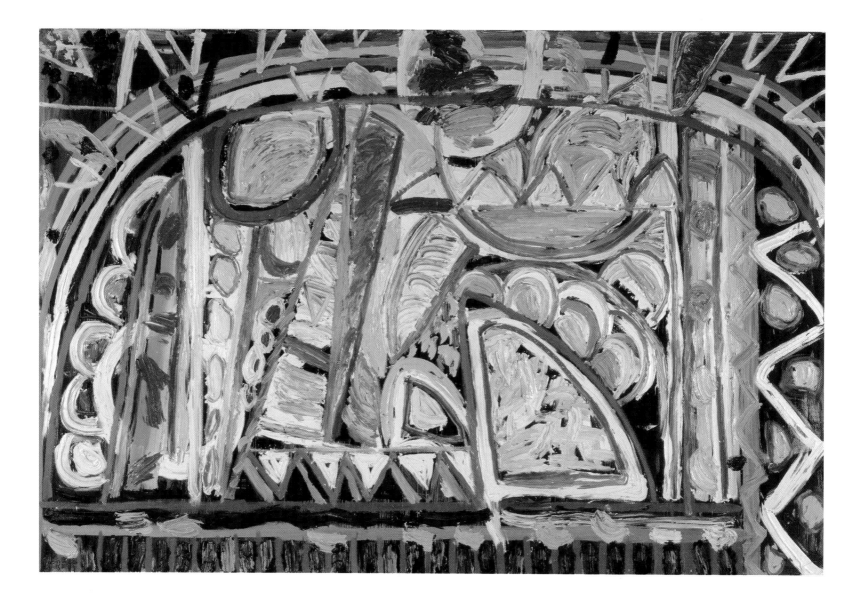

ABOVE
Phaeton
1990
oil on canvas
244 x 366 cm

RIGHT
Darius
1990–1
oil on canvas
244 x 213.4 cm

162 **The Paintings That You Want to See**

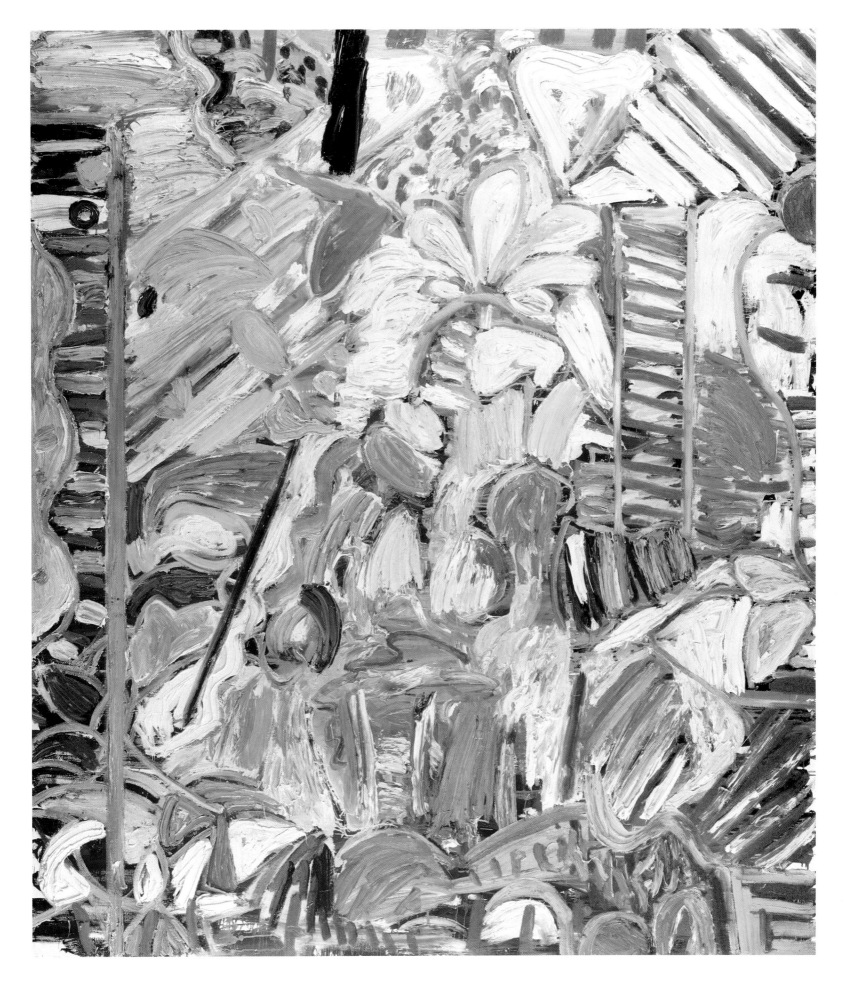

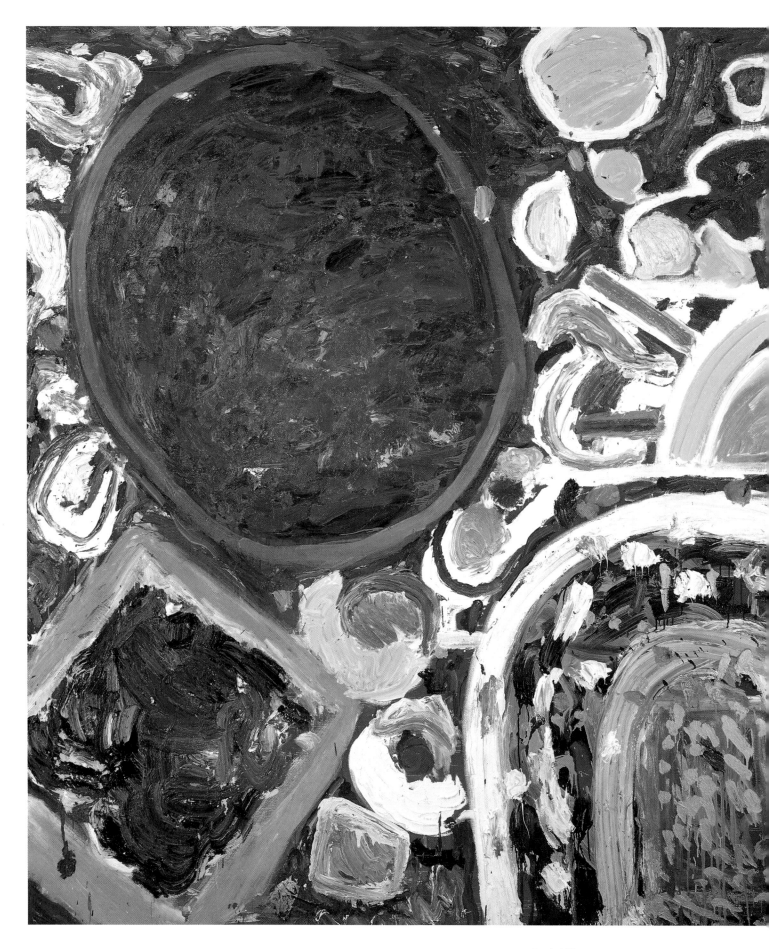

The Paintings That You Want to See

Sundark Blues
1993–4
oil on canvas
244 x 426 cm (two canvases)

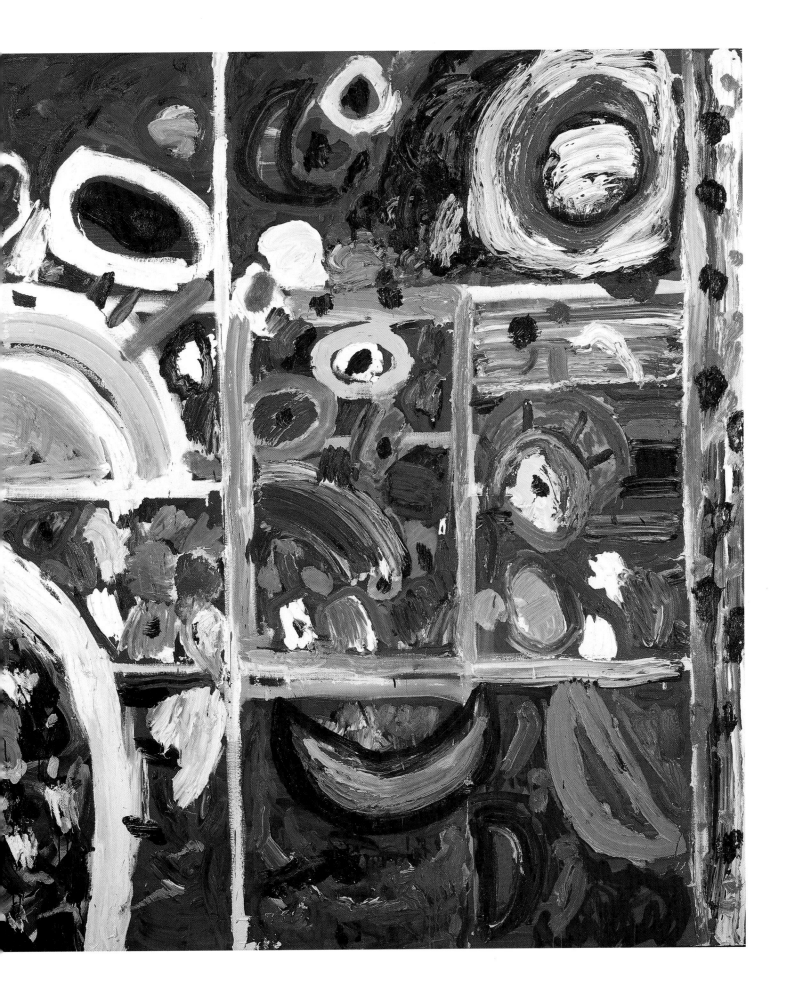

Sucked Up Sunslips
*c.*1994
oil on canvas
244 x 213.4 cm

The Paintings That You Want to See

Suddenly Last Summer
1996
oil on canvas
244 x 366 cm

Flighted Ones
1995
oil on canvas
244 x 426 cm (two canvases)

Tipsy Dance
1996
oil on canvas
91.5 × 91.5 cm

experience of *painting-as-such*. Above all, the sweeping strokes and marks, the poles and arabesques of colour, caught up in a complicated over-and-under interweave, in which surface colour is played against an imagined and constantly inconsistent depth of field, dissolve figure-ground relations into a synthesising totality of image. Its complex visual music confounds the distinction, as it were, of melody and harmonic texture.

It is in this aspect of her *later* work, rather than in any detailing device in the early tachist paintings, that Ayres finally takes up the radical challenge of Pollock's composing technics of 'gesture and trace'. The association of terms is Damisch's, who describes Pollock's procedures in the painting of *Shimmering Substance* (1946), now in the Museum of Modern Art, New York (a painting that, significantly for our purpose here, is predominantly brushed and predates the 'drip' technique), in terms that might apply perfectly to those of Ayres: 'each touch seems destined to destroy the effect born of the relation between the preceding touch and the background.' Speaking of her own methods Ayres is profoundly revealing on the nature of her own 'technical model': 'You are simply evolving something, rather in the way perhaps that a bar of music or a line of poetry follows from the last, developing and changing. It's not a matter of chance, but you have good days and bad days, and I'm not able to explain that: it's like tennis, you can suddenly sense that you are going to make a shot better than you usually do, and you do, and then you can't do it again.'

Ayres's response to the modernist requirements of self-definition and differentiation of purposes, and her rigorous definition of 'what it is that painting can do', and of what is proper to the art – the central project of her creative life – is the richer for its grounding in her profoundly critical appreciation of classic painting, her comprehension of its means and ends, and her recognition of a community of formal concerns between artists over the ages. Her reconciliation, in the making of a picture, of physical gesture to painterly structure, and the consequent elimination of figure/ground in her painting, recall her startling perception of the structural innovation of Titian's dynamic collapse of drawing into painting, and of his establishing at last the contradistinction of painting from 'classical sculpture'. In the talk at Winchester in 1980, in an expression that seems to refer back to conversations with Roger Hilton in the 1950s, she spoke of Titian's forms seeming 'to invade our space'. Titian, she declared, 'thought wholly in terms of paint – *paint for paint's sake* Since painting freed itself from sculpture it has probably led the visual arts.'

Aaron Kasmin and Tim Hilton in the studio, Llaniestyn, mid-1980s (photo: Sam Mundy)

There is a third principle of composition at work in Ayres's late style: what might be described as the paradox of movement-in-stasis. The framed containment of the action in these pictures has already been mentioned, and it is crucial to the typically energetic effect of her paintings. The importance of this device to the formal dynamics of the work is most emphatically confirmed in Ayres's use of the formats of the tondo and oval. It was remarked by Hilton in his 1983 essay, which places the early tondos (for example *It Was a Time*, 1982, and *Wells*, 1982) as central to the development of the 'Welsh style': 'The emphasis of a round painting is of course its circumference, which is both continuous, hence restless, and encompassing, therefore tending to shelter and concentrate the matter of the picture.' Hilton recognised that the significance for Ayres of the tondo, in the constraint created by 'the intransigence of the continuous curve', lay in its determination of an essentially *decorative* solution to pictorial problems. It confirmed the artist, at the timely moment, in her native bent.

Work room, Llaniestyn, 1980s (photo: Sam Mundy)

A characteristic of the late style, most quickly established in the tondos (a format to which she has frequently returned) is the illusion of arrest, as if a furiously kinetic actuality had been brought to a temporarily poised stillness. The 'late' paintings might be described, without forcing the analogy, as optical machines in which a wonderful multiplicity of diverse components is held in a momentary interlock. Indeed, grander paintings such as *Altair*, *Sundark Blues*, *Suddenly Last Summer* (1996), *Turkish Blue* and *The Flighted Ones* (1995) may remind us of Jean Tinguely's mad and marvellous machines, at rest for a brief moment before they whirr and spin once more into frenetic action. Ayres's images, however, carry inescapable suggestions of natural phenomena caught in the contingencies of natural process, something that is generally absent, of course, from Tinguely's programmed mechanics. These suggestions are present in colour and curved shapes, and in motifs that resemble organic forms. Implicit in the poise that

It Was a Time
1982
oil on canvas
61 cm (diameter)

Wells
1982
oil on canvas
213.4 cm (diameter)

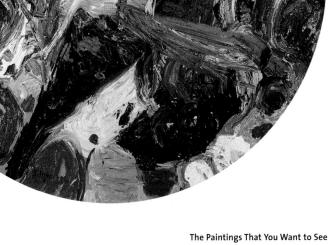

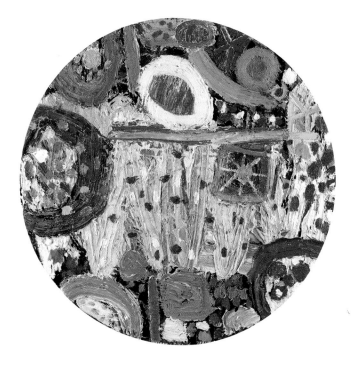

LEFT
City of Tiny Lights
1996
oil on canvas
122 cm (diameter)

BELOW
**Turkish Blue and Emerald Green
that in the Channel Stray**
1996
oil on canvas
244 × 396.5 cm

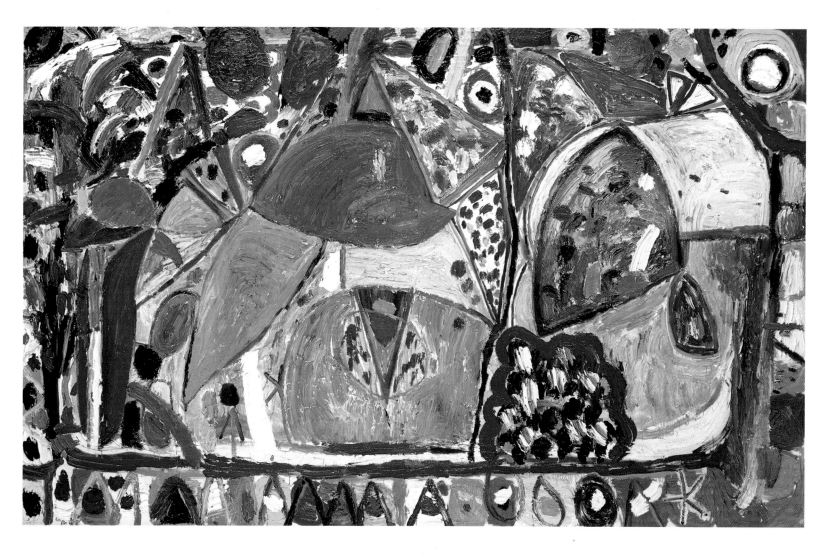

The Paintings That You Want to See

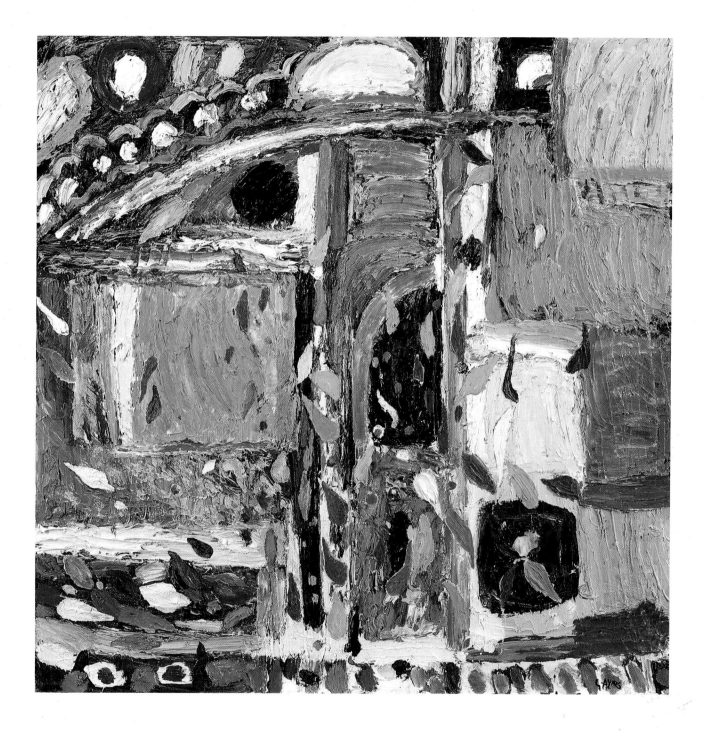

Weather in the Streets
1997–8
oil on canvas
152.4 x 152.4 cm

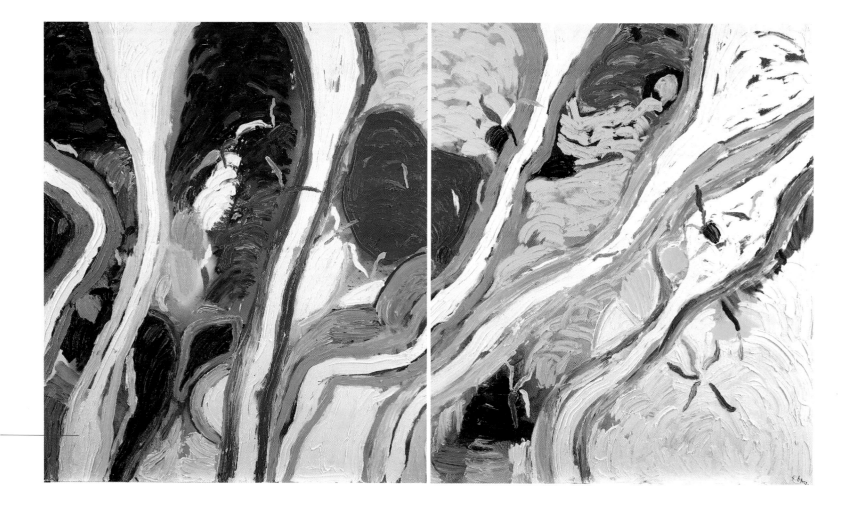

They Can't Take That Away From Me
1998
oil on canvas
243.8 x 426.7 cm

The Paintings That You Want to See

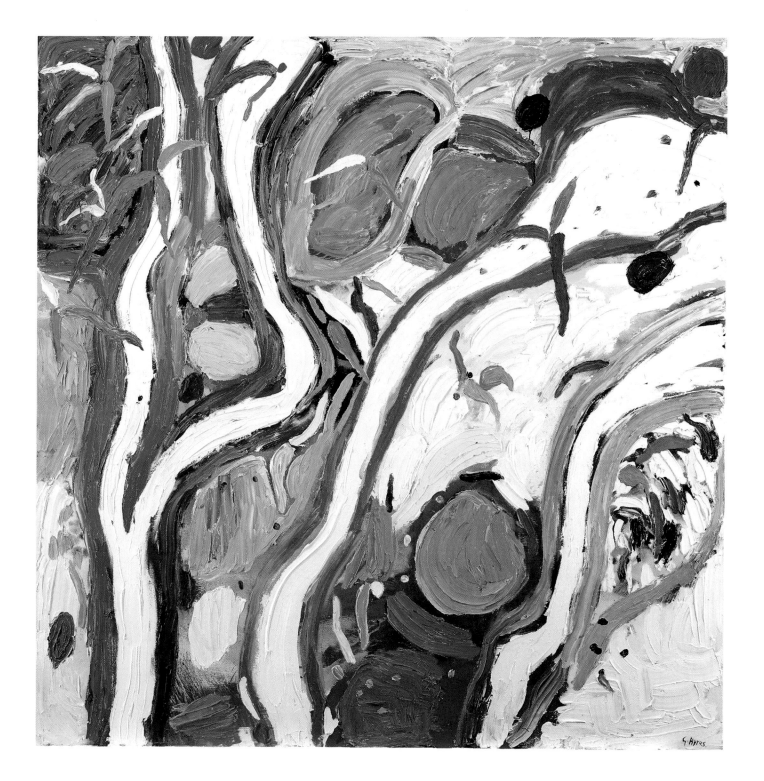

Ride White Swan
1998–9
oil on canvas
182.8 x 182.8 cm

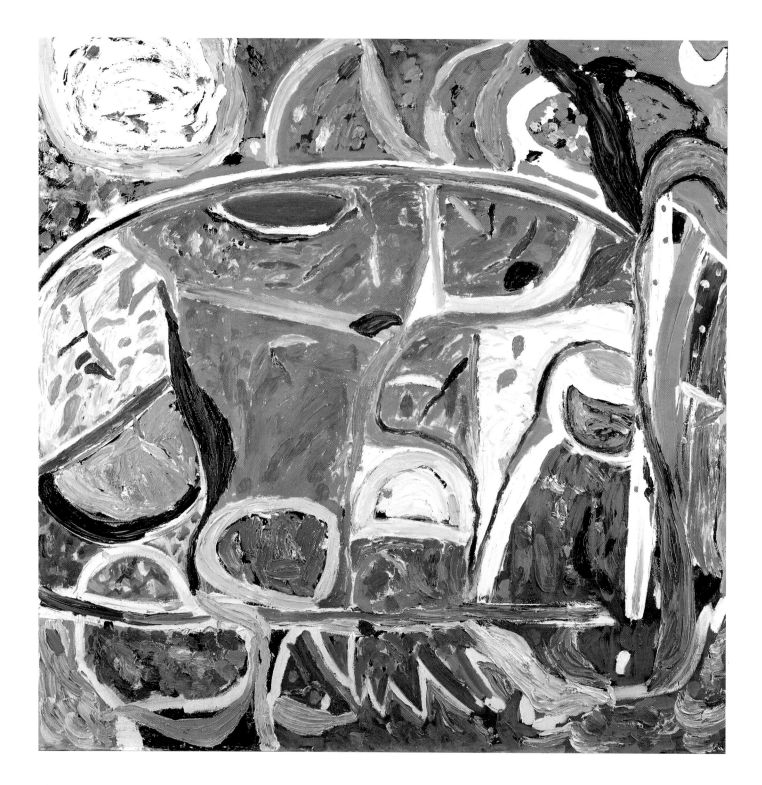

Hazy Shade of Winter
1998–9
oil on canvas
243.8 x 243.8 cm

The Paintings That You Want to See

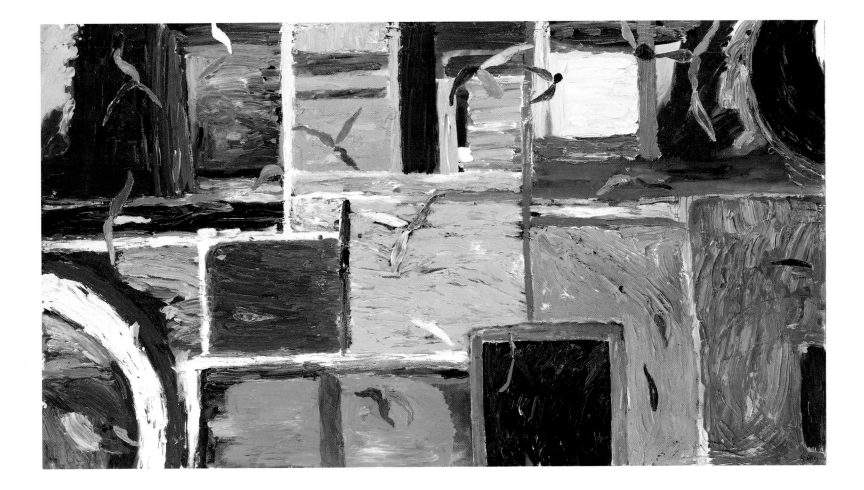

Deep Song
1998–9
oil on canvas
167.6 x 304.8 cm

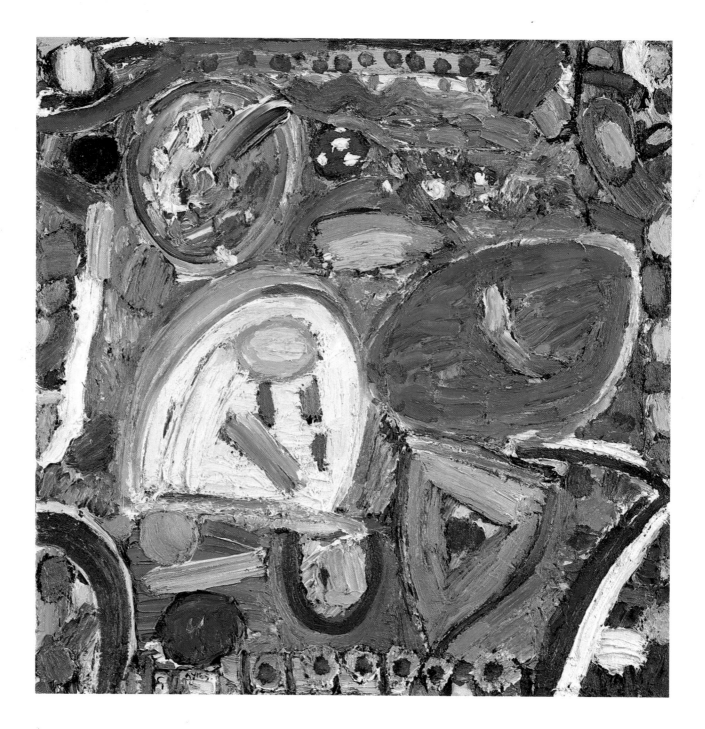

Azura
1999
oil on canvas
91.4 x 91.4 cm

The Paintings That You Want to See

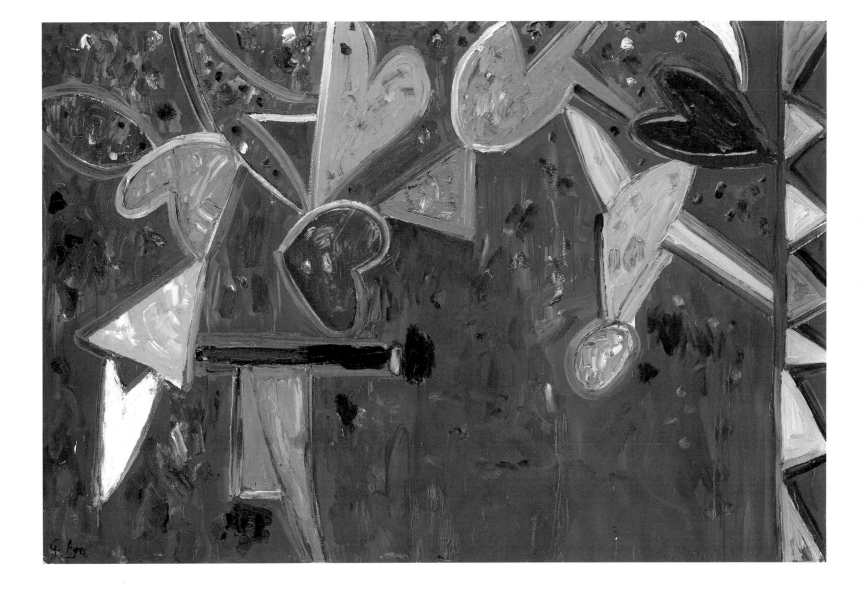

Wide Sargasso Sea
1999
oil on canvas
121.9 x 182.8 cm

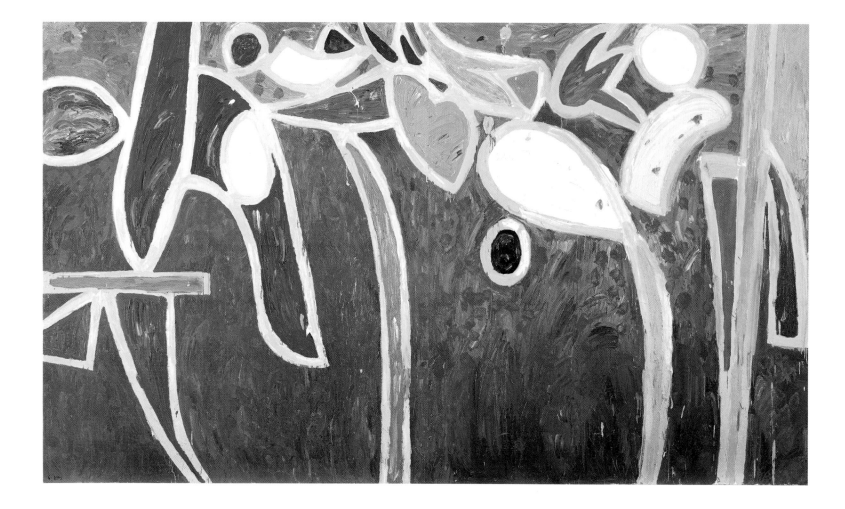

Rufous
1998–9
oil on canvas
243.8 × 426 cm (two canvases)

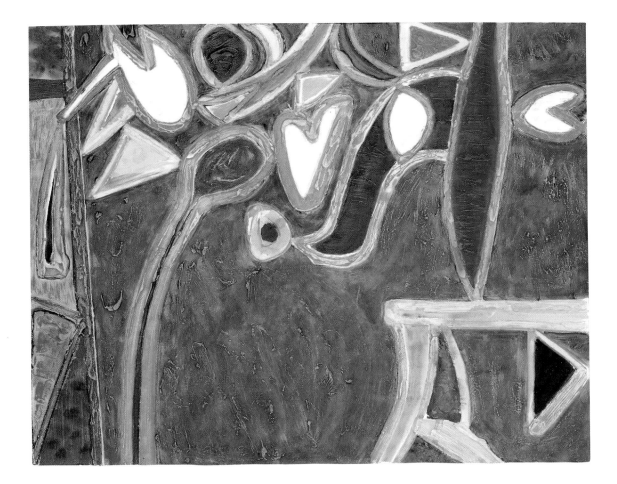

Blue Flame
1999
carborundum etching with hand colouring
120 x 160 cm

Springfield
1999
carborundum etching with hand colouring
120 x 160 cm

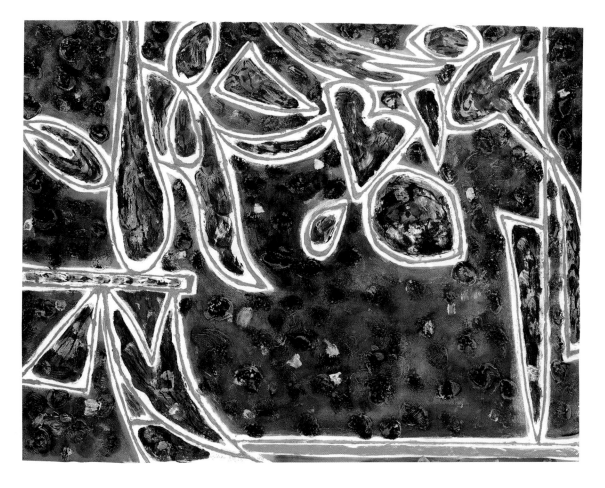

is pictured with such diversity in these paintings are the dialectical tensions, the counter energies of the centrifugal and the centripetal, that maintain any moment of natural stasis. These are images of instantaneous coherence, but we are aware that every such configuration must inevitably disintegrate, before its elements, like the fragments in a kaleidoscope, spin once more into a new and unprecedented pattern.

Ayres's lifelong commitment to what was known by critical shorthand as 'formalism' – the modality of painting that denied reference to the external world and insisted on the self-sufficiency of the painted image – has in no way inhibited a playful and suggestive deployment of recognisable signs and motifs, or the implicit acknowledgement that painting may claim as within its proper province the use of signifiers that have a history not only in art but elsewhere. Shapes that resemble petals, for example, as in *Sucked Up Sunslips* (*c*.1994), or birds' wings, leaves and seed cases, as in *Deep Song* and *Ride White Swan* (both 1998–9), or flowers, as in *A Painted Song*, or the sky, clouds, sun, moon and stars, hillsides and trees that might fancifully be discerned in her paintings. To these might be added, among other things, the recurrent architectural shapes of windows, doors, temple domes, pitched roofs and ladders that can be found in such paintings as *End Game*, *Darius* (1990–91), *A Midsummer Night* (1990) (painted in India), *Sundark Blues* and *Deep Song*, the memories of boats and sails on lake and sea (*Glas*, 1986; *Wide Sargasso Sea*, 1999). Who is to forbid the viewer the invention of such fantasies?

It is simply not possible to avoid evocation, or allusion, however strictly regulated by formal (or even moral) principles the use of colour, or the deployment of paint by brush and hand might be. Ayres encourages the pleasures, essentially poetic, taken in the colours that remind the viewer of natural or of cultural things. On one hand the daytime or midnight blues of sky and water, the gold of wheat, the greens, reds and yellows of plants and flowers; on the other the stripes of flags, the colours of bunting, the brilliant dyed hues of Indian saris: these inescapable associations must add immeasurably to a viewer's complex delight, just as the ridge and furrow, flow and wave (ah metaphor!) of brush stroke, hand mark and impasto inevitably provide eye and mind with matter for reverie. *But*: 'The colour I use', Ayres has said, 'doesn't come from nature in any direct sort of way. *It comes from pots of paint*. And that is very true.' Indeed it might be as true to say that the colour she uses finds its way *to* nature. It is necessary, however, to see these things as essentially incidental aspects of unavoidable circumstance, as likely to be enjoyed (or not) as any experience of the endless variegations of the perceived world. The paintings, it must however be said, offer other pleasures, of a deeper, more philosophic kind, not easily reducible to words, but rather to be mediated inwardly as part of the continuing, and necessarily subjective, structuring of our experience of art *and* nature. 'The act of painting is an act of belief,' Ayres has said, 'a condensation of sensation to perception; a creative experience for both the maker and the viewer. To arrive at an intuition of truth, you make the paintings that you want to see'.

After some years it became clear to Ayres that she could not live forever in a remote hamlet in North Wales. The peacocks had gone, their strange cries a disturbance to neighbours, the chickens were too familiar to eat and the crowded idyll of the first years become difficult to sustain in an environment that if not hostile was not entirely hospitable. The impulse to leave Llaniestyn was confirmed when, in 1986, Gareth Williams died in an accident near the Rectory. Ayres moved in 1987 to a small house hidden in a deep secluded coastal valley on the border between North Devon and Cornwall. She has continued to live and work as prolifically as ever at Tall Trees, 'one half a studio and the other half a cottage', in a seclusion interrupted by occasional journeys to London, exhibitions of her work and frequent visits from her sons and an ever-widening circle of friends and acquaintances. Harry Mundy is a constant companion. The house is full of the books – history, poetry, drama, philosophy and art – that have always been central to Ayres's crowded imaginative life. Outside, a stream runs through the garden and the wood to a spectacular rocky cove a mile away, and above the song of woodland birds can be heard the insistent rising cries of seagulls. Chickens, geese and dogs have their parts in this natural music. All this abundance is reflected in the paintings: 'To get something of that quality, of the grand things in nature, but to make the paint *itself* do it, has been a constant ambition; one's looking for something like that to happen.'

Tall Trees, North Devon
(photo: Gillian Ayres)

Notes and References

Unless otherwise indicated all quotations from Gillian Ayres are from *The Experience of Painting: Eight Modern Artists*, the catalogue to a South Bank Centre touring exhibition, South Bank Centre, London, 1989, with first-person texts by the artists edited from recorded conversations with Mel Gooding, or from extended recordings made with the artist by the author for the National Sound Archive, National Life Story Collection, Artists' Lives project, in 1999–2000, which are available for consultation at the British Library.

Introduction

p.8 For texts by Roger Coleman and Lawrence Alloway and other material relating to *Situation* (1960) see David Mellor, *The Sixties Art Scene in London*, Phaidon, London, 1993, published on the occasion of the exhibition of that title at the Barbican Art Gallery, London (11 March–13 June 1993).
p.9 Léger's pre-war essays on 'pure painting' can be found in Fernand Léger, *Functions of Painting*, Thames and Hudson, London, 1973.
p.9 Greenberg's widely discussed 1960 essay 'Modernist Painting' was first published in the UK in the magazine *Art and Literature*, no.4, Spring 1965. Greenberg wrote of 'the evolution of contemporary art' in his introduction to the catalogue of the exhibition *Post Painterly Abstraction*, which he selected for the Los Angeles Museum of Art in 1964.
p.9 Thomas McEvilley is quoted from the introductory essay to *The Exile's Return*, Cambridge University Press, 1993.

Chapter 1

p.14 Clive Bell's *Victor Pasmore* was published in the series 'Penguin Modern Painters' in 1945.

Chapter 2

p.20 Robert Medley's autobiography, *Drawn from the Life: A Memoir*, was published by Faber and Faber, London, 1983.
p.20 Geoff Hassell, *Camberwell School of Arts and Crafts: Its Students and Teachers, 1943–1960*, Antique Collectors Club, Woodbridge, 1995, is an invaluable reference source.
p.20 *The Townsend Journals: An Artist's Record of His Times, 1928–51*, edited by Andrew Forge, was published by the Tate Gallery in 1976.
p.22 Michael Rothenstein's dialogue 'The Romantic Impulse' was published as no.14 in a series of articles, 'Aspects of Modern Painting', in *World Review*, April 1948.

Chapter 3

p.28 Anna Utley's unpublished MA thesis, 'The Artists International Association' (Courtauld Institute, London, 1997) contains much information on the history of the AIA and in particular the involvement of Gillian Ayres and Henry Mundy with the AIA Gallery. See also Lynda Morris and Robert Radford, *The Story of the AIA, 1933–1953*, Museum of Modern Art, Oxford, 1983, and Robert Radford, *Art for a Purpose: The Artists International Association*, Winchester School of Art, Winchester, 1987.
p.30 The discussion towards *The Mirror and the Square* is described in Morris and Radford, 1983, pp.87–8. *Broadsheet No.1: Devoted to Abstract Art*, published by Lund Humphries, London, in conjunction with the 1951 AIA exhibition, contained, in addition to Kenneth Martin's essay, articles on 'New Architecture and Abstract Art' (H. F. Clark), 'Mondrian and Mies Van der Rohe' (John R. Weeks) and 'Mobiles and Alexander Calder' (Anthony Hill).
pp.30–1 Adrian Heath, *Abstract Art: Its Origins and Meanings* (1953), and Lawrence Alloway, *Nine Abstract Artists* (1954), were both published by Tiranti, London. Herbert Read, *Contemporary British Art* was published by Penguin Books, Harmondsworth, 1951.

Chapter 4

p.36 Patrick Heron's review 'The Americans at the Tate Gallery' first appeared in the magazine *Arts (NY)* in March 1956. It is reprinted in *Painter as Critic. Patrick Heron: Selected Writings* edited by Mel Gooding, Tate Gallery Publishing, London, 1998. Heron's critical campaign against 'a kind of cultural imperialism' (the title of one of three polemical articles he wrote for *Studio International* between 1966 and 1970) culminated in an extended essay published by the *Guardian* over three days beginning on 10 October 1974. *The Changing Forms of Art*, Routledge and Kegan Paul, London, 1955, an edited selection of his earlier writings, including many reviews for the *New Statesman and Nation*, was much admired by Ayres.
p.37 For Ayres's use of Ripolin, and a history and description of household paints, acrylics, etc, in modern painting, see Jo Crook and Tom Learner, *The Impact of Modern Paints*, Tate Gallery Publishing, London, 2000.
p.38 The circumstances and history of the *Hampstead Mural* is the subject of Fiona Gaskin 'Gillian Ayres's mural of 1957 for South Hampstead High School for Girls', in *Burlington Magazine*, April 2000. Lawrence Alloway, in his article 'Real Places', *Architectural Design*, June 1958, saw the *Mural* as taking the 'shaggy dog approach' to art in architectural settings: 'with the artist providing rough, lumpy, or curly forms' as a contrast ('handmade and inspirational') 'to the tidy geometrics of a building' As 'the first use of tachisme to decorate a British building', he wrote, 'it is a lesson in the prompt assimilation of current styles to an architectural purpose.'
p.39 Michel Tapié, *Un Art Autre* was published by Giraud in Paris in 1952. Tapié coined the phrase *art informel* around 1950; the invention of the term *tachisme* has been variously credited to Tapié, and to the French critics Pierre Guéguen and Charles Estienne. By the mid-1950s it had become widely and loosely adopted as generically applicable to any kind of painterly pure abstraction. Tapié is quoted in this chapter from *Un Art Autre*, extract in *Theories of Modern Art*, edited by Herschel B. Chipp, University of California Press, Berkeley and Los Angeles, 1968. An essential source for contemporary descriptions of the various national schools of the new informal abstraction, by well-informed writers,

is *Art Since 1945*, Thames and Hudson, London, 1959; the essay on art in Great Britain is by Herbert Read. Ayres is mentioned as one of 'a surprising number of artists of [the] school' of 'so-called "Tachiste" or "action" painting'. André Breton famously defined Surrealism as 'pure psychic automatism' in the first 'Manifesto of Surrealism' in 1924; see *Manifestoes of Surrealism*, André Breton, trans. Richard Seaver and Helen R. Lane, Ann Arbor Paperbacks, University of Michigan, 1972.

Chapter 5

p.47 The 'Coldstream reforms', following the recommendations of the Coldstream Report of 1960, included the abolition of the NDD and the introduction of a new degree-level Diploma in Art and Design, with History of Art and Liberal Studies as compulsory components.
p.47 The quotation from Clyfford Still is from a letter dated 5 February 1952, first published that year in the catalogue for the exhibition *15 Americans* at the Museum of Modern Art, New York.
p.48 Barnett Newman, 'The Sublime is Now' was a contribution to 'The Ides of Art, Six Opinions on What is Sublime in Art?' in *Tiger's Eye*, the New York artists' magazine, no.6, 15 December 1948; excerpted in Chipp, *Theories of Modern Art*.
pp.48–9 Lawrence Alloway, 'The American Sublime' was published in the ICA magazine *Living Arts* (no.2, June 1963). Edmund Burke, *A Philosophical Enquiry into the Origins of our Ideas of Sublime and Beautiful* was published in London in 1757. Kant's *Critique of Judgement* (1766) is quoted from James Creed Meredith's translation, Oxford University Press, Oxford, 1952. Samuel H. Monk's *The Sublime* (1935), University of Michigan, 1960, paperback, is the classic critical account of eighteenth-century theories of the subject. Edward J. Nygren's study, *James Ward's Gordale Scar: An Essay in the Sublime* was published by the Tate Gallery, London, in 1982.
p.49 Roger Hilton's remarks about the painting as an 'activator of space' are in his note for Alloway's *Nine Abstract Artists*.

Chapter 6

p.52 For Turner on atmospherics and colour see Lawrence Gowing's illuminating *Turner: Imagination and Reality*, Museum of Modern Art, New York, 1966, and John Gage, *Colour and Culture*, Thames and Hudson, London, 1993. The final words of Gowing's essay are highly relevant to the focus of this chapter. 'Now we find that a kind of painting, which is of vital concern to us, was anticipated by Turner. And by Turner alone; no one else before developed so far and with such devotion this special order of painting, which is so hard to define and yet so recognisable. *It is hard to define because the fantasy and the image are implicit in the material it is made of, inseparable from the actual behaviour of paint in the painter's hands*. Turner showed that a certain potentiality was inherent in the nature of painting. The latent possibility has emerged again. Turner's vision and his towering fantasy remain his own, beyond compare. Nevertheless we meet him with a sense of recognition.' (added emphasis).
p.54 David Mellor, *The Sixties Art Scene in London*, reprints Roger Coleman's text for 'Place', his introduction to *Situation* and Alloway's 'Size Wise' from *Art News and Review*, September 1960.
p.60 William Turnbull is quoted from two essays, 'Environmental Art' (1958) and 'Nature into Art' (1957), in *Uppercase 4*, edited by Theo Crosby, Whitefriars Press, London, 1960, an issue largely devoted to his work.

Chapter 7

p.74 Heron is quoted from 'Space in Painting and Architecture' and 'Space in Colour' respectively. Both essays reprinted in *Painter as Critic*.

Chapter 8

p.95 Guy Brett reviewed Jeremy Moon in the *Guardian*, 2 September 1962

Chapter 9

p.102 That London had become 'one of the world's three capitals of art' was the claim made in *Private View*, by Bryan Robertson, John Russell and Lord Snowdon, the survey of the 1960s art world in the city published in 1965 (Nelson, London).
p.102 Tim Hilton is quoted from his introduction to the Serpentine Gallery exhibition catalogue, *Gillian Ayres*, Arts Council of Great Britain, 1983.
p.106 The 1957 Claude Monet exhibition was selected and catalogued by Douglas Cooper and John Richardson for the Arts Council of Great Britain in association with the Edinburgh Festival Society. The catalogue was published by the Tate Gallery, London, 1957.
p.106 Heron described Sam Francis's painting in his obituary of the American artist in the *Independent*, 10 November 1994 (reprinted in *Painter as Critic*).

Chapter 10

p.129 A transcript of Ayres's talk, given at Winchester and at Chelsea College of Art in 1980, was published in *The Fine Art Letter*, Winchester School of Art, December 1980.
p.129 Berenson is quoted from *The Italian Painters of the Renaissance*, Phaidon Press, London, 1952, book 1, 'The Venetian Painters', sections XII and XX.

Chapter 11

p.160 Yve-Alain Bois's brilliant essay 'Painting as Model' can be found in *Painting as Model*, MIT Press, Cambridge, Mass., and London, 1993. It originated as a review of *Fenêtre jaune cadmium*, Editions de Seuil, Paris, 1984, by Hubert Damisch. Damisch is quoted from the Bois essay.
p.160 Mondrian's phrase is from *Natural Reality and Abstract Reality: An Essay in Trialogue Form* (1919–20), George Braziller, New York, 1995.
p.182 'One half a studio and the other half a cottage' was Alexandra Pringle's description of Tall Trees, in the catalogue accompanying the Royal Academy's *Gillian Ayres* exhibition in 1997.

Gillian Ayres on the beach, Sandymouth,
North Cornwall, 1998
(photo: Gautier Deblonde)

GILLIAN AYRES

Biography

1930	Born London
1941–6	St Paul's Girls' School
1946–50	Camberwell School of Art
1949	First *Young Contemporaries*
1951	Married to Henry Mundy
1951–9	Worked part time at AIA Gallery
1957	Commission for mural panels at South Hampstead High School for Girls
1958	Son James born
1959–65	Teaching at Bath Academy of Art, Corsham
1966	Son Sam born
1966–78	Teaching at St Martin's School of Art, London
1978–81	Head of Painting at Winchester School of Art
1981	Moved to North Wales
1982	Elected ARA
1986	Awarded OBE
1987	Moved to Devon. Elected RA
1994	Honorary Doctor of Literature, University of London
1996	Senior Fellow, Royal College of Art, London
1997	Sargent Fellowship, The British School at Rome

Solo Exhibitions

1956	Gallery One, London
1957	Kara Benson Gallery, Oslo
1960	Molton Gallery, London
1962	Molton Gallery, London
1963	Hamilton Gallery, London
1964	Arnolfini Gallery, Bristol
1965	Kasmin Gallery, London
1966	Midland Group, Nottingham
	Kasmin Gallery, London
1967	Alecto Gallery, London (prints, ceramics and drawings)
1969	Kasmin Gallery, London
1973	Hoya Gallery, London
	Oxford Gallery
1976	William Darby Gallery, London
	Women's Interart Center, New York
1977	Galeria Alvarez, Porto, Portugal
1978	Kettle's Yard, Cambridge
1979	Knoedler Gallery, London
1981	Museum of Modern Art, Oxford, toured to Rochdale Art Gallery; Ikon Gallery, Birmingham
1982	Knoedler Gallery, London
1983	Serpentine Gallery, London, toured to Cooper Gallery, Barnsley; Newlyn Gallery, Penzance; Nottingham University Art Gallery; Mostyn Art Gallery, Llandudno
1984	Knoedler Gallery, London
1985	M. Knoedler and Co., New York
1987	Knoedler Gallery, London
1988	Knoedler Gallery, London (drawings)
1989–90	Arnolfini Gallery, Bristol, toured to Fruitmarket Gallery, Edinburgh; Cornerhouse, Manchester; Castlefield Galleries, Manchester
1990	Fischer Fine Art, London
1991	Art Festival, Kilkenny Castle, Kilkenny, Ireland
1991–2	The British Council's Seventh Triennale, India: Delhi, Calcutta, Bangalore, Madras, Bombay; Spain: Leon, Murcia, Segovia, Majorca
1993	Purdy Hicks Gallery, London
	Manchester City Art Gallery
	Atkinson Gallery, Millfield, Somerset
	Atlantis Gallery, London
1994	Bolton City Art Gallery
1995	Solo Room, Tate Gallery, London
1996	Gimpel Fils, London
	Reg Vardy Gallery, University of Sunderland
1997	Sackler Galleries, Royal Academy of Arts, London, toured to Yale Center for British Art, New Haven, Connecticut; Iowa University Museum, Iowa
	Gimpel Fils, London (works on paper)
	The Customs House, South Shields, Tyne and Wear
1998	Storey Institute Gallery, Lancaster
1999	Gimpel Fils, London
	Alan Cristea Gallery, London (prints)
	De la Warr Pavilion, Bexhill-on-Sea, Sussex
2001	Gimpel Fils, London
	Alan Cristea Gallery, London (prints)

Group Exhibitions

1957	*Dimensions – British Abstract Art*, O'Hana Gallery, London
	Metavisual, Tachiste, Abstract Painting in England Today, Redfern Gallery, London
	Peinture Anglaise Contemporaine, Galerie du Perron, Geneva; Musée des Beaux-Arts, Liège
	La Peinture Britannique Contemporaine, Salle Balzac, Paris; Galeria Creuze, Paris
	Summer Exhibition, Redfern Gallery, London
1957–8	*British Abstract Painting*, Auckland City Art Gallery
1958	*New Trends in British Art*, New York/Rome Foundations, Rome
	Three British Abstractions, The Whitworth Art Gallery, Manchester
1959	*The Gregory Collection*, ICA, London
	Première Biennale de Paris, Musée d'Art Moderne de la Ville de Paris
1960	*Art Alive*, Northampton Museum of Art
	Artist at Work, Midland Group Gallery, Nottingham
	Contemporary Paintings, Bristol City Art Gallery

Guggenheim Award Paintings, RWS Galleries, London
Situation, RBA Galleries, London

1961 *Internationale Malerie*, Aschaffenburg, Germany
New London Situation, Marlborough Gallery, London
Opening Exhibition, Midland Group Gallery,
Nottingham; John Moores, Walker Art Gallery,
Liverpool

1962–3 *British Art*, touring exhibition, Denmark
British Painting, San Francisco Museum of Art; Dallas
Museum of Art; Santa Barbara Museum of Art
Situation, Arts Council travelling exhibition, Cambridge
Arts Council Gallery; Aberdeen Art Gallery; Hatton
Gallery, Newcastle upon Tyne; Bradford City Art
Gallery; Kettering Art Gallery; Walker Art Gallery,
Liverpool

1963 *British Painting in the Sixties*, Whitechapel Art Gallery,
London
Hamilton Painters and Sculptors, Hamilton Gallery,
London

1965 Corsham Painters and Sculptors, Arts Council, Bath

1966 *Aspects of New British Art*, British Council touring
exhibition, New Zealand and Australia
5, Arnolfini Gallery, Bristol

1967 *Recent British Painting*, Peter Stuyvesant Foundation,
Tate Gallery, London
British Painting: The New Generation, Museum of
Modern Art, New York
John Moores, Walker Art Gallery, Liverpool

1971 *Large Paintings – Three Painters* (with John Golding and
Alan Gouk), Hayward Gallery, London

1974 *British Painting '74*, Hayward Gallery, London

1977 *British Painting 1952–77*, Royal Academy of Arts, London

1980 *Hayward Annual*, Hayward Gallery, London

1983 *Peter Moores, Liverpool Project 7*, Walker Art Gallery,
Liverpool
Summer Exhibition, Royal Academy of Arts, London

1983–4 *Tolly Cobbold Eastern Arts 4th National Exhibition*,
Fitzwilliam Museum, Cambridge and tour

1984 *As of Now*, Douglas Hyde Gallery, Dublin

1985 *Summer in the City*, Ikon Gallery, Birmingham

1987 *British Art in the Twentieth Century*, Royal Academy of
Arts, London, and Staatsgalerie, Stuttgart
Current Affairs, Museum of Modern Art, Oxford, and
tour to Eastern Europe
Summer Exhibition, Royal Academy of Arts, London

1988 *Artists from Corsham*, Bath City Art Gallery and tour
Athena Awards, Barbican Arts Centre, London
100 Years of Art in Britain, Leeds City Art Gallery
*The Presence of Painting – Aspects of British Abstraction:
1958–1988*, Mappin Art Gallery, Sheffield, and tour
Summer Exhibition, Royal Academy of Arts, London

1989 *The Experience of Painting*, South Bank Centre, London;
Laing Art Gallery, Newcastle upon Tyne, and tour

Blasphemies, Ecstasies, Cries, Serpentine Gallery, London
The President's Choice, Royal Academy of Arts, London
Summer Exhibition, Royal Academy of Arts, London

1990 *Glasgow's Great British Art Show*, City Art Gallery,
Glasgow
Summer Exhibition, Royal Academy of Arts, London

1991 Sole British Representative for the British Council's
Seventh Triennale, India

1992 *Gillian Ayres, Basil Beattie, Brian Fielding, John Hoyland –
Paintings 1978–1982*, Pomeroy Purdy Gallery, London
The Discerning Eye, Mall Galleries, London
Heaven and Hell, Pomeroy Purdy Gallery, London
Summer Exhibition, Royal College of Art, London

1992–3 *Ready Steady Go: Paintings of the Sixties from the Arts
Council Collection*, touring exhibition of the South
Bank Centre, London

1993 *Gallery Artists*, Purdy Hicks Gallery, London
The Sixties Art Scene in London, Barbican Art Centre,
London
Summer Exhibition, Royal Academy of Arts, London

1995 *Newlyn Art Gallery: 100 Years – Context and Continuity*,
Newlyn Art Gallery, Penzance
Summer Exhibition, Royal Academy of Arts, London

1995–7 *Home and Away: Internationalism and British Art
1900–1990*, Tate Gallery, Liverpool

1996 *Ace! Arts Council Collection New Purchases*, Hayward
Gallery, London
Harlech Biennale, Oriel Senig, Gwynedd
Summer Exhibition, Royal Academy of Arts, London

1998 *Coming to Light, Recent Acquisitions*, Birmingham
Museum and Art Gallery
In/Sight, University of Exeter, Faculty of Arts
Summer Exhibition, Royal Academy of Arts, London
25 Years of Arts Week, The Butler Gallery, Kilkenny
Castle, Ireland

Select Bibliography

1958 Alloway, Lawrence, 'Real Places', *Architectural Design*,
June

1959 Gilliatt, Penelope, 'Imaginary Colloquy in the face of
Art Autre', *Vogue*, June

1960 Alloway, Lawrence, introduction to catalogue,
Molton Gallery, London

1962 Bowness, Alan, introduction to catalogue,
Molton Gallery, London

1980 Collings, Matthew, 'Gillian Ayres', *Flash Art*, no.94–5
January/February

1981 Hilton, Tim, introduction to catalogue, Museum of
Modern Art, Oxford
Whittet, G. S., 'London: *Détente Prevails*', *International
Herald Tribune*, 24 May
Williams, Gareth, 'Notes on Gillian Ayres', *Art
International*, March/April

1983 Berthoud, Roger, 'A New Sense of Freedom', *The Times*, 24 December

Jamie, Rasaad, 'Gillian Ayres', *Artscribe*, no.43, 10 October

Hilton, Tim, introduction to catalogue, Serpentine Gallery, London; chronology compiled by Catherine Lampert

1984 Packer, William, *Financial Times*, 3 January

1989 Ayres, Gillian, transcript of interview in catalogue *The Experience of Painting*, South Bank Centre, London

Barker, Barry, *Of nothing but a dream*, note in catalogue, Arnolfini Gallery, Bristol

Gowrie, Grey, interview, *Modern Painters*, Autumn

Hicks, Alistair, introduction to catalogue, Arnolfini Gallery, Bristol

1990 Elliot, David, introduction to catalogue, Fischer Fine Art, London

Marks, Laurence, 'The Incandescent Art of the Purple Lozenge', *Observer*, 11 November

1991 Hilton, Tim, 'Splash it all over', *Guardian*, 27 February

Vaizey, Marina, introduction to catalogue, British Council's *Seventh Triennale*, New Delhi; preface to catalogue by Upadhyay, Vidhya Sagar

1993 Bumpus, Judith, 'Experience of India', *Contemporary Art*, no.4, Summer

Hilton, Tim, 'Shape of things gone by', *Independent on Sunday*, 30 May

Hubbard, Sue, 'Rainbow Warrior', *New Statesman*, 29 October

Lambirth, Andrew, interview, *Art Review*, June

1995 Rocco, Fiammetta, 'It's Colour She Loves', *Independent on Sunday*, 24 September

1996 Ayres, Gillian, 'What the Genius of Cézanne means to us', *The Times*, 5 February

'Gillian Ayres on Matisse', *Guardian*, 17 September

Conran, Shirley, 'Calm Behind the Storm', *Royal Academy Magazine*, no.53, Winter

Craddock, Sacha, 'The bright spark in a brown world', *The Times*, 21 May

Gooding, Mel, 'Taking a Good Look', *Royal Academy Magazine*, no.53, Winter

Lambirth, Andrew, 'Gillian Ayres at Gimpel Fils', *What's On in London*, 22–9 May

1997 Barber, Lynn, 'Take Heart', *Observer, Life* section, 9 February

'All for Beauty', *Modern Painters*, Spring

Collins-Hughes, Laura, 'Explosions of Color', *New Haven Register*, 25 May

Craddock, Sacha, *White Light – Golden Age*, introduction to catalogue, Royal Academy of Arts, London

Hensher, Philip, 'Driven to Distraction', *Mail on Sunday*, 9 February

Hoffman, Hank, 'Color Happy', *New Haven Advocate*, 8–14 May

Hubbard, Sue, 'Gillian Ayres at the Sackler Galleries', *Contemporary Visual Arts*, no.14, Spring

Lee, David, 'Abstraction is the Theme', *Press Citizen*, Iowa, 15 November

Pringle, Alexandra 'One half a studio and the other half a cottage', catalogue essay, Royal Academy of Arts, London

Radl, Bill, 'The Art of the Abstract', *The Arts/Books*, Iowa, 17 November

1998 Dunne, Aidan, '25 Years of Kilkenny', *Irish Times*, 19 August

Hilton, Tim, 'Coming to Light', *Independent on Sunday*, 25 October

1999 Stiles, Peter, 'The Weight of Colour', *Artists and Illustrators*, June

2000 Gaskin, Fiona, 'Gillian Ayres's mural of 1957 for South Hampstead High School for Girls', *Burlington Magazine*, April

Public Collections

Art Gallery of South Australia
Arts Council of England
Arts Council of Northern Ireland
Atkinson Art Gallery, Southport
Birmingham Museum and Art Gallery
Bolton Museum and Art Gallery
British Council
British Council, New Delhi
British Museum
Cecil Higgins Art Gallery, Bedford
Contemporary Art Society, London
Government Art Collection
Gulbenkian Foundation, Lisbon
John Creasey Collection of Contemporary Art, Salisbury
Laing Art Gallery, Newcastle upon Tyne
Leeds City Art Gallery
London Borough of Camden
Manchester City Art Gallery
Museum of Fine Arts, Boston, Massachusetts
Museum of Modern Art, Brasilia
Museum of Modern Art, New York
National Gallery, Canberra
New Orleans Museum of Art
Olinda Museum, São Paulo
Rochdale Art Gallery
Royal Bank of Scotland Art Collection
Southampton City Art Gallery
Swindon Museum and Art Gallery
Tate Gallery, London
Ulster Museum, Belfast
Victoria and Albert Museum, London
Walker Art Gallery, Liverpool
Whitworth Art Gallery, Manchester
Yale Center for British Art, New Haven, Connecticut

Awards

1963 Japan International Art Promotion Association Award
1975 Arts Council of Great Britain Bursary
1979 Arts Council of Great Britain Purchase Award
1982 Second Prize, John Moores Biennale, Walker Art Gallery,
 Liverpool
1988 The Blackstone Prize, Royal Academy Summer
 Exhibition
1989 The Charles Wollaston Award, Royal Academy Summer
 Exhibition
 The Blackstone Prize, Royal Academy Summer
 Exhibition
 Korn/Ferry Prize, Royal Academy Summer Exhibition
1991 Prizewinner, Gold Medal, British Council's Seventh
 Triennale, India

Film

1985 *Looking into Painting*, TV film for Open University,
 Channel 4 with Norbert Lynton
 Openess and Light, Gillian Ayres in conversation with
 Alistair Hicks (slide tape)
1988 *Gillian Ayres '88*, Grove Films
2000 *Artist at Work: Gillian Ayres*, Jeremy Isaacs Productions

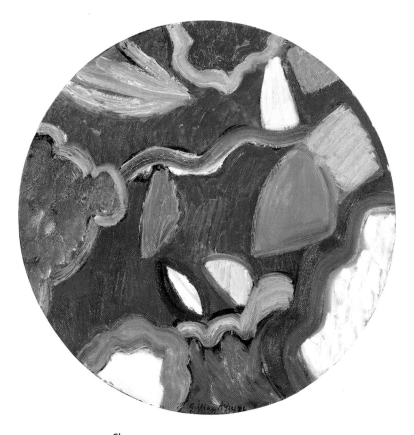

Glas
1986
oil on canvas
61 cm (diameter)

List of Illustrated Works

Since 1995 Gillian Ayres has been represented by Gimpel Fils.

Photographic credits are due to Prudence Cuming, David Godbold and Mike Fear.

Unless otherwise indicated works are listed in order of their illustrated appearance.

Measurements are given in inches followed by centimetres, height before width.

Introduction

Isle, 1988, oil on canvas, 36 in (91.5 cm) (diameter), Private Collection

Chapter 1

Harlyn Bay, 1945, oil on cardboard, 19½ x 24 in (50 x 61 cm), Private Collection

Chapter 2

Beached Boat, 1949, oil on canvas, 16½ x 18¼ in (42 x 46 cm), Courtesy of Peter Nahum at the Leicester Galleries, London
Railway Station, 1949, oil on board, 11 x 14 in (28 x 35.5 cm), Private Collection
Boats on a Beach, 1949, oil on canvas, 20 x 30 in (51 x 76.2 cm), Private Collection

Chapter 3

Vertical Blues, 1956, oil and household paint on board, 46 x 16 in (117 x 40.6 cm), Private Collection
Green and White, c.1955, oil on board, 10½ x 15½ in (26.5 x 39.5 cm), Private Collection
Grey, Green and White, c.1955, oil on board, 7¾ x 9¾ in (19.7 x 24.8 cm), Private Collection

Chapter 4

Tachiste Painting No.1, 1957, oil and ripolin on board, 48 x 48 in (122 x 122 cm), Private Collection
Untitled, 1956, oil and ripolin on board, 19 x 12½ in (48.7 x 31.8 cm), Private Collection
Hampstead Mural, 1957, ripolin on blockboard, 90 x 36/ x 44/x 108/x 132 in (230 x 91.5/x 111.8/x 274.4/x 335 cm) (four panels respectively), South Hampstead High School for Girls, London

Chapter 5

Distillation, 1957, oil and ripolin on board, 84 x 60 in (203 x 152.5 cm), Tate Gallery, London

Chapter 6

Cumuli, 1959, oil and ripolin on board, 120 x 126 in (305 x 320 cm) (two panels), Collection of the Artist
Cwm Bran, 1959, oil and ripolin on board, 63 x 120 in (160 x 305 cm), Collection of the Artist

Cwm, 1959, oil and ripolin on board, 63 x 120 in (160 x 305 cm), Collection of the Artist
Unstill Centre, 1959, oil and ripolin on board, 63 x 120 in (160 x 305 cm), Collection of the Artist
Untitled, 1960, oil and ripolin on board, 63 x 120 in (160 x 305 cm), Collection of the Artist
Muster, 1960, oil and ripolin on board, 63 x 120 in (160 x 305 cm), Collection of the Artist

Chapter 7

Nimbus, 1962, oil and ripolin on canvas, 108 x 60 in (274.4 x 152.5 cm), Private Collection
Blimps, 1961, oil and ripolin on canvas, 60 x 60 in (152.5 x 152.5 cm), Private Collection
Islands, 1961, oil on canvas, 60 x 84 in (152.5 x 213.4 cm), Private Collection
Pivot, 1961, oil on canvas, 70 x 108 in (183 x 274.4 cm), Private Collection (as reproduced in Molton Gallery catalogue, 1962)
Scud, 1961, oil on canvas, 72 x 108 in (183 x 274.4 cm), Private Collection (as reproduced in Molton Gallery catalogue, 1962)
Break-off, 1961, oil on canvas, 60 x 120 in (152.5 x 305 cm), Tate Gallery, London
Send-off, 1962, oil on canvas, 84 x 120 in (213.4 x 305 cm), Calouste Gulbenkian Foundation, Lisbon
Unvisited, 1962, oil on canvas, 72 x 60 in (182.5 x 152.5 cm), Calouste Gulbenkian Foundation, Lisbon
Brood, 1962, oil and ripolin on canvas, 84 x 120 in (213.4 x 305 cm), Private Collection
Untitled, 1962, oil and ripolin on canvas, 67 x 88 in (171 x 225 cm), Private Collection
Lure, 1963, oil on canvas, 60 x 60 in (152.5 x 152.5 cm), Arts Council Collection
Scott, 1963, oil on canvas, 60 x 60 in (152.5 x 152.5 cm), Private Collection, Dublin

Chapter 8

Stamboul, 1965, acrylic on canvas, 48 x 48 in (122.5 x 122.5 cm), Calouste Gulbenkian Foundation, Lisbon
Untitled Drawing, 1965, graphite and pastel on paper, 7 x 9 in (17.8 x 22.8 cm), Calouste Gulbenkian Foundation, Lisbon
Untitled Drawing, 1965, graphite and pastel on paper, 9 x 7 in (22.8 x 17.8 cm), Calouste Gulbenkian Foundation, Lisbon
Untitled Drawings, 1965, chalk on paper, 19 x 27½ in (48.3 x 69.9 cm) (sheet size), Arts Council Collection
Greenback, 1964, acrylic on canvas, 60 x 60 in (152.5 x 152.5 cm), Whereabouts Unknown
Untitled Drawing, 1965, graphite and pastel on paper, 9 x 7 in (22.7 x 17.5 cm), Calouste Gulbenkian Foundation, Lisbon
Untitled Drawing, 1965, graphite and pastel on paper, 7 x 9 in (17.5 x 22.7 cm), Calouste Gulbenkian Foundation, Lisbon
Isfahan, 1964, acrylic on canvas, 108 x 108 in (274.4 x 274.4 cm), Whereabouts Unknown
Piranha, 1964, acrylic on canvas, 94 x 60 in (239 x 152.5 cm), Whereabouts Unknown (Exhibited at Kasmin in 1965 as *Untitled*. Reproduced here from front cover of Kasmin catalogue card, 1965)
Send, 1964, acrylic on canvas, 60 x 60 in (152.5 x 152.5 cm), Whereabouts Unknown (Reproduced here from back cover of Kasmin catalogue card, 1965)
Untitled Drawing No.11, 1967, graphite and crayon on paper, 21½ x 29¾ in (54.6 x 75.6 cm), British Council Collection
Height, 1964, acrylic on canvas, 84 x 120 in (213.4 x 305 cm), Whereabouts Unknown

Lorenzo the Magnificent and Niccolo the Gear, 1967, silkscreen print, 30 x 22 in (76.2 x 56 cm), (Editions Alecto: printed at Kelpra Studios)
Crivelli's Room I and II, 1967, silkscreen prints, 30 x 22 in (76.2 x 56 cm) (*Crivelli I*) and 22 x 30 in (56 x 76.2 cm) (*Crivelli II*) (Editions Alecto: printed at Kelpra Studios)
Subterranean, 1964, acrylic on canvas, 60 x 60 in (152.5 x 152.5 cm), Whereabouts Unknown
Shiraz, 1965, acrylic on canvas, 60 x 60 in (152.5 x 152.5 cm), Whereabouts Unknown
Umbria, 1966, acrylic on canvas, 60 x 60 in (152.5 x 152.5 cm), Arts Council Collection
Tashkent, 1966, acrylic on canvas, 48 x 48 in (122 x 122 cm), Whereabouts Unknown
Fountain, 1967, acrylic on canvas, 84 x 60 in (213.4 x 152.5 cm), Private Collection
Untitled (Green Pools), 1968, acrylic on canvas, 88 x 60 in (227 x 152.5 cm), Private Collection
Untitled (Scatter), 1969, acrylic on canvas, 84 x 60 in (213.4 x 152.5 cm), Private Collection

Chapter 9

Yellow Painting, 1976, acrylic on canvas, 96 x 60 in (244 x 152.5 cm), Collection of the Artist
Untitled (Lily Pond), c.1971–2, acrylic on canvas, 84 x 324 in (213.4 x 820 cm) (approx), Collection of the Artist (All details. Photographs taken by Mel Gooding, Tall Trees, June 2000)
Untitled (Purples), 1971, acrylic on canvas, 84 x 240 in (213.4 x 610 cm), Collection of the Artist (Installation photograph at the Hayward Gallery's *Large Paintings* show, London, 1973)
Untitled (Purples) (detail), 1971, acrylic on canvas, 84 x 240 in (213.4 x 610 cm), Collection of the Artist (Photo: the author)
Untitled, 1973–4, acrylic on canvas, 120 x 180 in (305 x 457.5 cm), Whereabouts Unknown (Photograph as reproduced in the catalogue of *British Painting '74* at the Hayward Gallery, London, with caption, 'Studio photograph before painting was stretched')
Untitled, 1972, pastel and crayon on paper, 8 x 14½ in (20.5 x 37 cm), Collection of the Artist
Untitled, 1972, pastel on paper, 9½ x 14½ in (24 x 37 cm), Collection of the Artist
Pinks with blue border, 1973, watercolour on paper, 22 x 30 in (56 x 76.2 cm), Collection of the Artist
Untitled (Cerise), 1972, acrylic on canvas, 84 x 240 in (213.4 x 610 cm), Collection of the Artist (Photographs taken by the author, Tall Trees, June 2000)
Red Painting, 1975–6, acrylic on canvas, 96 x 60 in (244 x 152.5 cm), Private Collection, USA (Installation photograph at Women's Interart Center, New York, December 1976)
Weddell, c.1973–4, acrylic on canvas, 60 x 48 in (152.5 x 122 cm), Collection of the Artist
Untitled (Eau de Nil), 1974–5, acrylic on canvas, 60 x 72 in (152.5 x 183 cm), Collection of the Artist
Winter Work, 1975–6, acrylic on canvas, 60 x 84 in (152.5 x 213.4 cm), Collection of the Artist
Winter's Traces, c.1976, acrylic on canvas, 96 x 84 in (244 x 213.4 cm), Collection of the Artist

Chapter 10

Mons Graupius, 1979–80, oil on canvas, 96 x 108 in (244 x 274.4 cm), Rochdale City Art Gallery
Bellona, 1976–8, acrylic and oil on canvas, 60 x 96 in (152.5. x 244 cm), Arts Council Collection
Hinba, 1977–8, oil on canvas, 84 x 120 in (213.4 x 305 cm), Southampton Art Gallery

Orlando Furioso, 1977–9, oil on canvas, 90 x 90 in
(233 x 233 cm), Arts Council Collection
Pala d'Oro, 1977–9, oil on canvas, 96 x 104 in
(244 x 264 cm), Private Collection
Achnabreck, 1978–9, oil on canvas, 96 x 60 in
(244 x 152.5 cm), Collection of the Artist
Ultima Thule, 1978–80, oil on canvas, 144 x 90 in
(366 x 228 cm), Arts Council Collection
Angelus and Pastores, 1980–1, oil on board, 30 x 24 in
(76.2 x 61 cm), Private Collection
Cairnbaan, 1979–81, oil on canvas, 81 x 84 in
(206 x 213.4 cm), Private Collection
Flow Not so Fast ye Fountains, 1979–81, oil on canvas,
90 x 84 in (228 x 114 cm), Private Collection
Untitled drawings 1979–80, watercolour on paper, three
images approx 25 x 20 in (63 x 51 cm), one image approx
20 x 25 in (51 x 63 cm), Private Collections

Chapter 11

Lume del Sol, 1986–7, oil on canvas, 44 x 44 in
(112 x 112 cm), Private Collection
Ariadne on Naxos, 1979–81, oil on canvas, 108 x 124 in
(274.4 x 315 cm), Museum of Modern Art, Brasilia
Piva, 1981, oil on canvas, 36 in (91.5 cm) (diameter),
Private Collection
Anthony and Cleopatra, 1982, oil on canvas, 114 x 113 in
(289.3 x 287.2 cm), Tate Gallery, London
Papagena, 1983, oil on canvas, 84 x 84 in (213.4 x 213.4 cm),
Private Collection
Prometheus, 1983, oil on canvas, 72 x 128 in
(182.9 x 327.6 cm), Private Collection
A Belt of Straw and Ivy Buds, 1983, oil on canvas,
122 x 66 in (310 x 167.6 cm), Private Collection
Black Mountains, 1983, oil on canvas, 114 x 114 in
(287 x 287 cm), Whereabouts Unknown
Dowland's Book of Ayres, 1984, oil on canvas, 42 x 30 in
(106.8 x 76.4 cm) (oval), Private Collection, USA
Quito, 1984, oil on canvas, 48 x 48 in (122 x 122 cm),
Private Collection
Fairest of Stars, 1984, oil on canvas, 132 x 72 in
(335 x 183 cm), Collection of the Artist
Whan that Aprill, 1984, oil on canvas, 120 x 120 in
(305 x 305 cm), Private Collection, USA
End Game, 1985, oil on canvas, 108 x 103 in (275 x 260 cm),
Private Collection
Dido and Aeneas, 1988, oil on canvas, 108 x 120 in
(274 x 305 cm), Private Collection
Full Fathom Five, 1987, oil on canvas, 78 x 138 in
(198 x 350 cm), Private Collection, USA
A Painted Tale, c.1984, oil on canvas, 96 x 108 in
(244 x 274.4 cm), Collection of the Artist
Selene, Sylvan and Fauns, 1989–90, oil on canvas,
108 x 108 in (274.4 x 274.4 cm), Private Collection
Indian Summer, 1990, oil on canvas, 60 x 60 in
(152.5 x 152.5 cm), British Council Collection
Altair, 1989, oil on canvas, 96 x 168 in (243 x 426 cm)
(two canvases), Private Collection
Sun Stars, 1990, oil on canvas, 120 x 120 in (305 x 305 cm),
Jaipur School of Art, India
A Midsummer Night, 1990, oil on canvas (triptych),
72 x 48 in (183 x 122 cm) (each canvas), Birmingham City
Art Gallery
Lily of Laguna, 1991–2, oil on canvas, 96 x 84 in
(244 x 213.4 cm), Collection of the Artist
Phaeton, 1990, oil on canvas, 96 x 144 in (244 x 366 cm),
Tate Gallery, London
Darius, 1990–1, oil on canvas, 96 x 84 in (244 x 213.4 cm),
Private Collection
Sundark Blues, 1993–4, oil on canvas, 96 x 168 in
(244 x 426 cm) (two canvases), Tate Gallery, London

Sucked Up Sunslips, c.1994, oil on canvas, 96 x 84 in
(244 x 213.4 cm), Collection of the Artist
Suddenly Last Summer, 1996, oil on canvas, 96 x 144 in
(244 x 366 cm), Collection of the Artist
Flighted Ones, 1995, oil on canvas, 96 x 168 in
(244 x 426 cm) (two canvases), Yale Centre for British Art
Tipsy Dance, 1996, oil on canvas, 36 x 36 in (91.5 x 91.5 cm),
Private Collection
It Was a Time, 1982, oil on canvas, 24 in (61 cm)
(diameter), Private Collection
Wells, 1982, oil on canvas, 84 in (213.4 cm) (diameter),
Private Collection
City of Tiny Lights, 1996, oil on canvas, 48 in (122 cm)
(diameter), Private Collection
*Turkish Blue and Emerald Green that in the Channel
Stray*, 1996, oil on canvas, 96 x 156 in (244 x 396.5 cm),
Collection of the Artist
Weather in the Streets, 1997–8, oil on canvas,
60 x 60 in (152.4 x 152.4 cm), Private Collection
They Can't Take That Away From Me, 1998, oil on canvas,
96 x 168 in (243.8 x 426.7 cm), Collection of the Artist
Ride White Swan, 1998–9, oil on canvas, 72 x 72 in
(182.8 x 182.8 cm), Collection of the Artist
Hazy Shade of Winter, 1998–9, oil on canvas, 96 x 96 in
(243.8 x 243.8 cm), Collection of the Artist
Deep Song, 1998–9, oil on canvas, 66 x 120 in
(167.6 x 304.8 cm), Collection of the Artist
Azura, 1999, oil on canvas, 36 x 36 in (91.4 x 91.4 cm),
Private Collection
Wide Sargasso Sea, 1999, oil on canvas, 48 x 72 in
(121.9 x 182.8 cm), Private Collection
Rufous, 1998–9, oil on canvas, 96 x 168 in (243.8 x 426 cm)
(two canvases), Collection of the Artist
Blue Flame, 1999, carborundum etching with hand
colouring, 47½ x 63 in (120 x 160 cm) (Proofed and
printed at 107 Workshop, Wiltshire), Courtesy of Alan
Cristea
Springfield, 1999, carborundum etching with hand
colouring, 47½ x 63 in (120 x 160 cm) (Proofed and
printed at 107 Workshop, Wiltshire), Courtesy of Alan
Cristea

Awards/Film

Glas, 1986, oil on canvas, 24 in (61 cm) (diameter),
Collection of the Artist

Achnabreck (1978–9) 122, *127*
Alecto Gallery 85
Alloway, Lawrence 31, 39, 54, 59, 61
Angelus and Pastores (1980–1) 129, *130*
Anthony and Cleopatra (1982) 138, *140*, 148
Ariadne on Naxos (1979–81) 138, *139*
Artists International Association (AIA) Gallery 28–31, 46
Arts Council 54, 69, 80, 132
Ayres, Gillian, background 7–10; early life 14–15; school
 years 15–16; at Camberwell 16–17, 20–3, 25; at AIA
 28–31; marriage 28; first show 31, 33, 36; as a tachist
 37–8, 102; *Hampstead Mural* 38–41; at Corsham
 46–7, 64; approach to painting 47–9; effect of being
 'in nature' 52, 54; American influence 54, 59–61; and
 Situation exhibition 54, 59–60; new style 64, 68–9;
 mixed media drawings 76; cool style 80, 85, 95–6;
 gallery support for 80; programmatic paintings 80,
 85; at St Martin's 102, 120; live performance art 102,
 106–7, 112, 116; influence of Hofmann on 116, 120, 122;
 at Winchester 120; illness/life changes 120; greater
 use of light/colour-forms 129, 132; late style 138, 148,
 160, 170, 182
Ayres, Stephen (father) 15

Bath Academy of Art (Corsham) 46–7, 64
Beached Boat (1949) *19*, 23
Bellona (1976–8) 122, *123*
A Belt of Straw and Ivy Buds (1983) *143*, 148, 160
Blimps (1961) *64*, 68
Boats on a Beach (1949) 23, *24*
Bowness, Alan 64, 95
Break-off (1961) *67*, 68, 69
Brett, Guy 95–6
Brood (1962) *72*, 74

Cairnbaan (1979–81) *131*, 132
Camberwell School of Arts and Crafts 16–17, 20–2
Cohen, Bernard 54, 60, 80
Coleman, Roger 54, 59, 60
Crivelli's Room I and *II* (1967) 85, *88*
Cumuli (1959) *51*, 52, 54
Cwm (1959) 54, *55*, 61
Cwm Bran (1959) *53*, 54, 61

Darius (1990–1) *163*, 182
Deep Song (1998–9) *177*, 182
Denny, Robyn 46, 54, 59, 60, 80, 95
Dido and Aeneas (1988) 148, *151*
Distillation (1957) *45*, 46, 47–9
Dowland's Book of Ayres (1984) *145*, 148

Ellis, Clifford and Rosemary 46
End Game (1985) 148, *150*, 182
Euston Road approach 20, 21, 28

Festival of Britain (1951) 28
Flighted Ones (1995) *168*, 170
Flow Not so Fast ye Fountains (1979–81) 132, *133*
Fountain (1967) 85, *94*, 95
Full Fathom Five (1987) 148, *152*

Galeria Alvarez 112
Gallery One 31, 33, 36
Gilliatt, Penelope 60
Gordale Scar (Ward, 1812–14) *49*, 49
Green and White (c.1955) *32*, 33
Greenback (1964) *83*, 85
Greenwood, Michael 38
Grey, Green and White (c.1955) *32*, 33

Hamilton Gallery 74, 80
Hampstead Mural (1957) 40–1, *41–3*, 60
Harlyn Bay (1945) *13*, 17
Hayward Gallery 102, 107
Heron, Patrick 36, 64, 74, 106
Hilton, Roger 31, 33
Hinba (1977–8) 122, *124*, 129
Hofmann, Hans 116, 120
House, Gordon 54, 60
Hoyland, John 54, 60

Irwin, Gwyther 46, 54
Islands (1961) *65*, 68
It Was a Time (1982) 170, *171*

Johnstone, William 20

Kasmin Limited 80, 102, 132
Kettle's Yard, Cambridge 132
Knoedler Gallery 132

Large Paintings: Three Painters exhibition (1971) 102
Lily of Laguna (1991–2) 148, *161*
Lorenzo the Magnificent and Niccolo the Gear (1967) 85,
 88
Lure (1963) 74, *75*

McEvilley, Thomas 9–10
Marlborough New London Gallery 54, 64
Metavisual, Tachiste, Abstract (1957) 38
A Midsummer Night (1990) *159*, 182
Minton, John 20, 22, 23, 28
Modern Art in the United States exhibition (1956) 8, 36
Molton Gallery 39, 64, 80
Mundy, Henry 28, 31, 46, 52, 54, 60, 64, 102, 138, 182
Museum of Modern Art (MOMA) 120, 132, 170
Muster (1960) 54, *58*

Nan-Kivell, Rex 36
Nuttall-Smith, Ralph 16–17

Orlando Furioso (1977–9) 122, *125*, 129

Pala d'Oro (1977–9) 122, *126*, 129
Papagena (1983) *141*, 148
Pasmore, Victor 14, 20–1
Picasso, Pablo 10, 22, 37, 38
Piccadilly Gallery 36
Pictures without Paint exhibition (1958) 46
Pinks with blue border (1973) 107, *109*
Pivot (1961) *65*, 68

Pollock, Jackson 37, 38, 39, 170
Prometheus (1983) *142*, 148

Railway Station (1949) 23, *24*
RBA Galleries 8, 54
Red Painting (1975–6) 112, *112*
Redfern Gallery 46
Robert Fraser Gallery 80
Rothenstein, Michael 22, 23, 28
Rumney, Ralph 54, 59

St Martin's School of Art 102
St Paul's Girls' School 14, 15–16
Scott (1963) 74, *77*
Scott, William 33, 46, 64
Scud (1961) *66*, 68
Send-off (1962) 68, *70*
Serpentine Gallery 68, 132
Shiraz (1965) 85, *91*
Situation exhibitions (1961–3) 54, 59–61, 64, 68
Smith, Richard 59, 80
Some Pictures from the E. J. Power Collection exhibition
 (1958) 47, 59
Still, Clyfford 47, 59
Stuyvesant Collection 95
Sucked Up Sunslips (c.1994) *166*, 182
Suddenly Last Summer (1996) *167*, 170
Sundark Blues (1993–4) 160, *164–5*, 182

Tapié, Michel 37, 39, 40
Tate Gallery 36, 37, 54, 95, 106, 107
Townsend, William 20, 21
Turnbull, William 54, 60

Ultima Thule (1978–80) 122, *128*, 129
Untitled (1956) 37–8, *39*
Untitled (1960) 54, *57*
Untitled (1962) *73*, 74
Untitled (1972) 107, *108*
Untitled (Cerise) (1972) 107, *110–11*
Untitled Drawing No.11 (1967) 85, *87*
Untitled (Eau de Nil) (1974–5) 112, *114*
Untitled (Green Pools) (1968) 96, *97*, 102
Untitled (Lily Pond) (c.1971–2) 102, *103*, 106
Untitled (Purples) (1971) *104–5*, 106
Untitled (Scatter) (1969) 96, *98*, 102
Unvisited (1962) 68, *71*

Vertical Blues (1956) *27*, 33

Weddell (c.1973–4) 112, *113*
Wells (1982) 170, *171*
Whan that Aprill with his shoures soote (1984) 148, *149*
Whitechapel Art Gallery 8
Wide Sargasso Sea (1999) *179*, 182
Williams, Gareth 120, 138, 182
Williams, Shirley 14, 16
Winter Work (1975–6) 112, *115*
Winter's Traces (c.1976) 112, *117*
Women's Interart Center 116